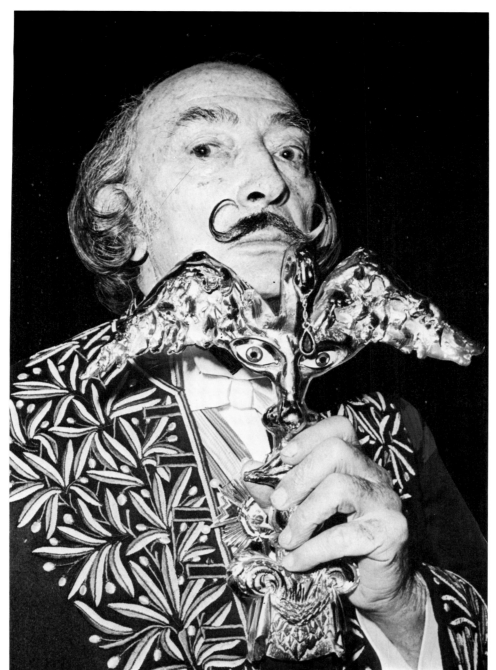

homage to

HOMAGE TO SALVADOR DALI

Special issue of the XXᵉ Siècle Review

Translations by: Joan Marie Weiss Davidson

© 1980 by Leon Amiel Publisher, New York

ISBN 0-89009-369-5

PRINTED AND MANUFACTURED IN THE UNITED STATES OF AMERICA

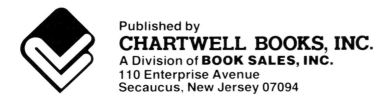

Published by
CHARTWELL BOOKS, INC.
A Division of **BOOK SALES, INC.**
110 Enterprise Avenue
Secaucus, New Jersey 07094

A DOUBLE PAGE LITHOGRAPH OF "LA BATAILLE DE TÉTOUAN" BY SALVADOR DALI

Dali with wig and double mustache.
(Photo by Toni Vidal. Editions Poligrafa, Barcelona).

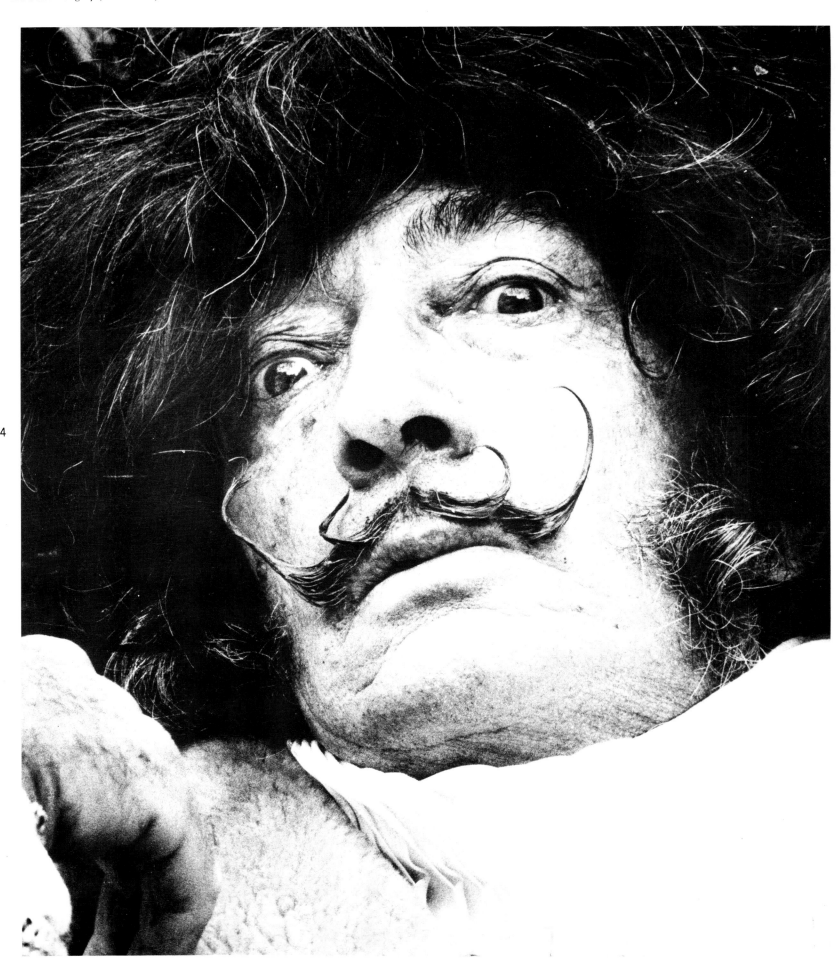

dali and his masks

by pierre volboudt

Life is an oeuvre, the work a replica of the creator's phantasms and secret themes which reflect in each face of the double figure of the one who is and the one who creates. Of these two images a persona is composed. They communicate within him, contradicting themselves, blending in this unique being who is split between the simple act of being and the action that possesses him, that obliges him endlessly to measure up to his deepest requirements.

Those traits that astonish, those attitudes that disconcert are perhaps the truth of the most intimate, the most inaccessible individual. Enlarged, deformed to excess, they authenticate what alone would be merely sterile pleasure, absurd obsession, a useless grimace before the icy indifference of a mirror. The voluntary, showy exaggeration is less a seduction than a challenge to the gaze of the audience to whom it is addressed and from whom it awaits credit in return, like an extreme and paradoxical value, of some monstrous, inexpressible even admirable quality that subjugates by its excess and partakes of the extravagance of the Fable.

Dali is at the center of a mythology that he has fashioned from whole cloth for his personal use. He has set down the genesis of it, the customs, and their rituals, their presumptuous emblems. Undoubtedly he owes to them what another expert in these games of the Double and the Singular defined as the "inebriating felicity you taste in the thought that you feel yourself all alone and that you are acting for society a drama that repays you for the cost of the scenery with every pleasurable sensation of contempt." In the shelter of this role, in the corridors of consciousness, in the scandalous license of existence, he rediscovers himself as he is not, and only what he is.

Throughout this provoking self-parody, watched for from all points in the arena, the hero faces himself in single combat. The Double and Same selves that he has raised, he sees himself in them and from his calculated pranks he fashions an uncommon ego, gives flesh and color to that multiple Narcissus who paints himself in the fixed display of his perpetual hypnosis.

Once and for all, Dali has sacrificed his person to his persona. "Hombre de Ostentacion," the title Balthasar Gracian gives to the man who is endowed with the cardinal virtue of sacrificing being to appearance, seems made for him. Dali recognizes himself in the dazzling amazement of both seeing himself haloed by all the mirages of unreality that his inventiveness tirelessly exudes, and of receiving this second identity about which it is hard to say whether it is the mask or the face, whether the face adjusts to the mask or the mask replaces it, stamped with an irreproachable otherness. He sets himself up as the arbiter between dream and reality. Without respite, he goes from baroque exaggeration to the dry and cutting nakedness of reality. He conceals what is below the simulation of what is not. He knows, with Gracian, that "display gives to everything an extra

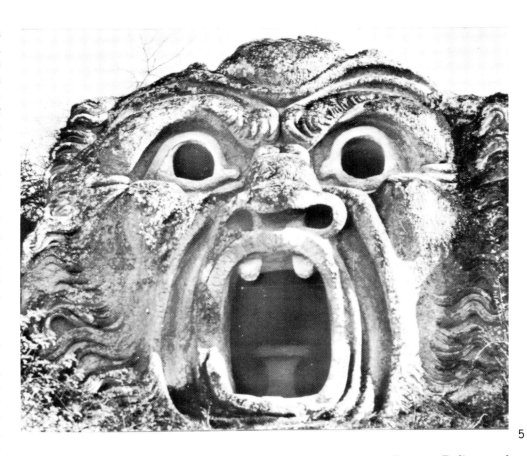

5

Bomarzo Rediscovered By Dali.
1938.

Dada-Dali.
1966. (Schoenemann Verlag, Bremen. Photo by Werner Bokelberg).

existence" and to the man whose talent is to parade his ego most pridefully exposed a luster that will not fade. Such an attitude makes the artist the focus of the convergence and refraction of images whose elements he reassembles through his own mental prism, the key point of his position facing the world and facing himself, these two antithetical protagonists between whom glides the shadow, Dali's phantom of smoke and glory. This airy despotism borders on dandyism. However, it is not affectation but a vainglory that has the relentless seductions of clear priority, a dandyism of majesty.

As if on the edge, next to the painting, the man is the real mask. Mask masked by the work which is also a mask, it too, a talking mask. A formal distance opens up between the world and the person who opposes his magic screens to it. His word rings with an oracular extravagance. The self becomes its own sounding board. From the dark recesses where its inspiration is nourished, painting yields some clues. The writer comments on their mechanics and their arrangements.

But the blinding glare of all these spotlights that he has carefully aimed at his person overwhelms—however well surrounded it may be—the human target which is offered to so many eyes, and is reabsorbed in a will power that emanates from it in order to be reflected there. The trails that he has marked out with innumerable masterpieces, in the half light where they penetrate and hide, listen, confuse the too vivid images of a universe where man changes into what he wishes and changes only his perspectives, so as to get a good grip on himself in the fatality of his visionary pleasure. "I don't change," Dali has written, "I modify myself." Isn't that the very essence of the metamorphic genius that Proteus embodied? "Vertere, vertere, Formose Proteu. . ."

All around him Dali sees not changes but exchanges in the nature of things. Everything is altered to suit his vision. A strange perversion seizes the world order. Appearance becomes malleable, gnawed upon by the cruel sorcery of the imaginary. Form conforms to all the suggestions of pictoral matter from which it breaks loose, as from the "Limbus Major" of the hermits and, outside of this elementary compost, becomes prey to the irrational. From there, those barbarous skingraftings, those convulsive alliterations of states of the visible, at first crystallized in the sharpness of its perfection, then scattered among the kingdoms. Each canvas shows these unions of the impossible and proves that the wager on making them the credo of an art has been won. Flesh cracks, is lacerated, is hardened in sharp petrifications. It knows the spasms of chaos, the silent ravages of decline. Saturated with juices and sap, it is simultaneously pulp, squama, exfoliation, skin, scale. Through the faults and fissures an entire larval life overflows from the lip that the painter's brush—that scalpel—opens at the flank of those misshapen bodies, those gaping eviscerated rocks. Dali tears away from reality that "skin of

things" covering the works. He crumples the shreds of it, bruises them, drapes them over the anarchistic images of his haunting dreams. From the dismembered reality, from his *disjecta membra,* from these disparate things he recreates extravagant anatomies. As under the fingers of an illusionist, the masks of the unusual pass from one to the other of these anatomical models that the artist prepares in the image of his phantasmagorias. On the stage where this apocalyptic drama is performed, they are the anamorphoses of his myths, joined to the shadowy species that the demonic brings into the world in parodic abundance. These "feverish and breathless materializations," like aberrant avatars, are born of the subsoil of an incongruous regeneration. The cracked shell that a hand of stone raises by the tips of its fingers above the waters that swallowed the true face of Narcissus, is the mask behind which the germinations of the dream take place, behind which all that moves and ferments in the sealed lairs develops and bursts out, and from there the mind, by a kind of interior seizure, projects them into the light.

Dali's final mask is perhaps only this smooth and naked oval of prophetic fissures, melting pot of "sublimations." There, on the reverse side of everything, in tete a tete with himself, he who one day admitted hating simplicity "in all its forms" paints himself in its labyrinths, transmuted from the Same to the Same into the Other who is still himself, in the fierce absolutism of the Singular.

PIERRE VOLBOUDT

dali-magus

by marcel brion of the french academy

Someone, Ariosto or Calderon perhaps, said that the greatest charmer would be the one who succeeded in charming himself. The act would require a dissociation of the ego and the superego, and the hard-won submissiveness of the charmed and, above all, the supernatural virtuosity of the magician, subduing the magic of the superego. Dali has allowed himself to be caught in the toils of the sorcery of his imagination. He has a magical genius for the invention of such images as do not exist in today's art and such images as never were so furiously comical and so marvelously inspired and inspiring, except perhaps in the work of Hieronymus Bosch.

The apparent gratuitousness of the image sometimes fools us, but one would be wrong to translate the growth of Dalian myths into metaphysical vocables or, simply, into the language of logical relationships. For these myths possess the double characteristic of the helmet of Mambrun: to appear as a common cap to the eyes of the vulgar, but to the vision of the seer the hat of a sovereign sorcerer. Because Don Quixote was initiated in the superior wisdom that has nothing to do with matter, custom or logic, he did not see the same objects as his servant and his parish priest. Ourselves, admiring Dali's images and marveling at them, must—in order to catch up with him—pass from the other side of objects to reach their hidden side. And because we inflict on them neither explanations nor commentaries, and on that condition alone, these images *will be* what they really *are:* devices of magic charm as the country sorcerers and a few, a very few, great artists of the imaginary know how to make them.

By taking this road we have an opportunity to meet the real Dali, the one who enjoys himself juggling with his masks, playing hide-and-seek with us,

Six Apparitions of Lenin on a Piano (detail). *1931. Oil on canvas. 114 x 146 cm. (Museum of Modern Art, Paris).*

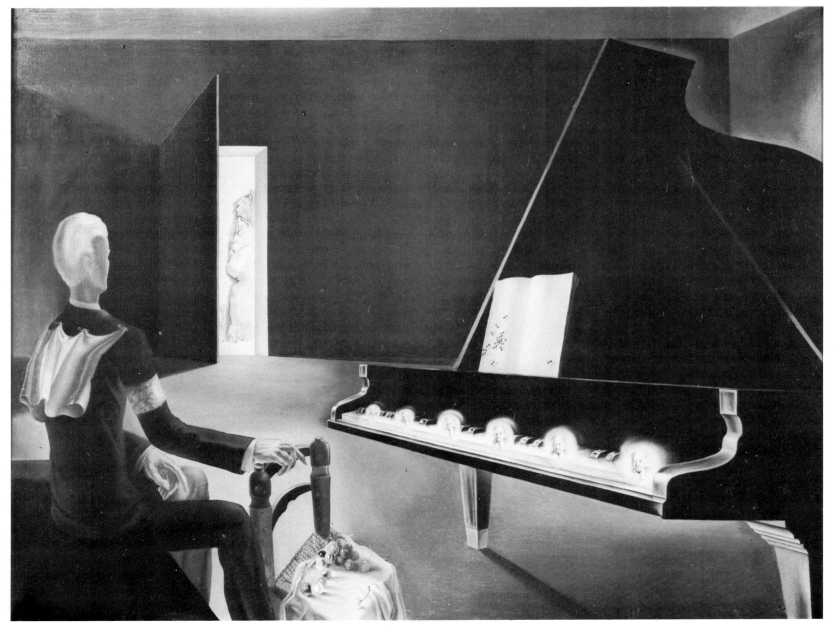

8

and shadow-boxing. It is not just anyone who boxes with his shadow or, playing blind-man's buff, touching his body and face, observes that the player you have caught is yourself. This fantastic image maker cannot be satisfied with a repertory of forms, no matter how fabulously diverse it may be. Even beyond the confusing muddle of dreams he elucidates figures that have their own reality, all the while adding a new accent, a different tone, the equivocation of lived experience, that ambiguity so marvelously capable of feigning anything and of admitting anything.

All the magician's principalities are open to him: he deals familiarly with the alchemist's, magisterially with the conjurer's. On an intimate basis with Prospero and with Ariel, he does not despise Caliban, because his mother was a sorceress, and he himself an ugly sort of monster. The monster has always interested Dali by the attraction of its peculiarity and because deformity successively reveals and conceals the secret elements of the things or the beings that it deforms, or malforms.

What could be more natural than that this *magico prodigioso* should be caught in the trap of his own abracadabras, and that the man should accept the captivity of this hermetic circle? What better guarantee of the artist's sincerity? When the imaginary is honest, and Dali's is without exception, the continents that he discovers and visits are real. As different from the norm as Dalian time and space may be, they are—in what concerns Dali and in what concerns us in regard to him—indisputably real: as real as mirages when they do not pretend to be anything else.

There is a Dalian landscape that comes to mind with the haunting persistence of a constant: a sort of desert, not quite the Sahara or the Gobi; the barren plateaus of the Ebro Valley or the cliffs along the English Channel will do for the comparison. At the edge of this desert is a miniscule person who is looking. Looking at What? The void. Sometimes this person begins to walk. Sometimes he even borrows a cart that, jolting along all alone, so slowly, so sorrowfully, can only be the chariot of death of the old popular legends; trailing behind it, washed out and torn, are the last shreds of the being that it drags across the cold dry wind of non-existence.

There is always as much emptiness around the

**Six apparitions de
Lénine sur un pianoforte** (detail).
*1931. Huile sur toile.
114 x 146 cm. (Museé
d'Art Moderne, Paris).*

**Six Apparitions of Lenin
on a Piano** (detail).
*1931. Oil on canvas.
114 x 146 cm. (Museum of
Modern Art, Paris).*

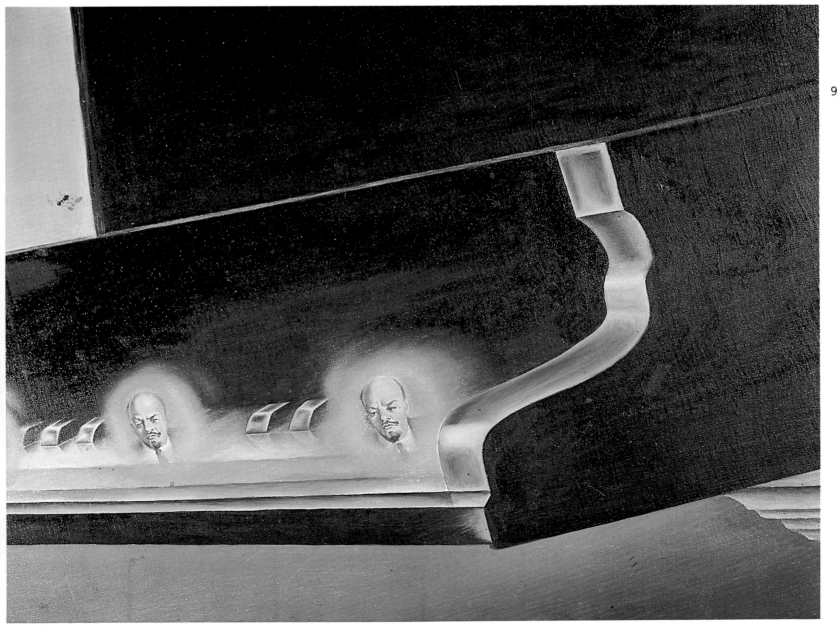

10

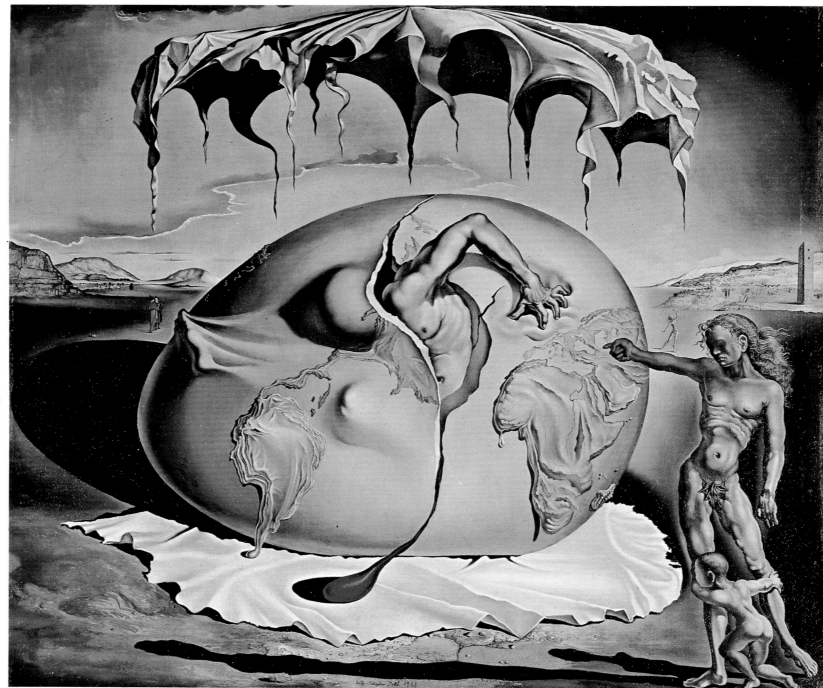

**Enfant Géopolitique
observant la naissance
de l'homme nouveau.**
*1943. Huile sur toile.
46 x 52 cm. (Coll. A.
Reynolds Morse, Cleveland,
U.S.A.).*

**Geopoliticus observing
the Birth of the
New Man.**
*1943. Oil on canvas.
46 x 25 cm. (The Reynolds
Morse Foundation, Cleveland).*

Métamorphose de Narcisse.
1936 / 1937. Huile sur toile.
51 x 76 cm. (Coll. Edward
F.W. James, Angleterre).

The Metamorphosis of Narcissus.
1936 / 1937. Oil on canvas.
51 x 76 cm. Edward James
Collection, Sussex).

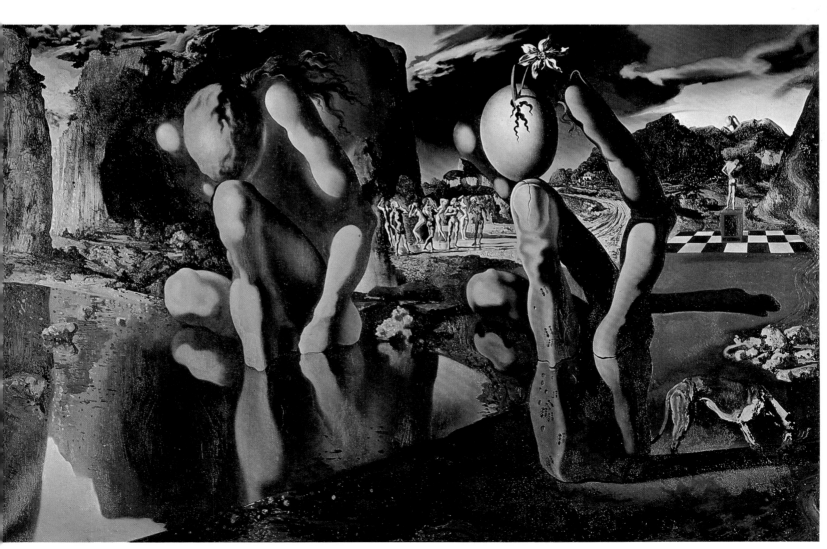

12

Le cabinet anthropomorphique.
1936. Huile sur panneau.
25 x 43 cm. (Coll. James
Henry Gray, Atlanta U.S.A.).

The Anthropomorphic Cabinet.
1936. Oil on wood panel.
25 x 43 cm. (The James
Henry Gray Collection,
Atlanta).

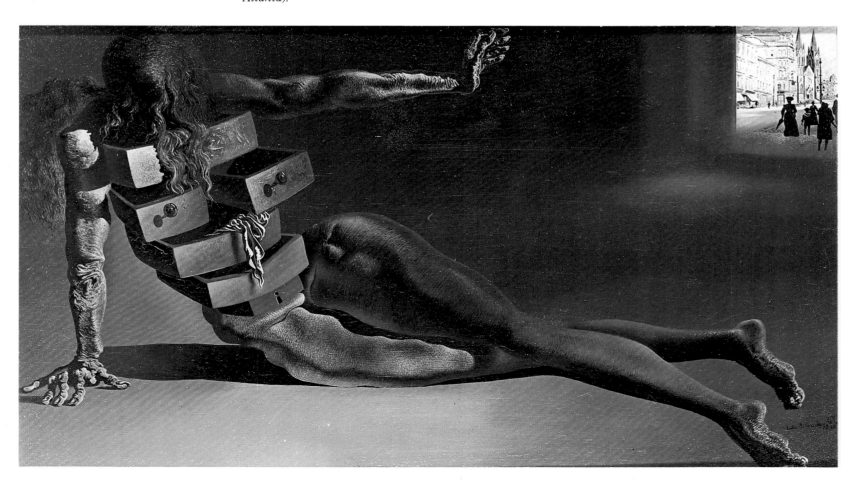

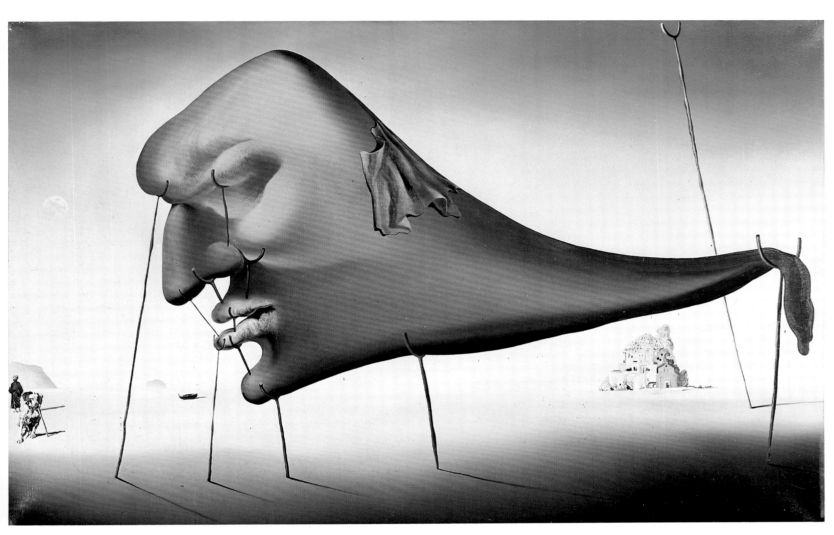

13

Le sommeil.
1937. Huile sur toile.
58 x 78 cm. (Coll. Edward
F.W. James, Angleterre).

The Dream.
1937. Oil on canvas.
51 x 78 cm. (The Edward
James Collection, Sussex).

14

Echo morphologique.
1936. Huile sur panneau.
30 x 33 cm. (Coll. A.
Reynolds Morse,
Cleveland, U.S.A.).

Morphological Echo.
1936. Oil on wood panel.
30 x 33 cm. (The Reynolds
Morse Foundation, Cleveland).

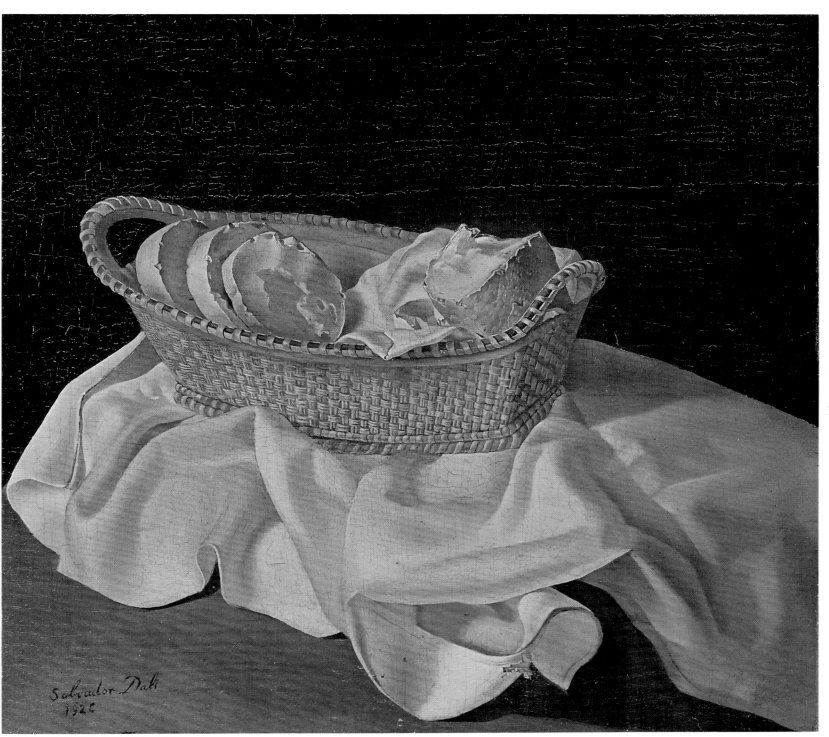

15

La corbeille à pain.
1926. Huile sur bois.
31.7 x 31.7 cm. (Coll.
A. Reynolds Morse,
Cleveland, U.S.A.).

The Basket of Bread.
1926. Oil on wood.
31.7 x 31.7 cm. (The Reynolds
Morse Foundation, Cleveland).

La Cène.
1955. Huile sur toile.
167 x 268 cm. (Galerie
Nationale d'Art, Washington.
Coll. Chester Dale).

The Last Supper.
1955. Oil on canvas.
167 x 268 cm. (Chester Dale,
National Gallery of Art
Washington).

16

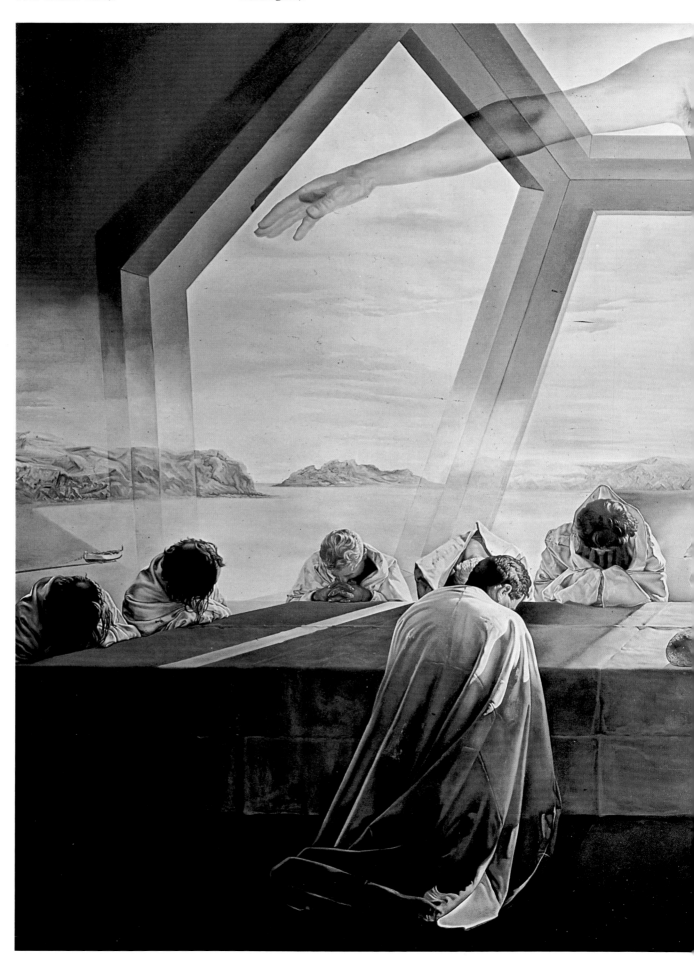

La madone de Port Lligat.
1950. Huile sur toile.
366 x 244 cm. (Coll.
A. Reynolds Morse,
Cleveland, U.S.A.).

The Madonna of Port Lligat
1950. Oil on Canvas
366 x 244 cm. (The Reynolds
Morse Foundation, Cleveland).

18

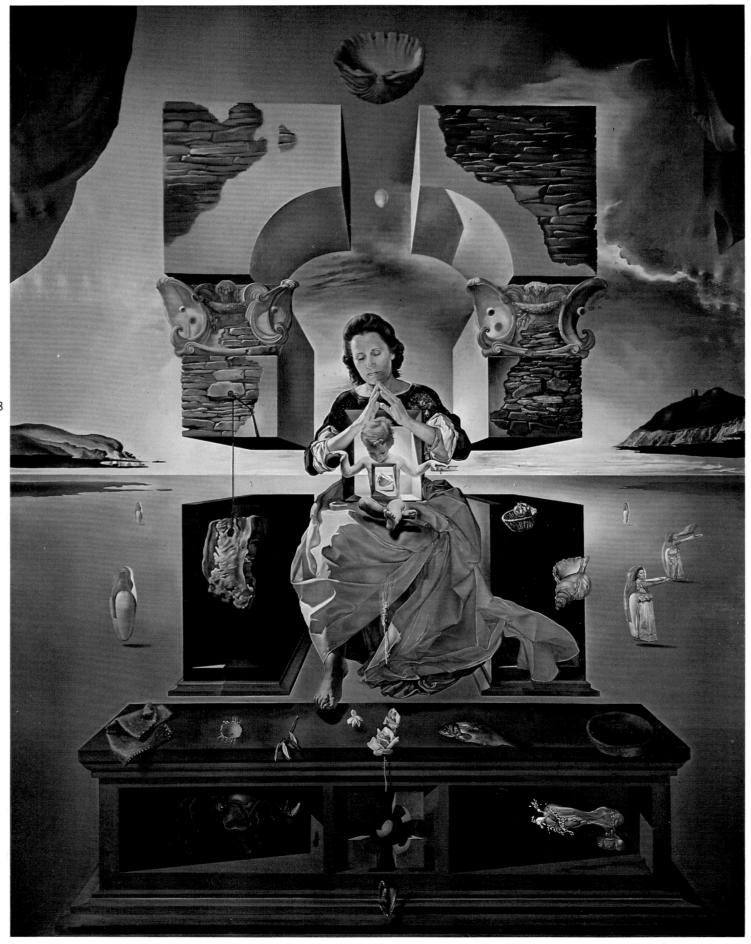

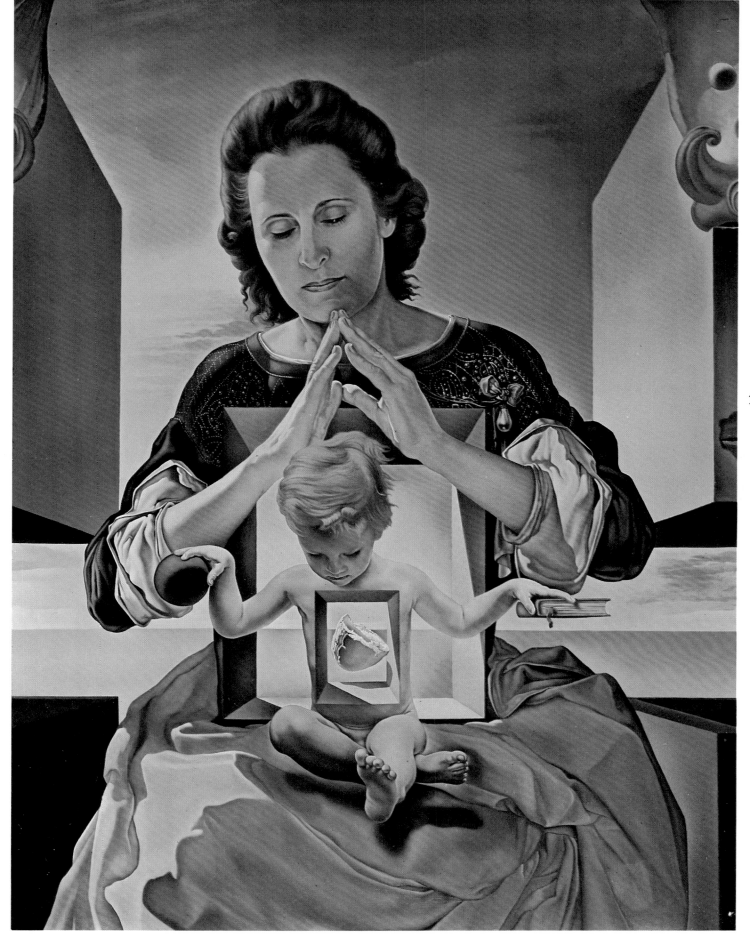

Concile œcuménique.
1960. Huile sur toile.
399 x 297 cm. (Coll.
A. Reynolds Morse,
Cleveland, U.S.A.).

The Ecumenical Council.
1960. Oil on canvas.
399 x 297 cm. (The Reynolds
Morse Foundation, Cleveland).

20

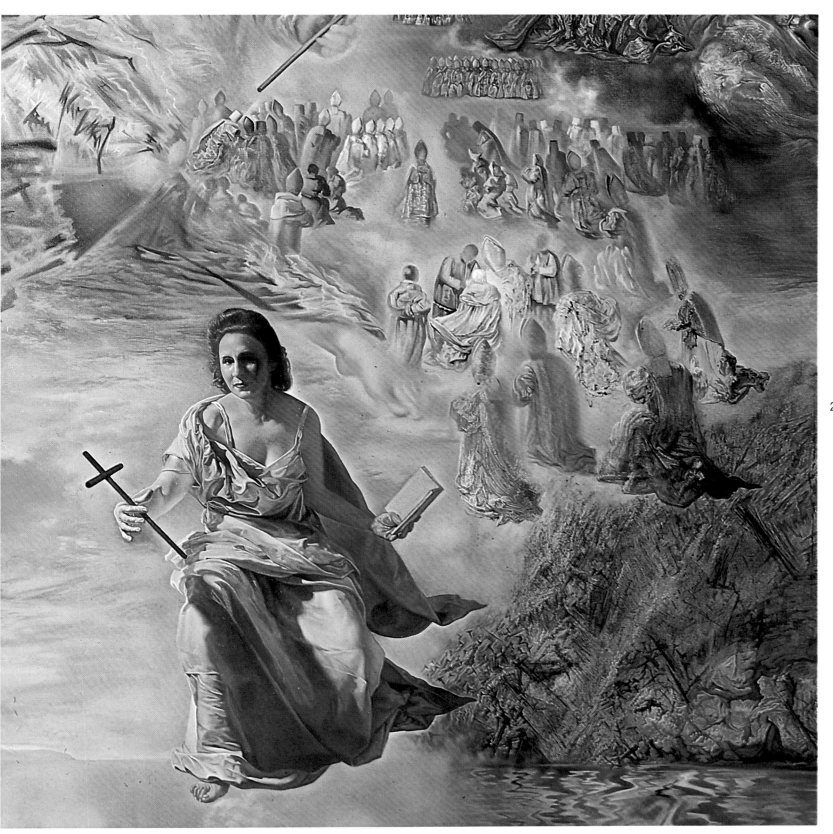

Profanation de l'hostie.
1929. Huile sur toile.
100 x 73 cm. Coll.
A. Reynolds Morse,
Cleveland, U.S.A.).

▷

Profanation of the Host
1929. Oil on canvas.
100 x 73 cm. (The Reynolds
Morse Foundation, Cleveland).

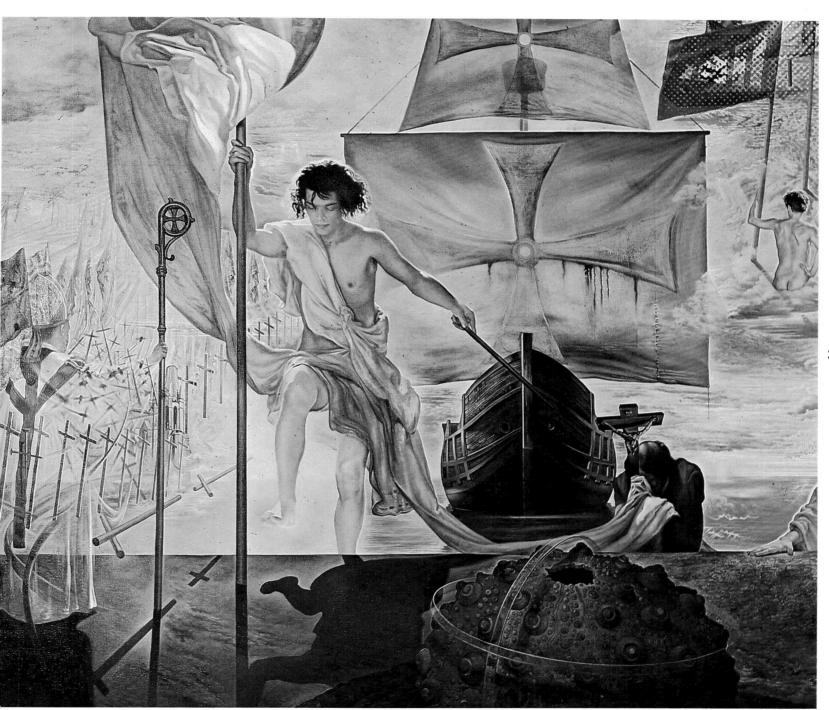

23

Détail of
**Decouverte de l'Amérique du
sud par Christophe Colomb.**

Detail of
**The Discovery of America
by Christopher Columbus.**

Découverte de l'Amérique du
sud par Christophe Colomb.
1958 / 1959. Huile sur toile.
410 x 310 cm. (Coll.
A. Reynolds Morse,
Cleveland, U.S.A.).

The Discovery of America
by Christopher Columbus.
1958 / 1959. Oil on canvas.
410 x 310 cm. (The Reynolds
Morse Foundation, Cleveland).

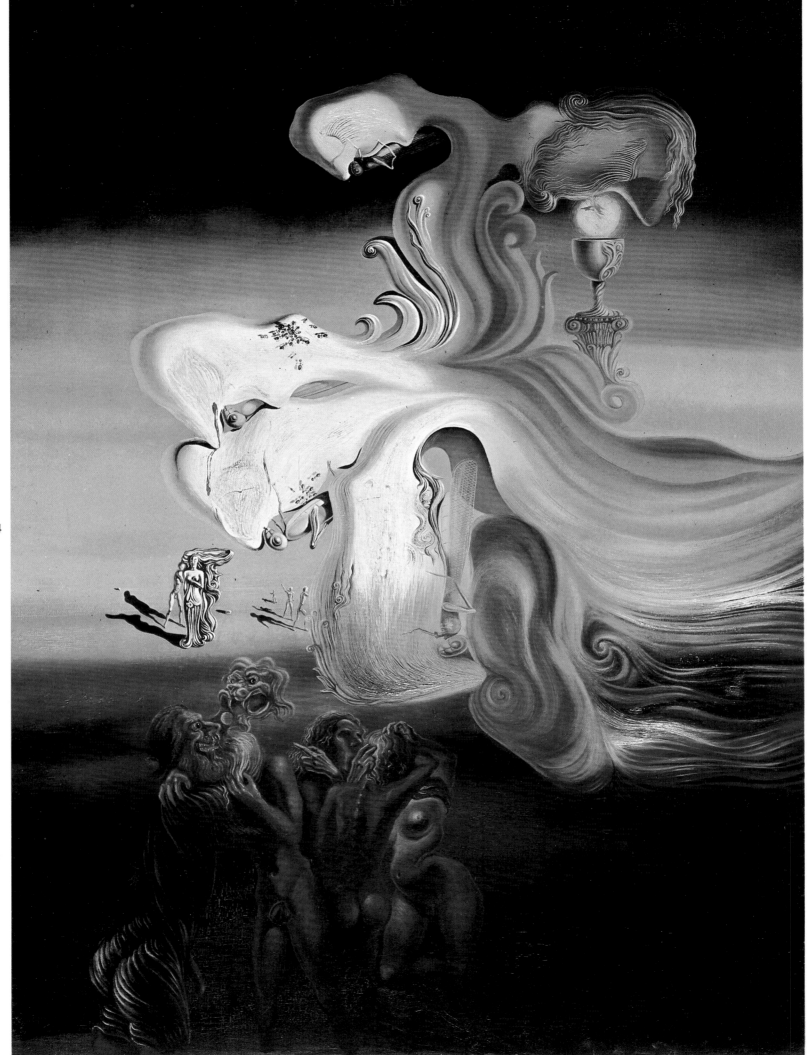

Dalian stroller as there is within him. What the figure moves and what he carries in his hands, his pockets or his head—whether he is seated on the beach of a sea where there never will be or never were any waves, or whether the weary traveller reclines upon a milestone or rests his back against a tree by the roadside—Dali has deliberately and for all time dedicated to the non-existence of nothingness, to the infernal void, that hollow inside the man's heart, or to those chasms all around him, to all that which obliges him to abandon the logic of his senses and his reason.

What does Dali give in exchange to this miserable creature who is stuck at the point where all the dimensions of space converge and intersect? Perhaps the uncomfortable assurance of belonging, body and soul, to the categories of the irrational growing solely in his dreams, burdening his nights with absurd objects, with unwanted peregrinations, with uncertain footsteps. Dali is surely the cousin of the Aragonian who engraved diabolical lines on copper and proved that "the dream of reason produces monsters." But he didn't tell us whether or not chaste Reason takes advantage of those nocturnal pleasures to copulate exquisitely with the monster-babies that Reason brings into the world and swaddles in gloomy clothes. And because the spaces of the night are vague and unfathomable, the Dalian landscapes filled to bursting with emptiness—for in Dali's work the void is gorged with explosive energy, with irresistable power—induce a dizziness born of the spectacle of negation of terrestrial and cosmic laws. And this spirit of negation, affirmative negation, creative negation, particular to Dali and superlatively cultivated by him, refuses to acknowledge the universe of metaphysicians and biologists and the concise code that restricts the changes of nature.

From there to the perversion of nature is only a matter of time and the distance of an action, quasi-divine or proudly imitative of a divine model. How could a soft watch keep the right time in its pasty works, and tell the correct time with hands of grass sculling on a watery face? The soft watch is not a whim. Neither is it a challenge to customs and to good sense. Nor is it a symbol relative itself to the relativity of physical dogmas. The birth and recurrence of a theme in Dali's painting, the strict economy of variations that do not allow of brilliant metaphysical hocus-pocus and rests content with a rigorous objectivity, make us attentive to something of his that is always hidden and evident at the same time, as though, with reference to the purloined letter in Poe, the hidden were the supremely apparent and the sentence even truer when the parts were reversed.

There are no concessions to metaphysics, none whatsoever. When he is religious, Dali is at once, with a single bound, a mystic: like Saint John of the Cross, his cousin, and his cousin Saint Theresa of Avila, and his master Our Lord Don Quixote (as Miguel de Unamuno used to say), that lightning composite of saint, hero, and *iaarodiviy,* divine madman. There are no symbols: images that are certainly magical but of a dazzling reality. The most tangible, the most sensory truth: that which helped Dali to feel Dante so deeply and to interpret him so well. What a strange Dali-Dante might be written if one had the time...) Anticipation of hell or awareness of its proximity; what a strange perception and

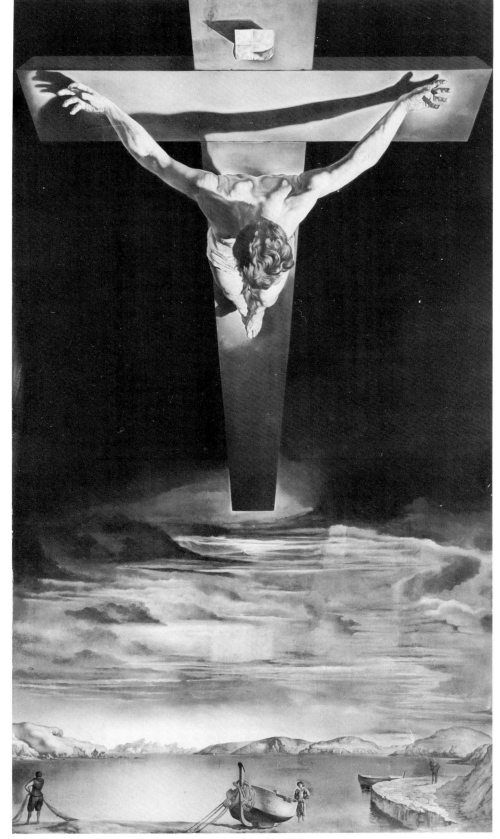

Christt of St. John of the Cross.
1951. Oil on canvas. 205 x 216 cm. (Glasgow Museum & Art Gallery, Scotland).

25

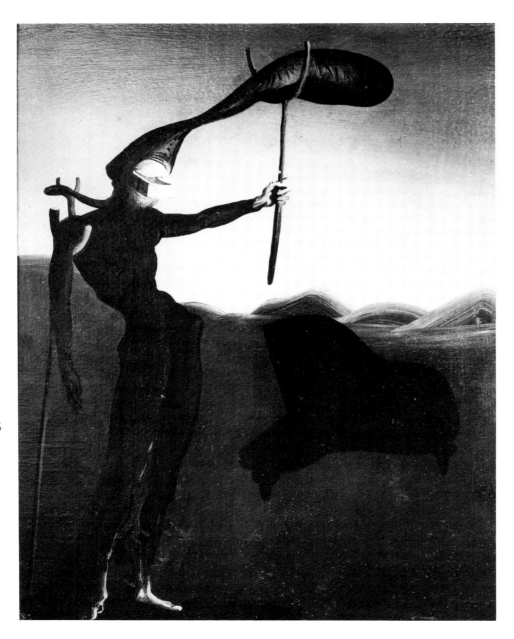

Invisible Harp.
1934. Oil on canvas.
16 x 21 cm. (Manou
Ponderoux Collection,
Paris. Photo by
Jacqueline Hyde).

tion or immobilized at the center of a lucid nightmare, and who walk with the gliding steps of somnambulists,—this deceitful presence—could well be nothing but an insidious mask of absence. On the infinite plain beings who will never meet are dispersed far apart: a woman in mourning petrified into a statue of a Fate, a little boy thrown into catalepsy from contemplating his slender fencingfoil shadow, the musician incapable of giving zest for life to the softened piano (in the final stage, death and dissolution, from the same illness that affects the soft watches); and, finally, lying on the proscenium like the hero of one of his operas, a Richard Wagner with a granite profile, wearing a student's bonnet, a velvet jacket and a conspirator's cape (in the Ruth Page Collection). Then there is the "phantom chariot"—let's look at it again—whose wheels groan loudly as it traverses so many problematic dreams and as it advances—in the painting from the Thomas Fine Howard Collection as well as in the well-known old film by Victor Sjostrom—it seems to create and unfurl the space that it then proceeds to devour and destroy.

Or else one, or two or three cypresses, pointing their black sundial hands to some unknown place in a timeless space, with the proud and artificial air of a cemetery tree, of a walking stick from the oldest of the three Fates. This is why those imagined landscapes convince us of their incontrovertible truth: by the supreme brio of invention and the authentic magic of *painting,* each stroke of the brush accompanying the movement of the hand or of the magic wand of the "prodigious" magician. Thus Dali paints what was not, what the enchanted brush brings into existence with a scrupulous accuracy and an almost photographic sense for the "likeness" such as Hieronymus Bosch used to portray his monstrous hybrids. And such painting might occasionally be labeled academic Surrealism or Surrealist Academism, because Dali so prolongs the wonderful craft and cult of objective reality once pursued by the great German visionaries of yesteryear—Ratgeb von Gmund, Grunewald, Altdorfer, Durer. The dubious aid of chiaroscuro favorable to fake prodigies is repugnant to the Spaniard's ardent, icy objectivity.

Light without shadow, contours without interrogation, matter without enigma: this is what his native land of stone and sun gave him to make into a world. Nothing more is needed for the deployment, with all the enchantment of its vestments of truth—the dress of light for the hour of truth in the arena—of the great procession of mystery, the parades of the absurd and the comical, the cortege of the festival of the Goddess of Unreason. Thus mystery is dressed in a dazzling light which defines it and makes it blinding, and the mirages themselves, which Dali believes in more than in the solidity of the volume of things, the mirages that vegetate in the fictitious horizons of those deserts are truer than the reality of the rocky masses of African deserts: for example that painting

manifestation of emptiness is experienced within and by means of those stupifying images that are painted with such scrupulous truthfulness as to give us the sensation that the landscape *breathes* and that we breath its breath: *The Aeorodynamic Chair,* from the De Beer collection, or *Noon on the Beach* which droops with the leaden heat of the hour the Greeks called stationary and that enveloped the sleep of the Great Pan in the complete silence of nature and men.

Dali has a completely pagan intuition of this dense, compact noon which descends upon empty space and there deposits the funeral ashes of dead hours, up to the topmost level of the narrow neck of the hour glass. In that hellish space he can seat the unforeseen confederates of the void which is made even emptier by their presence. For the presence of spectral forms, of awakened sleepers who are in mo-

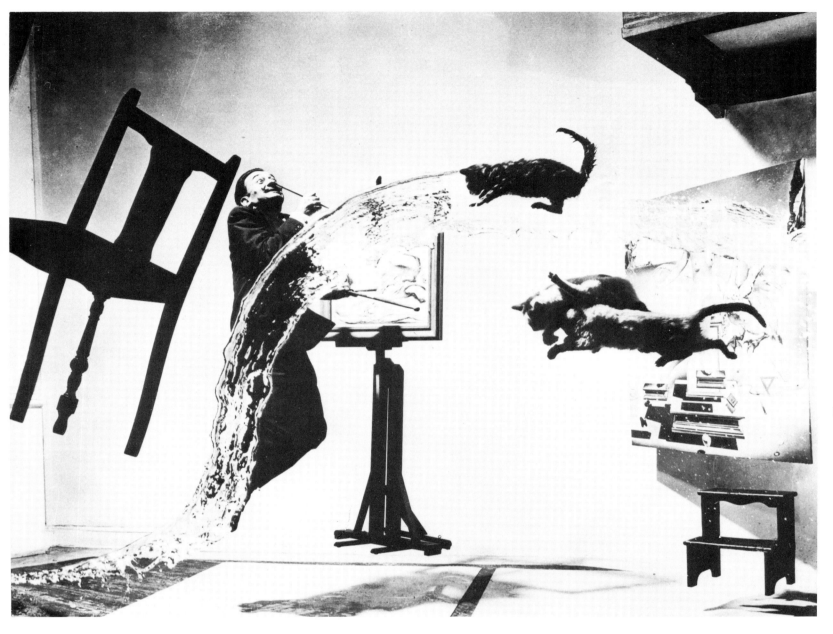

Dali names *Shades of Night Descending* (Mr. and Mrs. A. Reynolds Morse Collection), one of his most astonishing. A clairvoyant magus, who is perhaps also attentive to his own momentary inner image, with the aberrant remains of a cosmic cataclysm Dali composes a sort of geological panorama of ancient times, of the period when the earth, trembling, made mountains bud on its surface, or of an era to come which will be rid of the swarming of all human, animal, and vegetable life and will grow nothing but the skeletal elements of primordial rocks for tragic and bizarre adornment.

Passing from the extremely hard to the infinitely fluid, Dali the alchemist works on the process of the Great Work by virtue of a spagyric art that is personal to him. Transmutations of images of things, attaining the very heart of these things, these metamorphoses reveal a strange intuition that is

sensitized to the laws of the unity of matter. One hopes that he would extend his cult of heroes to the eminent masters of the Rosecrucian brotherhood, Valentin, Andreae, Christian Rosenkreuz himself—and why not the very great Paracelseus?—and that the illustrator of Dante and Don Quixote would illustrate the *Noces Chimiques, La Confession,* the *Echos de la Fraternite,* major Rosecrucian books whose difficult pages, furrowed with holes of shadows and lights, he would make flame and crackle.

A phenomenon that is characteristic of Dali's enjoyment of metamorphoses, occurring less frequently than the softening of solid objects in the rearrangement of the Dalian universe, is the mineralization of forms and matter. Dali shows a marked preference for the intermediate states of substance, those mixtures where nothing is fixed, so that movements flow

"Atomicus".
From series of photos by Philippe Halsman: Dali's famous mustache. *(Photo by Magnum).*

from one state to another, contrary to it or only just different. Not that he favors the reconciliation or marriage of opposites; he would rather intensify their conflicts and antagonisms. His pursuit is highly and authentically alchemical in the sense that from the melting pot where he has haphazardly poured the incongruous and the splendid, the noble and the suspicious, the definite and the vanishing, the questionable metals and fragments of the very august philosopher's stone, Dali extracts an element of dazzling novelty, the never-seen and never-imagined of which he is, in the majority acceptance of the word and according to the vocabulary of Genesis, the *creator.*

Klee's art is alchemical too, but it is more white than black, attracting to the surface of the visible forms sleeping in the depths of the invisible. Dali's artistic pursuit, which is altogether different from Klee's, is saturated with some odors of sorcery in the course of manipulations of the visible world which, with Dali, simultaneously shows the power of the "magus of images" and the subtle artifice of the illusionist. To roam in the intermediary states of matter, where it is theoretically possible that the magical high-top hat change the white rabbit it contains into a string of flags, is to amass all kinds of objects, undecided what they are or what they might become, and to act upon them, without their knowledge or, less infrequently, with their complete willingness, to decompose their unity or amalgamate incongruous pieces, adjusting, mending the incom-

28

patible to present to the astounded spectators *l'animalaccio:* you remember, that unclassifiable, horrible creature that Leonardo da Vinci constructed one day by using ingenious graftings of insects glued onto reptiles transformed into birds, and *it* lived. Hieronymus Bosch, constantly flirting with sorcery, also created monsters. It is true that he did it only in painting, but his painted monsters live as prodigiously as the "dirty little animals," the Italian's hideous miniature-dragon; and his demonic hybridizations of kitchen utensils, of degenerate beasts and ulcerous freaks, are terrifying in their grotesque malignancy and ignoble guile, which they use to man's detriment.

Dali is so completely convinced of the efficacy of such wonders that in the tradition of so many painters of the Middle Ages and the Baroque era he arranged his own stupifying spectacle of a parade of monsters capable of terrorizing Saint Anthony and discouraging him from seeking the salvation of his soul, since the mainspring of temptation is to insinuate into minds consumed by asceticism that the devil, the creator of monsters, might be as great as God, the creator of the universe. To achieve his purposes Dali convenes the parade of an infernal circus, a file of elephants tottering on interminable spider's legs, demon-horses out of the stud farms of Fussli and Baldun Grien, with legs that might have been lengthened by a lunatic biologist.

But such games are not always enough for an artist-alchemist and illusionist who feels he is

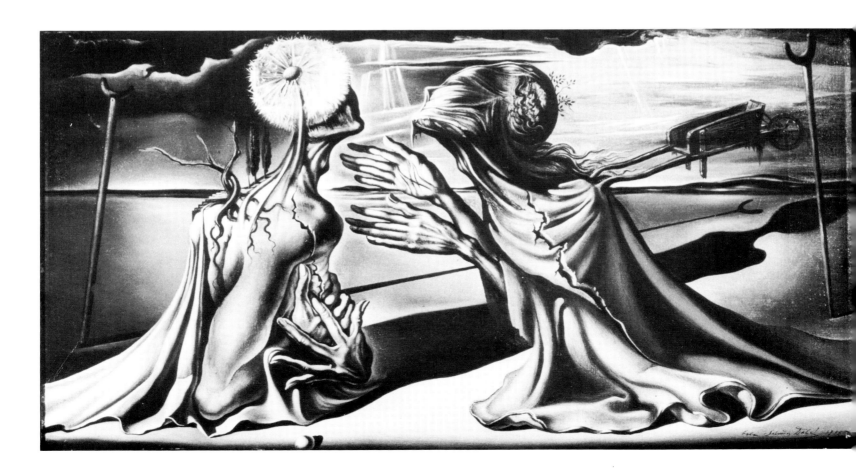

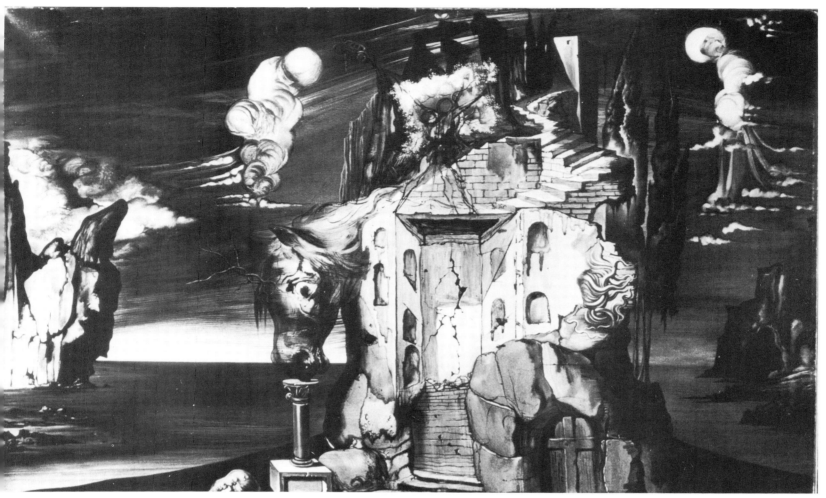

master of a creativity that is more refined in its means and ends. Not content merely to disguise petty devils as creatures superbly impossible, and proud of their impossibility, Dali branches off toward the trail where associations outside of nature or against nature that delight the infernal creators and their creatures no longer have a run, but where, in exchange, there proliferate exquisite games of metaphysical errors and optical illusions, which Dali calls the paranoiac heads. A very old popular game of visual puzzles amused innocent people by inviting them to look for a certain shape in the landscape or in a pile of objects—a pointless search when the hidden object or person had no relation to the illustrated anecdote; highly suggestive when the branches of a tree or the outgrowth of a trunk simulated a head coiffed with a regulation army hat while the illustration as a whole showed highwaymen poaching in a forest: *"Look for the game keeper."*

If these skillful conjurings, on the verge of making us doubt the accuracy of what is ill-advisedly called the "evidence of our senses," were not protected against the assault of some metaphysical devilry, if the Arch-Swindler were to try thus to lead our attention and our reasoning astray, leaving them to wander in some desert where the void has devoured all the roads, or in some labyrinth where a multitude of roads and their entanglements end by losing us, body and soul. . ., who would not see this as a dizzying experience?

The nonrealism of transcendance, the irrationalism of mistaken sensation and strict fidelity to that hyperconcrete by which we try to prove the truth of the world's existence, the shatterings and the rebuildings or reflections of images give an accurate rendering of it on all the faces and facets of Dalian magic. A magic whose charms and wonders scorn the facile convenience of the dark or of chiaroscuro, and take effect in bright light, under the full glare of projectors that illuminate the trail on the middle of which the illusionist is working without the trickery of trapdoors and backstage maneuvres. The inspired Grandville showed that "everything might be metamorphosed into everything," and demonstrated that, according to Clemens Brentano, "things are true only up to a certain point." To these intuitions of radical doubt and of the infinity of possibilities, Dali adds the gnostic plunge into an apparent delirium of images. Beyond that, beyond the deliriums—this word has yet to be defined—Dali, the true religious painter of his time, adds the delirium in which the heroism and the holiness and the madness of the Cross are created.

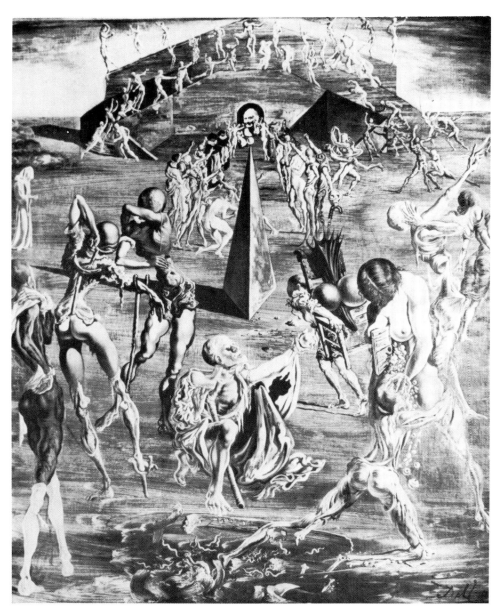

The Resurrection of the Flesh.
1940/1945. Oil on canvas.
90 x 72 cm. (Bruno Pagliai
Collection, Mexico).

spiritual regions, to direct his vision toward the *chateaux d'ame* of which the Carmelite speaks. It is as if Merlin of Breton lore broke his magic wand and placed himself in the service of the Grail. The "prodigious magician" (Calderon's magician was perhaps an ancestor) who sets the giraffes on fire from hoof to horn, who opens the secret drawers of women's chests, who unreels the macabre dance of his apocalyptic *Resurrection of the Flesh* (John Perona Collection), the magus who caused the loss of sense and proportion in forms and thoughts, abandons the predilection for his monstrous children, next to whom the offspring of Goya's children of dreams dwell in an innocent nursery.

Picking up the Grandvillian thought that "everything can be metamorphosed into everything" and applying it to Dali is perhaps the only way to grasp a corner of the cloak of elusiveness, the only way to hazard an interpretation of the stream of incantations that is his work, without venturing to define or close in on what has always made and always burst the categories that total elucidation would like to classify and restrict. This marvelous liveliness, so capable of concealing itself in the unrest of disguise and feigning the untrue in order to better certify the true, reminds me of two characters who are related to him: Arcimboldo of the Court of Rudolf II and the gentle poet Jacapone de Todi.

Arcimboldo made the likeness of his portraits sparkle by concealing the models' faces in a clever arrangement of still lifes of fish, tinderboxes and firetongs, flowers or fruits, books, feathers or inkwells. Aiming higher than the childish puzzle of the gamekeeper, Arcimboldo announced earlier than Dali that appearance discloses reality and that, instead of saying, "Everything is appearance," we must not tire of repeating, "Everything is real." Let us not refuse the right of life to beings decked in the masks of monsters: the roads of high initiation pass through grottos, shadows, bottomless pits and the underworld; it was a great moment in Don Quixote's initiation, that moment when he descended into the abyss of the enchanter Montesinos, at the end of a rope.

And Jacapone? That aimiable little friar was once invited to a wedding and attended the ceremony naked, covered with glue and dressed in feathers. A caprice? A dare? A need to attract attention? Not at all. To anyone astonished by his dress Jacapone answered, "All the guests paid their respects to the married couple with their wisdom; I render homage with my madness." The point is this: when I see Dali extend his hand to the blessed Jacapone, I recognize the gesture of the great soldiers of fortune of Holy Unreason. The world perishes by submitting to people who are reasonable, or who think they are or want to convince us that they are. Let the magi of Super-reason or of Infra-reason save what can still be saved.

In this universe beyond reason, which Dali invents and which, from the moment he makes and arranges it, there is a world of pitiless Spanish inhumanity, pride, rigor, *arroganza*—never to be translated "arrogance." The work of this inexhaustible enchanter began a half century ago in an overflowing of fantasy and originality far from the paths already trodden by innovators, while he isolated himself from all the trends in order to build, without the remembrance of what had been or the contamination of "what was being made," a world of images that would be completely his and his alone. One might believe that in this universe Dali connects with the old epic and mystic roots of his race, the great Baroque lyricism of the sixteenth-century, the Golden Age.

The colossal inspiration that comes to him from family heroes, Saint James, Christopher Columbus and, soaring high above commonplace, worldly wisdom, the Archangel of Irrationality, Don Quixote, impels him to take risks, to venture into

MARCEL BRION of the French Academy

under the triumphal arch of soft structures by pierre courthion

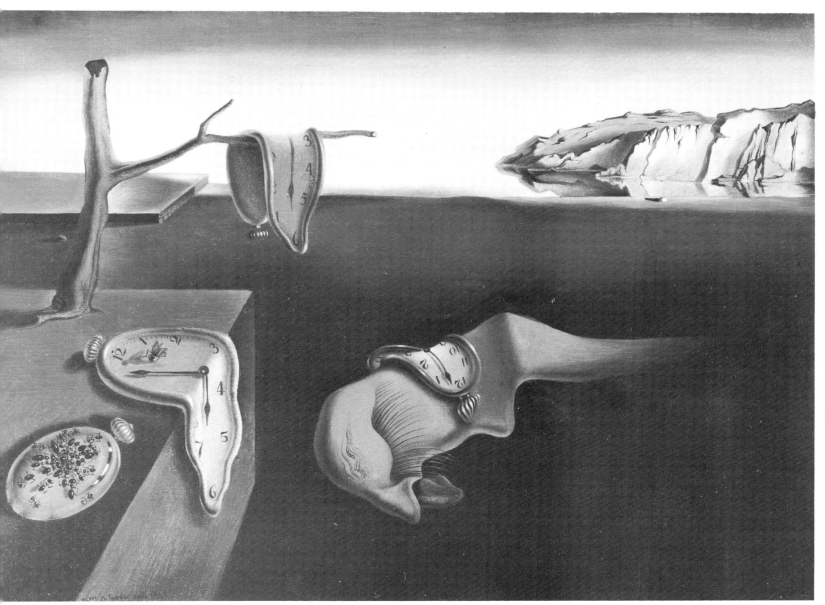

It would be amusing to make an accounting of what is soft—painting and sculpture—in the history of art. We would find it in certain feminine figures with fleshy curves in pre-historic works. But the truly soft really appears only with casting, which makes form less angular. Although rare in the upright linear art of the Middle Ages, the soft would find its adherents among the Renaissance painters with the followers of da Vinci, like the author of the glycerized *Saint John,* or even in certain works by Correggio, Andrea del Sarto, and those who misused *fumato*—shadow.

However, it is a matter of the soft in the technique of painting itself and not the soft in the objects created. From this point of view, it is characteristic of Salvador Dali, in his best years, to have considered the soft as a preferred motif in pictorial representation. Dali knew how to collect and imagine the latent life of the subconscious antecedent to memory, so that reality is transformed with him into what it is not. Fragile and gigantic tubercles

appear before our eyes. The woman-vase sticks her profile onto the head of the man-lion. The grasshopper and the ant stick to the woman's lips. The dry seeks out the moist. Hands contact viscous or sticky material. A loupe would be necessary to take inventory of the fantasies of this painting which, at a time when abstract art is in its glory, has recourse to the illusionism of imitative art, and rejects Cezanne to glorify Meissonier. Its author throws discredit upon the "logical intuition" which he considers a "prostitution," and he denounces us as "made idiots by mechanization." He defines his painting as a "spontaneous method of irrational knowledge, based on the critical-interpretive association of disordered phenomena." And he adds, in his own special style: "Critical-Paranoiac activity discovers by this method new and objective meanings of the irrational; it makes the world itself move tangibly from delirium to the field of reality."

As revealed in issue number 12 of the *Revolution surrealiste,* which reproduced three of his paintings

The **Persistence of Memory.**
1932. Oil on canvas.
25 x 36 cm. (Museum of
Modern Art, New York).

31

Poster for Dali Exhibition
in the Julien Levy Gallery.
New York, 1934.

JULIEN LEVY
GALLERY

602 MADISON AVENUE

NOV. 21 – DEC. 10

1934

DALI

32

in 1929, Salvador Dali is the baroque of the soft and frothy. But he is also the gourmand of insects, the voyeur at the keyhole, experienced with "tender doors of veal liver," the choreographer of the flame-woman of "visceral flying lacerations," the sadist of the living-devoured. And he is, above all, the painter of dermatological elements. For nothing concerning the skin is foreign to him. He imagines the swelling, the bloating, the slackening of the skin. He stretches and lengthens the erectile tissues, folds them in half and with strange suspending rods supports what hangs over. His painting is attacked by dermatitis. He goes so far as to show skin borers at work, like the chigger. But never in his fantasmascope will you find a piece of flesh in wholesome erection as may be seen in the secret museum of Naples. His blister of skin swells up and becomes a crust; it expands endlessly but seems emptied of its hard or hardening substance. Dali is always attracted to the soft, and he hastens to make a tired erectile tissue of it. He inflates his pustules. But he also loves the glairy and what Bachelard calls "an agression by ordure." His painting is visited by flying or wormlike larva. The oyster-inkwell appears in certain paintings. He stretches and expands a phallus into a marshmallow. His universe of the soft is inhabited by breasts without milk and with nonproductive penises which the fork of a prop shores up. His human figure never stands up alone. He needs crutches.

The Surrealists whom Dali broke with around 1934 are, to him, "the caviar," and "believe me," he wrote in *La Conquete de l'irrationnel,* "caviar is the extravagance and the actual understanding of taste." He speaks of "salivary expectations" but on the other hand denounces as "gluttonous, gummy, ignominious, and sublime" the assaults made by "the jaws of the masses in the congested, bloody and supremely biological cutlet which is that of politics." Under this social aspect Dali was always oscillating.

In 1929, in his preface to Dali's first exhibition, Andre Breton spoke of "Salvador Dali's new beings and their way of multiplying and *melting.*"[1] He had put his finger on the limpness of Dali's painting.

The soft watches appeared in 1931 in *The Persistance of Memory.* "Rest assured," said the painter, "that the famous soft watches are nothing more than the tender critical-paranoiac, extravagant camembert isolated in time and space." According to Marcel Jean, Dali's soft watches emanate from a childhood memory, "when the doctor asks the patient to *show* his tongue."* And Jean continues: "The tongue itself is a symbol of the limp penis. Dali has always been haunted by ideas of inadequacy. The great number of crutches and of softly deformed beings that he always enjoyed painting is revealing."[1] Sometimes, the soft watch is replaced by a watchcase swarming with insects or else by clothing which hangs in its place, from the branch of

*Note: In French show — montrer; watch — montre.

Œufs sur le plat sans le plat.
1932.
60 x 42 cm. (Coll. A. Reynolds
Morse, Cleveland, U.S.A.).

Fried Eggs Without the Plate.
1932.
60 x 42 cm. (The Reynolds
Morse Foundation, Cleveland).

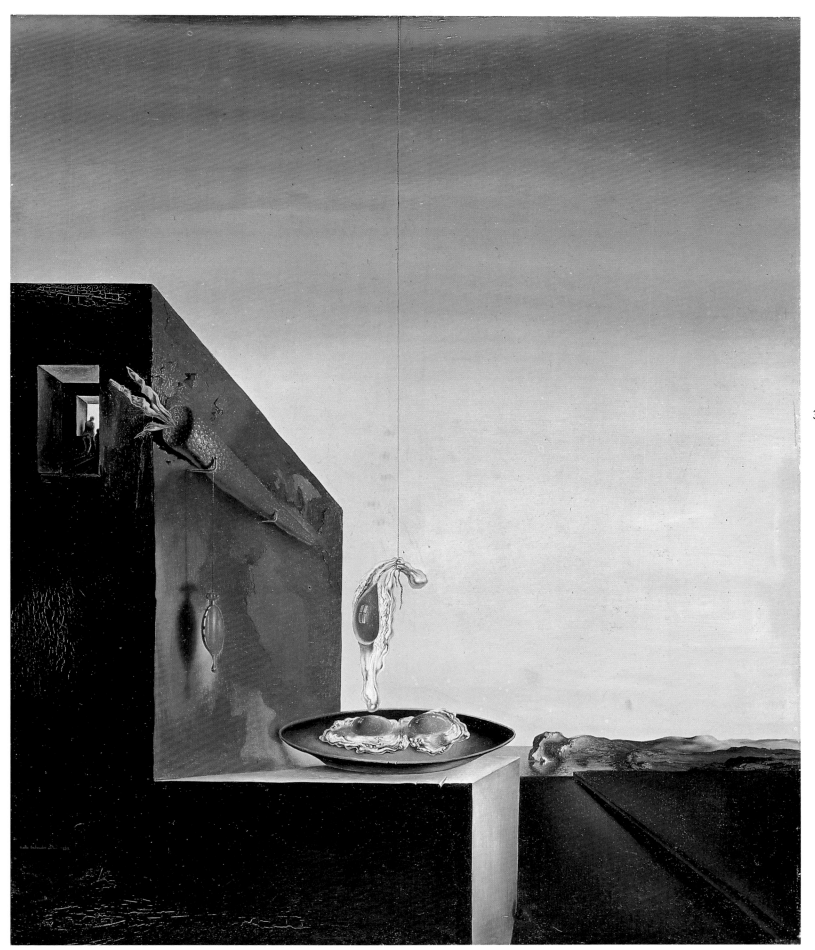

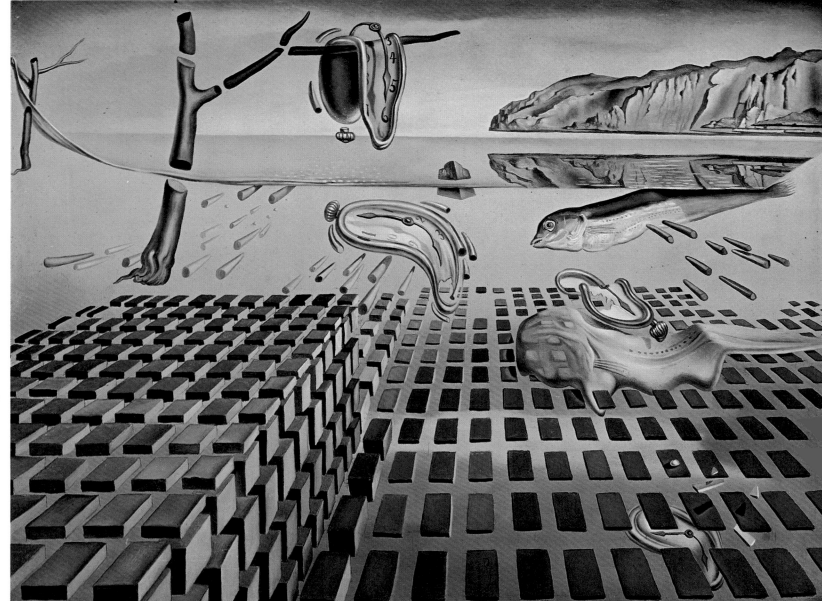

La désintégration de la persistance
(le chromosome d'un œil de poisson
très coloré entamant la
désintégration de la persistance
de la mémoire).
1952 / 1954. Huile sur toile.
25 x 33 cm. (Coll. A. Reynolds
Morse, Cleveland, U.S.A.).

The Disintegration of the
Persistence of Memory.(The
Chromosome of a Highly Colored
Fish's Eye, Initiating the
Disintegration of the Persistence
of Memory).
1952 / 1954. Oil on canvas
25 x 33 cm. (The Reynolds
Morse Foundation, Cleveland).

Araignee du soir, espoir!
1940. Huile sur toile.
41 x 51 cm. (Coll. A.
Reynolds Morse,
Cleveland, U.S.A.).

Daddy Longlegs of the
Evening...Hope!
1940. Oil on canvas.
41 x 51 cm.
(The Reynolds Morse
Foundation, Cleveland).

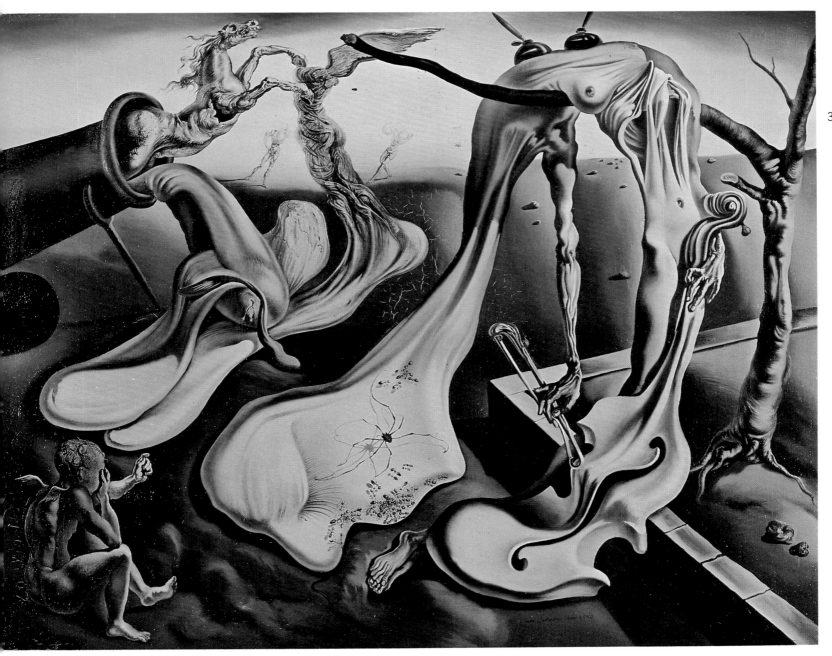

Le grand masturbateur.
1929. Huile sur toile.
110 x 150 cm. (Coll. Privée).

The Great Masturbator.
1929. oil on canvas.
110 x 150 cm.
(Private Collection).

36

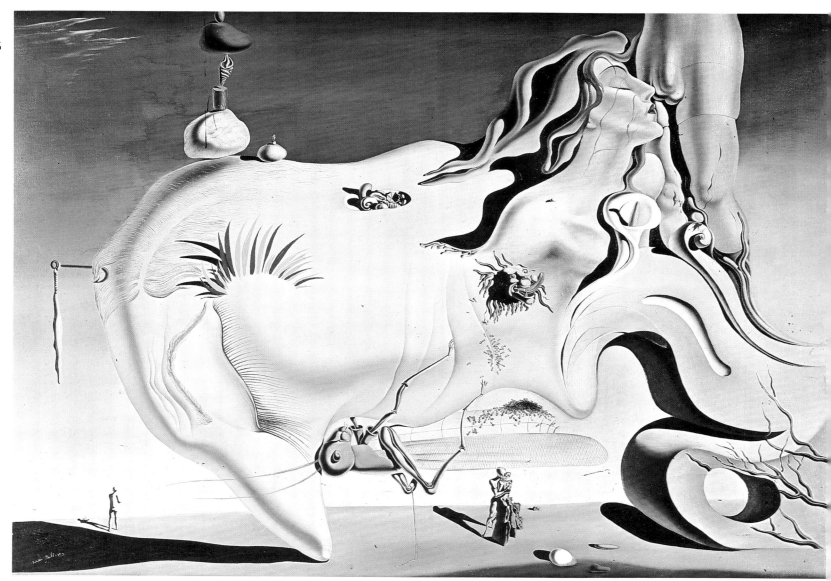

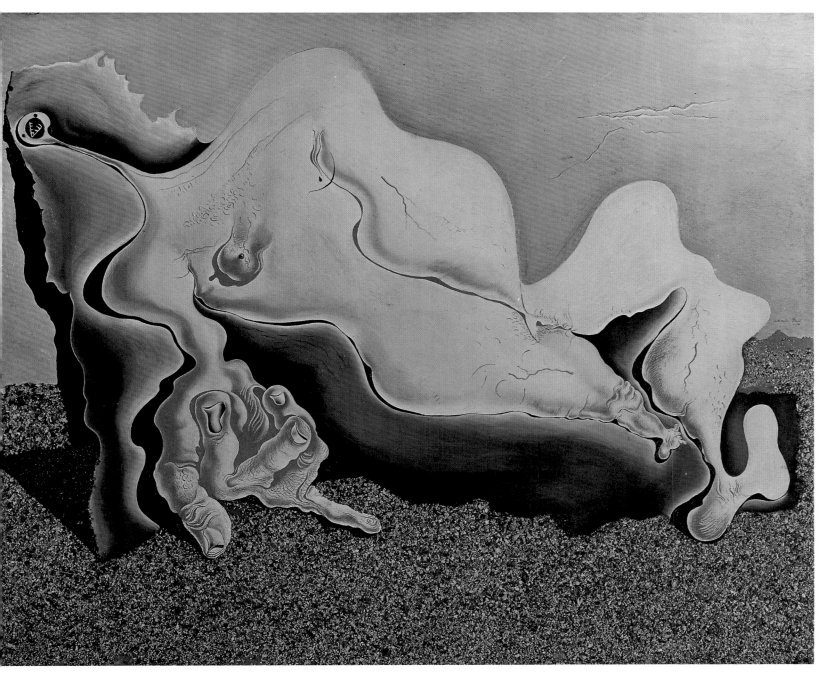

Baigneuse (sic).
1928. Huile et collage
de gravier sur aggloméré.
63 x 75 cm. (Coll. A. Reynolds
Morse, Cleveland, U.S.A.).

The Bather.
1928. Oil and sand collage
on fibre board.
63 x 75 cm. The Reynolds
Morse Foundation, Cleveland).

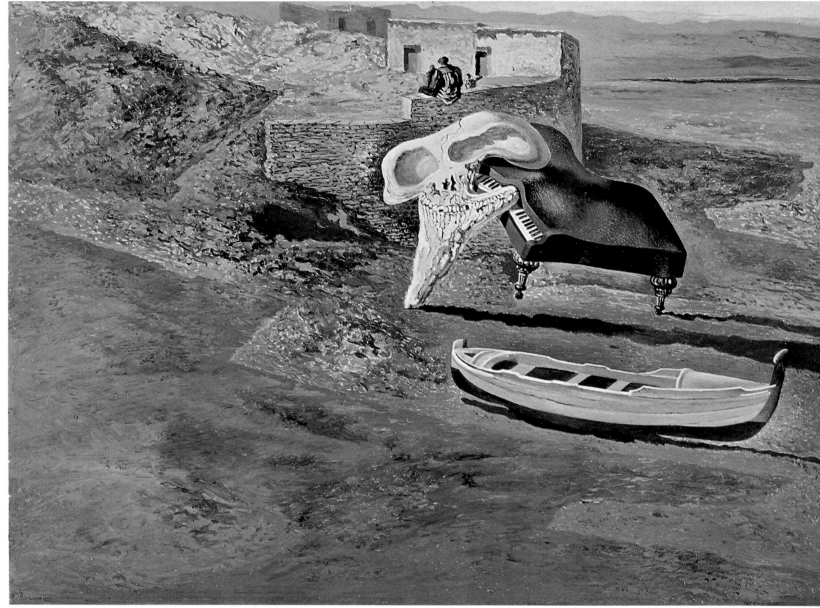

Crâne atmosphérique.
1934. Huile sur panneau.
14 x 18 cm. (Coll. A. Reynolds
Morse, Cleveland, U.S.A.).

Atmospheric Skull.
1934. Oil on wood panel.
14 x 18 cm. (The Reynolds
Morse Foundation, Cleveland).

Crâne avee son accessoire lyrique.
1934. Huile sur panneau.
(Coll. A. Reynolds Morse,
Cleveland, U.S.A.).

Skull with its Lyric Appendage.
1934. Oil on wood panel.
(The Reynolds Morse
Foundation, Cleveland).

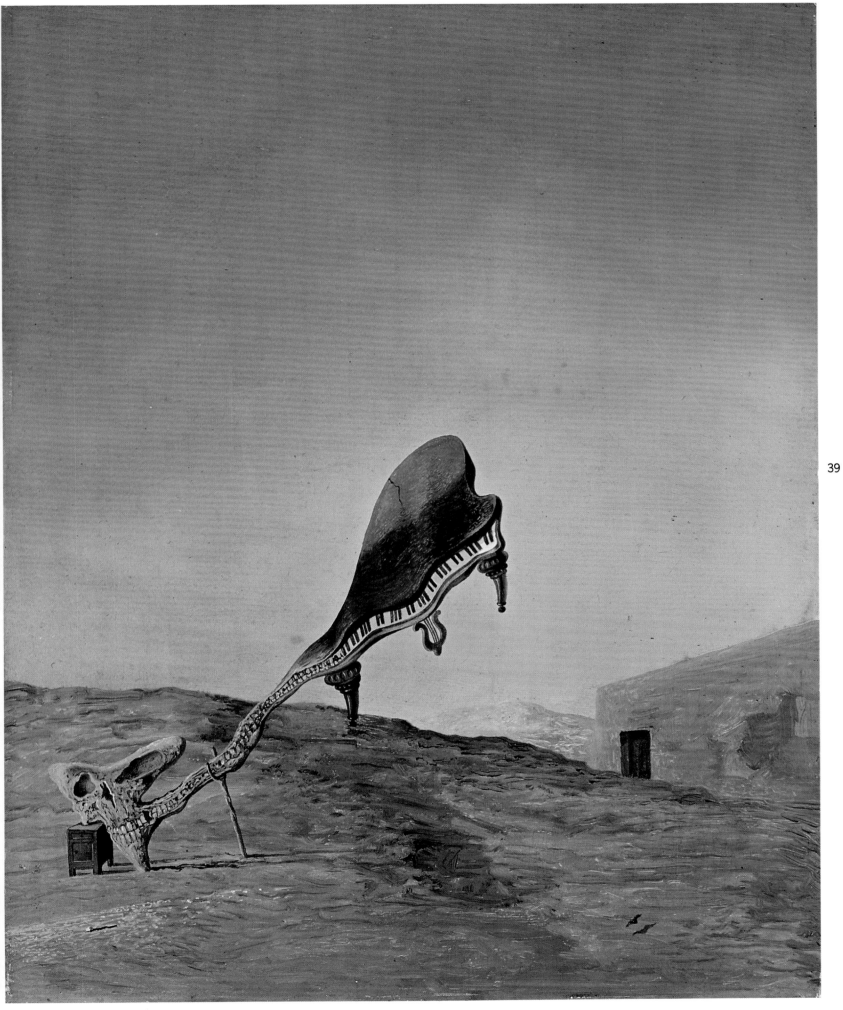

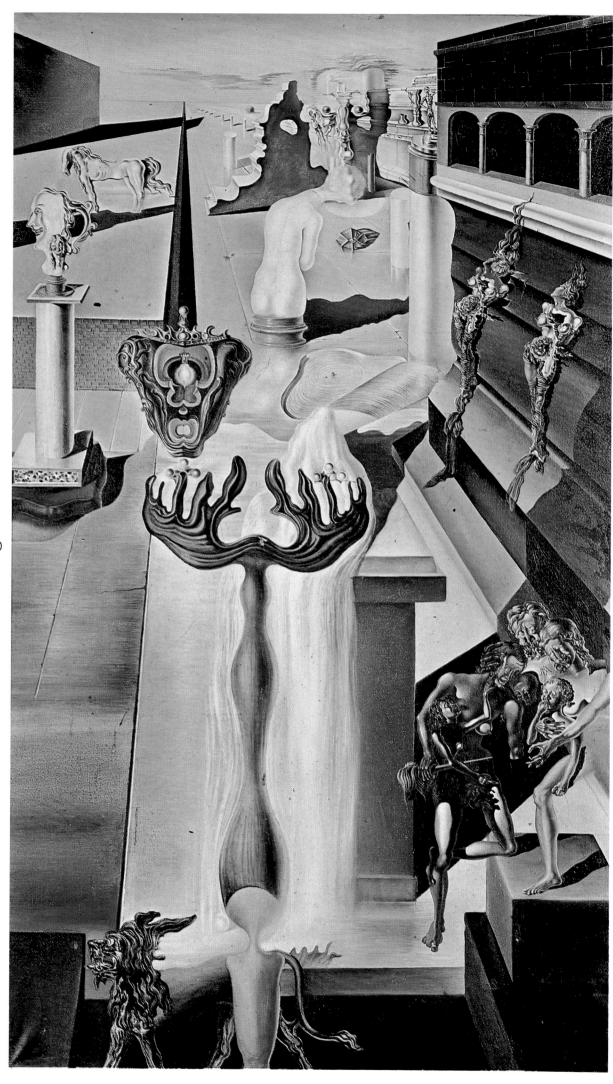

L'homme invisible.
1929 / 1933. Huile sur toile.
142 x 81 cm. (Coll. Privée).

The Invisible Man.
1929 / 1933. Oil on canvas.
142 x 81 cm. (Private Collection).

a tree. Dali could say with Hegel that "the plastic instinct is like an excretion, an act whereby the animal becomes exterior to itself." In his work there is also a regression toward unclean materials, a complacency toward the excremental, a sort of imaginary coprophagy. He is like the child who sees in his excretions the means of producing "structures of his own substance." (Bachelard).

Liquidity also has great importance in Dali's work, whether it be what is glimpsed in the shell of a mussel or what is poured into a wash basin by a woman's hand. In *The Birth of Liquid Desires* (1932) a cloth is thrown on the steps of a stairway after its watery contents have been sprayed out in a cascade. It's clear: even more than Max Ernst, Dali is a visual commentator of Freudianism.

Sometimes, in his paintings as in those of mental patients, there are repetitions of the same theme. Apart from Millet's *Angelus,* whose universal cliche

he multiplies everywhere (he turns and reverses the figures and entwines an extremely corpulent nude woman around the peasant kneeling to pray), or the myth of William Tell, he repeats in his *Piano aux Lenines,* the form of the organizer of the Soviet regime whose head appears six times on the keyboard. In *Illumined Pleasures* there is the bicycle racer balancing on his head an egg, and this image is propagated in various ways. These somewhat stereotyped repetitions are also representations of ideas of an obsessional character.

Femininity has diverse appearances in Dali: In *The Invisible Man* the male is formed of fragments of furniture, while will-o'-the-wisp women, with coiled tangles of hair, fuse, quicksilver, before the Chirico-like colonade.

The masculine-feminine figure in *The Specter of Sex Appeal* (1933) contrasts a tiny ossified penis with a pair of large breasts, sacks bulging with a

The Invisible Man.
1932. Oil on canvas.
16 x 24 cm. (The Reynolds
Morse Foundation, Cleveland).

41

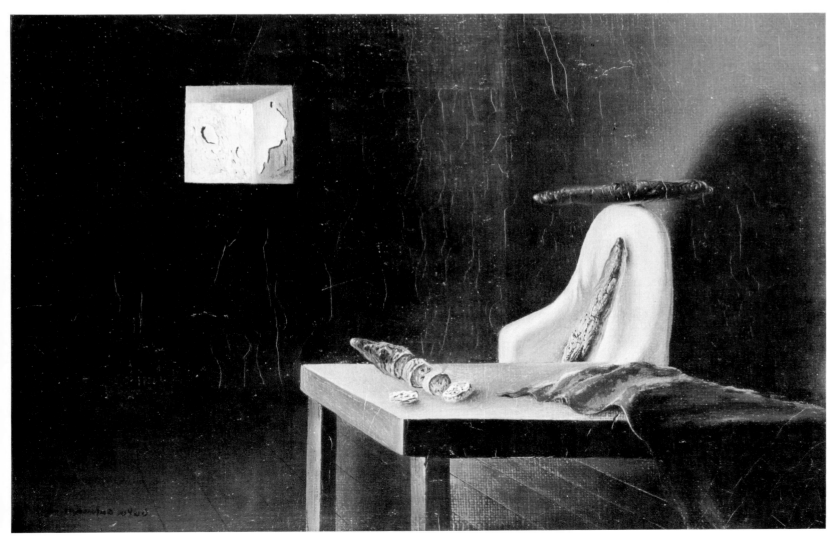

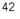

42

pulpy substance. Forked props hold the arms and legs of this strange apparition whose knee is bent. Lost in a corner a miniature child with a hoop is looking at the gigantic and mysterious symbolization of the androgyne which nearly merges with the surrounding terrain.

The soft excrescences reappear in the two paintings done in the same year. *The Invisible Harp* shows us, in a Spanish-type village, a passer-by whose loupe has fallen from his skull and, much larger than he, is supported by a fork, while in the *Average Bureaucrat in the Act of Milking a Cranial Harp,* the artist once again seems to want to mix the man's swollen sex organ and the teats of the cow-woman which seem assimilated to testicular tissue.

Salvador Dali had the courage to stand up in defense of figurative painting. Thus it is not astonishing that he should react against "abstract" art and what he calls the "sticky sections of scatalogical gold." From this too comes his tendancy to paint meticulously. His Surrealist imaginings caused him to rediscover the *subject* which he presents overlaid with bizarre, mysterious, and mystifying intentions. In short, Dali lives in reaction to his era and preserves an admiration for Renaissance techniques of which his own paintings are striking proof.

"My only ambition consists of materializing with the greatest imperialistic passion for precision the images of concrete irrationality," he wrote. For Dali has told us to hate in any form whatsoever the simplicity with which Valery said we must come to an end. And when he is simple, divested of his Freudian and Surrealizing garb, Dali loses his originality and becomes what is today called a reactionary.

Toward 1934 Dali broke with the Surrealists. Under the influence of Meissonier, rather than Vermeer, whom Dali erroneously claims as an influence, the painter completed *The Angelus of Gala.* Gala, once Eluard's companion, now Dali's wife, is shown twice, from the front and rear, the folds of her skirt forming a caressing hand in the area of the buttocks. On the wall is an interpretation of Millet's *Angelus.* Dali shows the two people seated. In another painting they appear standing, silhouetted on bread that forms the coiffure of the *Buste de femme retrospectif* (1933), with her brow eaten by ants.

Thereafter, lacking the elements which made him a typical visual Surrealist, Salvador Dali will vegetate in the academism and the conventionalism of the *Christ* of Glasgow. His genius for mystification will be transferred to his own person which will multiply everywhere his eye-bulging gaze, his upturned mustache, his paradoxical statements and the clownish extravagance of his attitudes.

PIERRE COURTHION

Seven Flies and a Model
(detail). *1954. Drawing.*
(The Reynolds Morse
Foundation, Cleveland).

[1] Marcel Jean, *Histoire de la peinture surrealiste,* Paris, 1959

dali and the human image or
the respectable dynamiter by julian clay

Human representation assumes a contradictory character in Dali's art: the reflection of the temperament of an artist ceaselessly torn between respect for the pictorial tradition and the requirements of a paranoia stemming from the peculiar conditions of his childhood. These Doctor Roumeguere has revealed in a study that appeared in *Dali de Draeger:* Dali was the exact likeness of a brother who died three years before Dali's birth. His parents had had the unusual idea of giving him the same proper name, Salvador. In their bedroom a large photograph of the brother was placed next to the image of Christ crucified. Thus the child found himself reduced to the condition of a double of this brother, simultaneously departed and yet present in the portrait that remained of him, in the name that was common to them, and in the living replica that was Dali himself. The stifling atmosphere of a bourgeois Catalan family of the early twentieth century—his father was a notary public—must have encouraged repressions, obsessions, neurotic phenomena of all kinds, as well as an imperious need to affirm himself, which led Dali to provocative acts and scandal. It is said that this paranoia which had been systematical-

ly cultivated and which became a source of inspiration after his acquaintance with the Surrealists, led the painter to a semidemented state from which only the encounter with Gala could save him.

If at the end of three years Dali was turned away from Madrid's Ecole des Beaux-Arts, he had nevertheless seriously studied pictorial techniques. He discovered the Impressionists after the Spanish painters of the nineteenth century. Then his attention turned to the Italian Futurists. In 1928 he met Picasso, Andre Breton and the Surrealist group. But it was not until 1937 that he visited Italy, the country whose Renaissance and Baroque periods were to have such a visible impact upon his later work. Nevertheless, from 1926 on he was in command of his work. This is shown in the famous *Basket of Bread* of that year. Painted with the minute detail of a Dutch master, it could just as well be attributed to one of them, if only it exhibited the attitude of loving humility before objects that characterizes those masters.

In Dali's work the human figure is submitted to a double process: the representation of the model in a realistic or classic spirit, and deformation of the

43

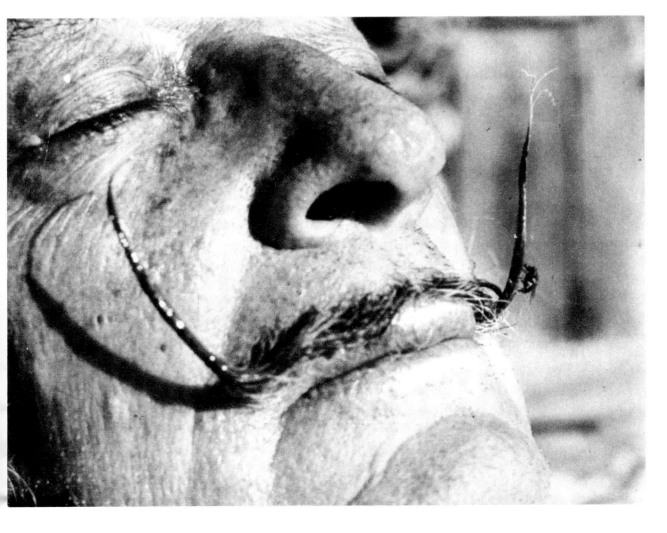

Fly on the mustache.

model in accordance with the needs of the painter's systematized delirium. Of course, there are some borderline cases in which a figurative reproduction appears in a somewhat paranoiac context, for example in the double portrait of the Viscountess de Noailles where two images of the model's face, one three quarters and the other in profile, are joined together. They are painted with a realism that does not conceal the angularity of the features. But the hair of the countenance viewed three quarters is replaced by flowers, the two heads are supported by ruffs resting on a pedestal placed on the end of a table. Behind them "a fountain pours its own form into a gold receptacle." (Dali, quoted by Robert Descharnes). Similarly, the portrait of Paul Eluard is limited to a bust, suspended in the sky and "supported by a lock of hair." Despite a cadaverous hand closing upon the forehead, the face seems to be a good portrait of the poet. But it is accompanied by a leonine head in the sky, and a mask, that can also be seen in *The Illumined Pleasures.* The inside of the jacket is adorned with a second bony hand and a certain number of accessories that are extended on the left by a bowed head; that red and green head is obstructed by an enormous grasshopper, the one from the *Great Masturbator,* painted in the same year. Thus realistic representation and delirium are joined together in a plastic unity; the lower half of the painting is taken up with a vast brown beach.

The first portrait from Dali's brush is altogether different. The painter was sixteen. The painting is a cubist self-portrait, laid out on a dominant vertical rhythm. One sees the upper half of the painter's face, a pipe, a box of matches, books, an issue of a Barcelona newspaper, *La Publicitat.* The light convergence of vertical lines gives the canvas an upward movement, as if it were a triumph of the author over himself.

Six years later, Dali went back to a more classical manner. The two portraits of his sister in 1926 are solidly grounded. In the half-length portrait she wears an attentive expression and is sewing next to a window. The face is clearly defined by distinct shadows. The strong, somewhat coarse, hands evoke Jan Gossert. In the other the girl is seen from the back. She has long hair with curls. The painter's interest seems to be focused on that head of hair of rich lustrous undulations, which appears to anticipate the paintings of Gnoli devoted to the same adornment of the woman's body.

On many occasions Gala has inspired the painter, whether he has introduced her into his profane or his sacred paintings or has simply painted her portrait. However, the artist's reverential adoration for his wife forbids complete freedom of expression with the subject. The images of Gala scarcely differ from painting to painting except for the model's age and the influence Dali is under at the time—classical, Dutch, Italian. She appears smiling, semi-nude, holding a fish in her hand, in a 1934 canvas showing some Port Lligat fishermen; in the shadow of a wall they are sheltered from the hot noonday sun which Gala disregards. The construction of the painting, the deserted hills onto which the wall opens, the shining silhouette of the young woman, the people in the background, give the work an unusual and original charm. In 1935 Dali painted *The Angelus of Gala.* It is an indoor setting; Gala is nevertheless seated on a wheelbarrow facing the artist, who has taken his place on a crate, his back to the spectator. Behind Gala is a very distorted reproduction of that "Angelus by Millet" which had just made its appearance in the artist's personal mythology at this time. Gala and Dali, wearing jackets composed of colored vertical bands, are bathed in a light that seems borrowed from Vermeer. Gala gazes fixedly at her husband with a countenance that is a bit severe and not found in her other portraits. They are both perfectly still, immobilized in anticipation of some

Apparatus and Hand.
1927. Oil on wood.
52 x 47.6 cm.
(The Reynolds Morse Foundation, Cleveland).

44

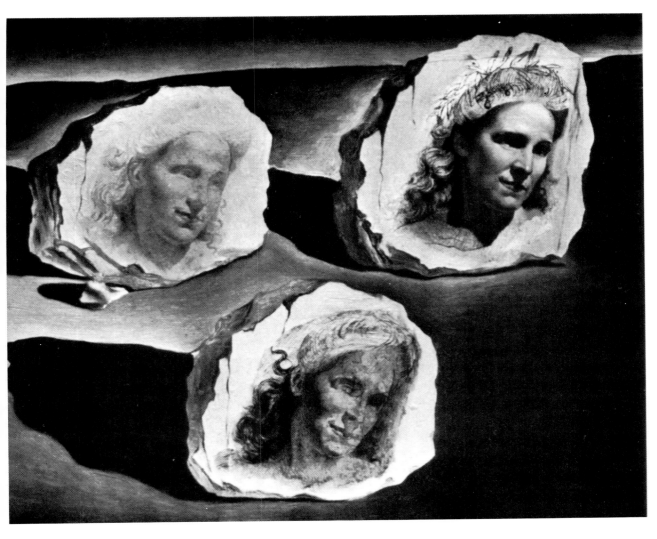

Three Faces of Gala Appearing Among the Rocks.
1945. Oil on canvas.
20.5 x 27.5 cm.
(Gala-Dali Collection).

event that is unforeseeable but certainly in keeping with the painting hanging on the wall. It is also a Dutch atmosphere that is found in *Two Galas in the Corridor,* this time closer to the work of Pieter de Hoch. A second Gala, viewed from the back in a room of wooden parquet, is looking at a Gala who is exactly identical but seated in a pink-tiled room opposite a white wall.

In *Dream provoked by the Flight of a Bee around a Pomegranate One Second before the Awakening* Gala is nude, stretched out above a flat rock surrounded by the sea. Her body does not rest on the rock but is suspended several centimeters above it, which has the double advantage of increasing the dreamlike quality of the scene and of avoiding the distortion of the flesh that contact with the rock would give. One leg is turned in, the other extended, the two arms joining under her head. On the left a pomegranate projects in front of a fish: from the open mouth two tigers rush out leaping toward their victim, preceded by a rifle with a bayonet attached.

The elephant of Bernini is suspended in the sky and rests its huge bony legs on the sea.

In 1945 the portraits multiply. In one three faces of Gala appear on rocks. In another she is shown with a keen eye, her blouse open to reveal a bare breast, in a canvas entitled *Galarina* where the artist seems to have forgotten the masters to confine himself to an entirely realistic image of the model. Elsewhere Dali paints *My Wife Nude Contemplating her own Flesh Becoming Stairs, Three Vetabrae of a Column, Sky and Architecture.* She is viewed from the rear, in front of architecture that is somewhat anthropomorphic. In this picture we can see a symbol of Dali himself, torn between the taste for exact representation and the demands of a paranoia to which he still gladly submits.

Gala will continue to enliven the painter's canvasses. She is the Madeleine of *The Crucifixion,* the pilgrim of *Saint James,* the Madonna of *Port Lligat,* the *Ecumenical Council* and of *The Discovery of America by Christopher Columbus.* Similarly, she is

the *Atomic Leda* of 1948, a painting of particular importance to Dali. "The *Atomic Leda* is the key painting of our lives," he said in remarks quoted by Robert Descharnes. "Everything in it is suspended in space without anything touching anything. The sea itself is elevated far above the earth." It is a composition which, as in *Dream provoked by the Flight of a Bee,* contributes to the oneiric impression which emanates from the painting and, above all, from the *Preliminary Study* where the swan does not appear yet and the model's pose seems to me to be more gracious and more convincing.

Though Dali has not included much room for himself in many of his paintings, he has painted a certain number of self-portraits: sometimes he is satisfied to sketch his own features, or he turns up in a corner of a painting, paintbrush in hand in the manner of the Old Masters, as is the case in the *Ecumenical Council.* His first self-portrait, painted in 1920 at age sixteen, shows scarcely more than a

Leda Atomica.
1949. Oil on canvas.
60 x 44 cm.
(Private Collection).

46

silhouette leaning toward a curtain in front of a window opened wide upon the sea. Yet one is struck by the inventiveness of his chromatic relations and the coldness of his colors. The *Self Portrait Splitting into Three,* "because," says Dali, "the painter must have three eyes," is painted in 1927. And if it clearly reflects experiences that Dali had just had in Paris, it also shows a powerful personality in the simplicity of its graphic design and color. In 1954 Dali is nude on the beach of Port Lligat, with his dog nearby. Dali has a knee on the ground, one arm extended with his hand open, the other hand resting on the sea, as if it were a solid surface. His face is turned toward the sky with a rather Don Quixotic expression. It must be said that a strange phenomenon is occuring here: "nuclear" elements in the form of spheres of various dimensions are gathering to form Gala's face.

The *Harlequin* of 1927 is close to the *Self Portrait Splitting into Three* of the same year. Like the latter, it establishes that Dali was familiar with Cubist collages of the era and with the works of Jean Arp. However, the painting is profoundly original in its dynamism and its chromatic sumptuousness, and in the relation of the form to a mask. The mask stands out in its asymmetry, where the dark colors of the diagonal that separates the yellow and red background areas cuts through the two faces to darken them. The head rests on a curve that is joined first to a shoulder then to the back of a chair. The *Head of a Woman* of 1927, which is simultaneously shown full face and in profile, belongs to this family of paintings.

Two years later the human image has taken on an altogether different appearance in Dali's work. If the paranoiac-critical method was not clearly formulated until 1935, it is nevertheless in full use from 1929 on. It results in the creation of a universe of monsters. Picasso knew how to impose deformations upon man's body and face corresponding to such an obvious necessity of expression that, after shocking the public, they were gradually assimilated. Thus instead of suffering from being viewed both from the front and in profile a young girl acquired a new grace. Today the only remaining possibility is to be astonished by the public reaction of rejection that those indispensable images had inspired. When monsters, minotaurs or others appear in the work of Picasso or even Goya or Fussli they are "plausible" —but not in Dali's art. His human flesh becomes soft, reduces itself to a covering which no longer holds the skeleton. So it is with the musician of *Spider of the Evening Hope* of 1940 whose torso is hung like a towel on the branch of a tree, her head pathetically spread on the ground along with the violin she seems still to be trying to play with her hands, the only healthy portions of this quasi-human sack. What remains of the face is an exact reproduction, eleven years afterwards, of the face in *The Great Masturbator* of 1929, except that the giant grasshopper clinging to the earlier face has disappeared. The head, lacking both mouth and

Soft Construction with Boiled Beans: Premonition of Civil War.
1936. Oil on canvas. 100 x 99 cm. (Louise and Walter Arensberg Collection. Philadelphia Museum of Art).

forehead, with its large nose, closed eyes and long lashes, seems to have haunted the painter, for it can be seen again in the *Illumined Pleasures* and *Lugubrious Games* of 1929, and in *The Sleep* of 1937 (however, in *The Sleep* there is a mouth). The head is perhaps an image of the mental imbecility that, at one period of his life, the artist feared would engulf him and that undoubtedly disturbed his sleep.

The hypertrophy of limbs and organs is another aspect of the metamorphoses imagined by the painter. In *The Enigma of William Tell* of 1934, Dali has endowed the paternal phantasm with an inordinately long buttock that, like the equally elongated visor of the cap, has to be supported by a crutch planted in the ground. In *The Ghost of Vermeer of Delft which can be used as a Table* of 1934, the same applies to Vermeer's legs, the left kneeling on the ground, the right thigh arranged horizontally to support a bottle and a glass. The thin limbs, the very narrow hips, twice squeezed by a kind of narrow corselet, give him the appearance of an insect. The right leg, lacking its foot, seems rooted in the ground near an intersection where a brick wall encloses an evening landscape. The silhouette of Vermeer is framed in this crossroad: here, particularly, the deformation appears to correspond to a purely esthetic norm.

However, one could not say the same about the macrocephaly that has attacked a number of characters, such as the peasants of *The Average Fine and Invisible Harp* of 1932 and the *Average Atmospherocephalic Bureaucrat in the Act of Milking a Cranial Harp* of 1932. In both cases the atrocious head, which, Dali says, "usurps the place of the stomach of the necroptere termite," is supported by a large crutch. The uneasiness that is elicited here is as unbearable as that which existed at the time in the streets of Spanish towns: beggars displayed limbs that had been knowingly deformed from infancy by their parents who were simultaneously rapacious and desirous of assuring the future of their offspring. For my part I see no explanation other than the attraction that horror has forever exercised upon Spanish art as well as, perhaps, an excessive taste for antithesis, for the introduction of these extraordinary characters into landscapes or peaceful settings.

Things are different in the *Soft Construction of Boiled Beans; Premonition of the Civil War* of 1936, where two beings are reduced to utmost simplicity— one, on the ground, consisting of a torso and two arms linked; the other, standing out against the sky, a head, a leg, and a single female breast—are engaged in ruthless combat. The superior being crushes the other with a foot, his adversary grinds the breast in his powerful hand. This daring reduction of human bodies to a few of their parts allows for the expression of the intense savagery which was to take shape somewhat later. Should I add that since each one of these two bodies possesses only limbs or organs that the other one is lacking one might wonder if this isn't one single body fighting against itself, that body of a divided Spain?

Then, in 1954, Dali committed a final outrage upon the human face by making the Virgin of Raphael break up into "nuclear" clusters and horns of flesh. It is a curious painting, organized in predominantly blue spirals, and instead of being explosive, it is harmonious. Around the parts of the face balls are arranged almost symmetrically. The sky is calm, as is the sea, surrounded by the cliffs of Port Lligat. The daring of the conception is compensated by the traditional treatment of the work. And so it goes with the artist's approach: Dali is a dynamiter, but a respectable dynamiter.

JULIAN CLAY

dali and transcendance from below

by jean-louis ferrier

In Ireland, until the nineteenth century, people visited the famous Saint Patrick's purgatory, a grotto where only audacious pilgrims prepared by a retreat of several days dared to venture, with the approval of monks who guarded the entryway. They returned to the world of the living with the terrifying vision of infernal flames in their eyes and the moaning of the abyss or, rather, of tormented souls in their ears. Several of them disappeared, seized by the chasm. Without knowing it, they were making a descent to the bottom of the Collective Unconscious, and occasionally did not return from it.

A striking instance of metaphysical speleology. The grotto is, in effect, a mental region. According to Plato's familiar myth of the cave, recorded in Book VII of *The Republic,* there exist two universes superimposed: the world of the shadows in whose interior we remain prisoners, and the intelligible world which is the universal source of all reality. It is not the pure invention of a philosopher. The Greek cavern of traditions of initiation precisely symbolizes the macrocosm—being the maternal matrix, image of the center and the heart in Eastern religion. The western world lived according to the Platonic system, which was taken up again independently and reinforced by Christianity during the Renaissance: between Appearance and Reality,

between the Upper and the Lower. In the domain of painting the result was idealization—the smile of Mona Lisa, the angelic sweetness of her face—itself born of the notion of transcendance without which there is no civilization. And in our modern society, under the pressure of science, transcendance is progressively destroyed.

It is to this problem, it seems to me, that the art and person of Salvador Dali are linked. "One must read my paintings as archetypal projections of a new Cave of Plato," he wrote. "A new awareness of humanity can begin with me, Dali."[1] Unlike the works of Picasso, none of Dali's work renounces transcendance and idealization. The precision and the quality of his craft prove it. Even though we know today that the idea of a metaphysical or religious absolute has become illusory, and that the quest of the irrational, which is *the transcendance from below,* alone subsists.

From this viewpoint, Picasso's renderings in art of people familiar to him in life is significant. Jaime Sabartes, his long-time friend transformed into a ridiculous hidalgo, the lovely Dora Maar ravaged by stone tears: if these are magnificent paintings—and the second one surely is—what a devastating picture they present of the human figure. And there are worse: the nudes by Dubuffet, his portraits of writers

48

"Avida Dollars."
Dali's anagram, coined by Andre Breton. From series of portraits by Philippe Halsman. *(Photo by Magnum).*

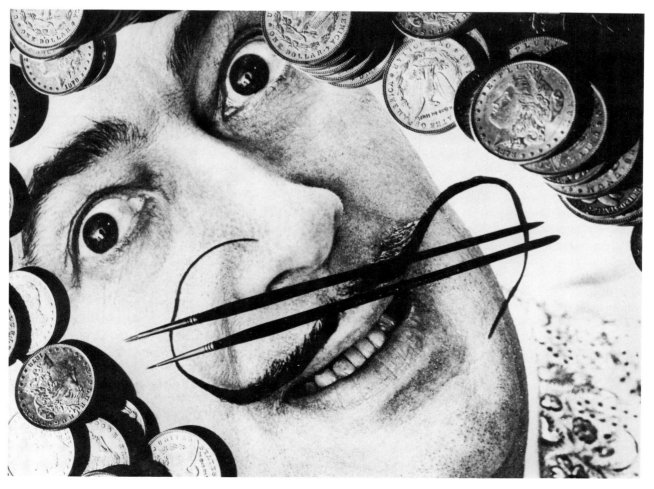

that art critics perceived to be imbued with wisdom but in which the infamous dabblings reflect, above all, the pessimism of an era that has ceased believing in life. With Dali the creative process is totally different. Gala with two lamb chops balanced on her shoulder, Gala who implodes into a myriad of little spheres, Gala as Leda, as Saint Helen (each time there is something that satisfies the needs of a certain classicism). And not only Gala, but the metamorphoses, the countless anamorphoses. As in Dali's celebrated *Premonition of the Civil War* in which the elongations of calcinated flesh are expressed with so much force that virtually anyone can immediately decipher the image.

His rapport with modern science and the vision of the world that emerges from it are revealing. At the beginning of the century, Cubism exploded from the tremendous impact of modern science, with these consequences: canvasses where barely perceptible fragments of divided objects overlap. It is the dislocation of Euclidian illusionism as it was codified by Alberti. Fifty years later Dali, to the contrary, pushes the effects to the extreme, creating a dizzying perspective wherein the various fragmented figurative elements remain immediately identifiable, as in *Disintegration of the Persistance of Memory* of 1954, with its checkerboard which seems to recede to infinity in space-time; or *Living Still Life,* which dates from nearly the same period and casts his weightless glasses to the four corners of the composition. In the first painting the image of the visible is reduced to scraps that are insufficient for Dali. In the second: an entirely new illumination of the real, but which still retains his essential features of legibility.

Does this mean that Dali is a painter of synthesis, comparable to the *pompiers* whom he flatters? Certainly not. Since everyone from kindergarten on dabbles in psychoanalysis nowadays, no one ignores anything about his origins: the analysis of Anna O. by Freud, which she sweetly called "chimney sweeping"; the illnesses she suffered, muscle spasms in varying spots, intermittent aphasia—so varied and so serious that she would not have survived if the cause had been organic; the clinical and epistomological consequences brought about by her case. This is only fair, since Freud overturned the representation of our psyche from top to bottom; but it remains incomplete so long as the central notion of archetype—Jungian of course—has not been defined.

In effect, Jung reports in his writings[2] the neurosis of a young female patient who is apparently afflicted with an Oedipus complex. Paradoxically, recourse to the Freudian theory of libido does not result in a cure. This patient, a professor of philosophy, was unsuccessful in forming lasting ties to her lovers, whom she would despise as soon as they began to court her, and this made her unhappy. A cure seemed most unlikely when she had a dream: her father, tall as a giant, walked with her on a hill and rocked her to the

rhythm of the wheat stalks that were waving in the breeze. After some hesitation Jung, who had belonged to a family of Protestant theologians, found the key to the riddle. The Biblical saying "God is Spirit" was retranscribed here in its original Greek form where the spirit is expressed by the word *pneuma,* which means "wind." The gigantic father was God. Jung shared his discovery with his young patient, who blasted him with sarcasms and, two or three months later, . . . married the man of her life. Apart from the fact that this dream could be a painting by Dali, the genius of Jung is his ability to decipher the background. He had laid bare other primeval images with other patients, but none were as clear as this one.

Portrait of Sigmund Freud.
1938. Drawing.
27 x 33 cm.
(Gala-Dali Collection).

There had to result from this the idea of a classification of the ego by archetypes, that is, by preformed mental structures arising at the beginning of the human species and, perhaps, of life. The organic transformism was duplicated by a psychic transformism and they protected each other, just as would be shown later by the works of McLean and Laborit on the three brains—reptilian, mammalian, and human—that make up our brain. This inspired a remark, not without humor, by Arthur Koestler, that there is always a crocodile shedding tears and a horse prancing beside us when we lie down on the analyst's couch.[3] Jung named the archetypes of the "great images" very well. From then on, moreover, he was finished with the *tabula rasa*.

Jungian theory constitutes the second birth certificate of psychoanalysis from which all Surrealism has derived ever since the nucleus of the unconscious became the Collective Imagination. Dali's important paintings do not take their meaning from the strange or the unusual. For if they merely surprised us they would not amount to much. These paintings create or rediscover archetypes. These are great images. They are executed in and by the disturbance of the mind.

The most complete example of archetype in a work that is not easily decoded and that Dali himself admits he does not always understand, is the magnificent *Atomic Leda* in the Figueras museum. Painted in 1949, it is one of Dali's most successful works. The ancient myth is the inspiration: the metamorphosis of Zeus into a swan in order to seduce Leda, a theme that appears again and again in traditional painting. However, instead of giving a repetitive version of the myth, this tableau offers the particular characteristic that all the elements in the composition—Leda seated on a pedestal, the swan beating his wings, the shell empty of Castor and Pollux—are in a state of levitation. The myth is *actualized*. Set in the modern era, it now evokes, more than Greek mythology, the discontinuity of matter taught by the quantum theory. There is an ancestral reversal, as in the *Living Still Life* where different objects are floating about in space. This is the first level of meaning in the painting.

But there is a second level that is more crucial. If one *undresses* the swan, removing the conventions, proprieties, and taboos that clothe life in society, the swan who elsewhere symbolizes beauty is, in these circumstances, nothing more than the feathered phallus of graffiti, present as well in erotic literature. Thus the myth becomes clear. This time Zeus did not beat about the bush; he transformed himself into a sexual organ to make love to Tyndareus's wife, and that explains the sustained sensuality, the caresses of the Ledas painted by Titian and Tintoretto who, in the voluptuary Venice of the sixteenth century, were not misled by it.

Now a dramatic turn of events. If the myth is thus unveiled, the dreams of levitation are always dreams of purity and never anything else in artistic creation. Dali's Christ, in which the cross is suspended over Cape Creus, and the Christ who appears before Gala in the air, flattened to a hypercube, are the opposite of the crucifixions of Grunewald with their powerful charge of physical and psychological violence. In an analogous way, the *Atomic Leda* is, in comparison with the Greek myth, a counter-interpretation: *the archetype of the unconsummated sexual act.* Or else one must see an expression of ecstasy in it, as in Bernini's *Saint Theresa,* in which sagging features of fleshly happiness are complete pleasure. But I don't believe it. The swan himself possesses the mercurial whiteness which in alchemy indicates the limpidity of the soul. Above all, the painting is in harmony with Cledalism, in the name of Solange of Cleda, the

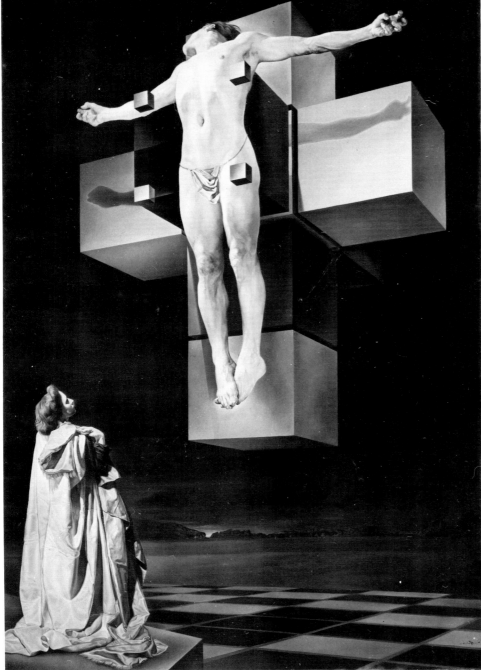

Crucifixion (Corpus Hypercubicus). *1954. Oil on canvas. 194 x 124 cm. (Chester Dale Collection, The Metropolitan Museum of Art, New York).*

50

heroine of *Visages caches (Hidden Faces),* the novel that Dali wrote in the United States during World War Two. Accordingly, when mystical and profane love intermingle, the lovers burn with a passion that is all the more intense because sexual union is forbidden.

Myths are an integral part of transcendance, which explains why the adventures and intrigues of ancient gods have for so many centuries been compatible with Christian iconography in the painting of the western world. Like the Christian God, myths were, for a long time, a socio-cultural reality. But, like God, they began to decline and it is their decline that gradually revealed them for what they are: archetypes. They cannot, any more than Platonic ideas, be lived today. The mysticism of *Atomic Leda* —insofar as one can use the term— is psychological, psychoanalytical. Ontological references are abandoned. It is a mysticism from below, a fiction— recognized as such.

The point of departure is found in the work of Gustave Moreau who sensed, from the beginning of the industrial revolution, the malaise of a society whose beliefs were collapsing. In his paintings Greek and Roman myths were replaced by Nordic and oriental myths. They were more unfathomable in his view. He called them *legends* and shifted them to the edges of civilization. This was the era when Hervey de Saint Denis called forth his dreams on command, prolonged them from one sleep to the next, and tried to direct them; when Alfred Maury showed the dependence on the dream world and on verbal associations. Before Freud, Moreau seeks the origin of the myth—as Jung will fifty years later— but confuses space and time. For he was still unaware of what Surrealism will bring to light, namely, that the unique transcendance of modern man inhabits the depths of his inner being.

The arrangement of worlds is no longer the same. Dali's frequent use of anamorphosis, which may be defined as an elongation of form, is the surest sign of it. In his work the anamorphosis is often a simple deformation: inordinate lengthening of William Tell's buttock, dorsal excrescences of the women with drawers in *The Flaming Giraffe,* etc. So it seems probable that the artist would have been familiar with Jean-Baptiste Lavit's *Traite de perspective,* an entire volume of which teaches, around 1800, how to distort the different parts of the body with a view to projecting them onto an arch or a ceiling. Dali's convulsive *Premonition of the Civil War,* even as it aspires to another goal, serves to drive the principal of deformation to extremes.

However, the most meaningful are the metamorphoses that become readable starting at a particular point, as in *Meditation on the Harp,* a painting of 1934. The work shows the embrace of a marble (or lard) couple, against the background of a vast sky, in which the clouds are gathering to suggest a torso of mist. The man, head lowered, hat in hand, is a replica of the peasant in Millet's *Angelus* which,

as is known, occupies an important place in Dali's imaginary world. The woman, undressed, conjures up a sort of Mannerist Venus. Before them we see a misshapen dwarf whose right elbow is stretched into a monstrous appendage supported by a crutch. Apparently this isn't one of Dali's major paintings. But when it is viewed from the side, everything changes: the appendage, whose image stands out while the scene in front dims, delivers its secret. It is a sneering death's head, an insidious presence in the pit of our stomach of what we refuse to look at or face and which each day in our life increases: our own nothingness.

It is easy to discover the origins of the painting. Anamorphosis, invented at the beginning of the six-

Meditation on a Harp.
1932-1933. Oil on canvas. 67 x 47 cm. (The Reynolds Morse Foundation, Cleveland).

**Archeological Reminiscence
of Millet's Angelus.**
*1935. Oil on wood panel.
32 x 39 cm. (The Reynolds
Morse Foundation, Cleveland).*

52

teenth century and brilliantly used by Holbein in *The French Ambassadors* was, a century later, the pictorial expression of Cartesian doubt. It corresponded perfectly to the philosophy of Descartes: a square tower on the horizon appears round; a stick seems to bend when it is plunged into water. Our senses deceive us so often that we cannot trust them. Anamorphosis, on the other hand, allows for the revival of sense. Not the correct use of reason following after medieval obscurantism, as the textbooks would put it, but the contrary: the first commotion of metaphysics in the western world.

Certain of Descartes' contemporaries were aware of this upheaval. To an anonymous seventeenth-century painter we owe, in fact, a canvas entitled *l'Academie des Arts et des Sciences* which is remarkable from this point of view. In a vast setting, in the style of Veronese, with colonnades and a host of characters, it unfurls before our eyes the entire panorama of knowledge of the age: a study of natural sciences with aquatic plants, a tortoise shell, human and animal skeletons; a library; the apparatus for lavage; a number of instruments lying on the ground, among them an Archimedean screw, a burning glass, a magic lantern, a clock, and an astronomical chart. In front of the background colonnade, bathed in light, an orchestra is playing as if the music of the spheres were pouring out upon so many accumulated scientific marvels. The painting is a hymn to human ingenuity now that ancient superstitions have been dismissed. Except for one

little detail that topples the entire composition: a man kneeling who seems to be looking at the cross section of a board showing strange streaks, like saw marks carpenters make, in the right-hand corner of the composition. And who, horrified, discovers the anamorphosis of a skull, identical to the one in Dali's painting.

From one pit to the other. Plato's prisoner does not cease climbing, using the ladder of dialectics which, much later, will still serve Hegel when he makes the senseless wager of setting down existence in time. The rope to which Dali clings to explore the Purgatory of Saint Patrick and his tormented souls bears a name. It is the paranoiac-critical activity that he describes as a "spontaneous method of irrational knowledge based on the critical-interpretive association of delirious phenomena."[4] We are at the antipodes of that witticism of Picasso's that caricatures Surrealist painting: "You put the dove up the station-master's ass and that's that." All of Dali is clinging to this precarious rope, with the abyss rumbling at his feet.

JEAN-LOUIS FERRIER

Notes:
1. Salvador Dali, *Comment on devient Dali*, Paris 1973. p. 301
2. Carl-Gustave Jung, *Dialectique du moi et de l'inconscient*, French translation, Paris 1964.
3. Arthur Koestler, *Le Cheval dans la locomotive*, French translation, Paris 1970.
4. Salvador Dali, *Oui*, Paris 1971, p. 19.

salvador dali, writer

by georges borgeaud

"The only thing that the world will not have enough of is exaggeration."
—Dali

The partisans and detractors of Salvador Dali tend to ignore information about him that can be found not only in the numerous books he has written but also in his statements to journalists, which abound in exasperated secrets and disclosures. His partisans are content to limit themselves to the snobbery which takes Dali for an engaging eccentric, not to say a fascinating madman. For his detractors scorn is sufficient. And yet, the writer Dali, when explaining himself in the roundabout way of the printed word or in an interview, discloses—sometimes with exaggeration, other times with great reserve—essential revelations about his proceedings as a painter, about a life that has been hot and cold, cruel and tender, about a thought that is seemingly so contradictory but basically rigorous and even logical.

Naturally, the legend that Dali has fashioned about himself, which he sustains and guides as he deems appropriate, simplifies the public man whose eccentricities are only surface movements designed to amuse or annoy opinion, the gallery, without anyone ever trying to find out what is present in the man, the hidden and touching aspects of the individual, which his writings disclose and justify. They give evidence that his "paranoiac" nature—to use Dali's own term—has a mad sense of continuity, and a coherence that belong to a mind that is scandalously free, provocative and disdainful of the opinion of others, which is a "pro domo" enterprise in reverse. One must recognize that he has conducted it superbly, proudly, and that it finds its nourishment in general human stupidity. Too bad for the dupes, bravo for those who do not allow themselves to be taken in, even as they admire the workings of the trap.

To approach Dali we must discard all analytic systems and all rationality, too, but not our perspicacity. It would be a mistake to think that Dali is like an adolescent playing hooky or causing an uproar, or that he obeys crazy impulses or creates scandal for his own pleasure. Along with Paul Valery, Dali would say that, to the contrary, stupidity is not his strong point. He is familiar with the ambiguity of the intellect and the delirium of the imagination. He tries to prevent their mutual destruction. This effort in no way resembles a disordered stampede of all the instincts, something looming in the mind of a man who would permit himself to be led astray by unbridled fantasy. So, when he says he is a scientist, a philosopher, an anarchist or a monarchist, almost a metaphysician, there is no spirit of contradiction in him. There is, instead, the conviction that the truth, like a trout, is elusive, that it swims in many streams and at every depth. Dali maneuvers his boat like the storm-tossed sailor who knows that stability depends on a movement that he must know how to follow. The ocean depths bear the

swell but they are not overcome by it. Just as the egg is, for Dali, the representation closest to his inner self. The creature develops and moves within an enclosed world whose shell must be broken for it to emerge from darkness. The egg is like the completed, exhibited art work that was nourished in secrecy, obscurity. Dali says of himself: *Everything modifies me, nothing changes me.*

Many misunderstandings surrounding his person stem from his failure to adhere to Surrealism. This was not entirely his own fault. In fact, up until today he has been faithful to Surrealism, even if he has brought it turmoil, and the gestures that detract from the solemnity of its doctrine. "Of course, I am a surrealist, but from birth. . . . I arrived in Paris with a painting, *The First Day of Spring*. It was, I believe, completely surrealist," How could the devotees of the school tolerate a person claiming to be a natural Surrealist without even referring to its orthodoxy? Dali wanted to devote himself to this commitment in his own way, by practicing the marvelous precepts of absolute freedom that Andre Breton preached. But the tribunal of the Surrealist chapel quickly condemned this overzealous Spaniard who was making too much noise and showing too much zeal, causing too much glitter, and seeking popularity too quickly. It must not be forgotten—and this is essential—that in the political realm Dali's choices were surprising, scandalous and compromising.

They should have understood that Dali's preferences were for regimes that supported an elite, hierarchies, ceremony and public festivities that included a ritual, liturgies, pomp and—why not?—armed forces more magnificent than effective. Dali had believed that Surrealism would surround him with these splendors, forgetting that the Left in politics is prosaic and economical. People found fault with his enthusiasms and wanted to restrain him.

In the name of freedom—hadn't Nietzche written that the word "freedom" itself was beginning to

Above right:
Portrait of Dali by Man Ray. *December, 1936. (From the cover of Time magazine).*

53

stink like a cadaver?—Andre Breton had set up an esthetic that, although he had wanted it to be devoted to the unconscious, accepted neither uncontrolled adventure nor negative or suspicious risks. In fact, this esthetic was to result in a kind of awareness, secular and sensitive, revolutionary and egalitarian, not so different after all from the morality that had preceded it, and certainly as intolerant. Some principles and directives were born of it, vague enough it seems, dictated by sympathies or antipathies that were more superficial than rigorous. The aristocratic anarchistic Catalan rebelled against this established system. Soon, the good comrades were denouncing him loudly, which gave birth to the Dalian legend. Why shouldn't the heretic profit from it? He refused protective custody, he did not respond to their slander, and he sometimes took advantage of it, as when Breton anagrammed his name in "avida dollars." Stoned, the man gathered the rocks that fell at his feet to erect his habitation.

When literary history ceases to flatter those who

made it in the flesh, it will be recognized that Dali was the victim of a misunderstanding. It will be acknowledged that he was closer to Surrealism than others who preferred submission. History will say that, in painting, the best Surrealist fruit grew on the trees of Dali, Magritte, and Max Ernst, men who were never servile and whose genius needed no escorts. Certainly we can quibble about the value of Dali's artwork, but not about the sincerity with which he served an art movement that seemed to correspond to his darkest impulses. This is the true situation of a free man, and truer than it seems, due to the malice and artifice that Dali has put into it so as not to be exposed by just anyone. The immodesty for which Dali has been reproached is, in fact, a way of protecting his innermost nature by magic conjuring tricks, simulated madness, and crazy language—though not so insane as some people say it is.

In his essential book, *The Secret Life of Salvador Dali* (Editions de la Table Ronde), Dali reveals to us his childhood, his adolescence, his youth in Figueras

The First Days of Spring.
1929. Oil on wood panel.
50 x 65 cm. (The Reynolds
Morse Foundation, Cleveland).

54

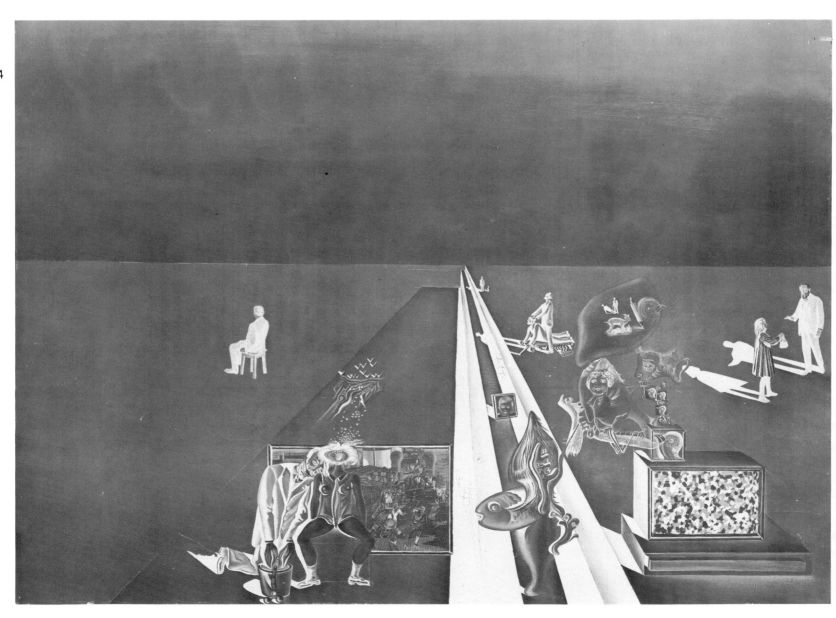

in Catalonia, where he was born in 1904, then his beginnings in Paris and the world, his meeting with Gala, his esthetic ideas and his travels until 1941, the year the book was published. As a student Salvador immediately rebelled against the antiquated ideas prescribed by education, but without, however, rejecting ideas that could be expressed in a fixed liturgical or regal display. The child at Figueras is already considered out of the ordinary, surprising his comrades and professors by his answers and his unforeseen actions, embarrassing them as would any child who is very talented, explosive, taciturn, capricious, and of a somber disposition. Undoubtedly some people thought that the devil lived inside him, that the child blasphemed when he uttered an unusual truth. If he was of the devil, it must be said that his demon had more seriousness than fantasy, for Dali immediately sensed the tragedy of life. His eccentricities are neither amusing nor laughable. They plunge into a gesticulating pathos. He has staked his life on the hatred of simplicity and has said as much. He has extracted his expression from the inner morass and not merely from the beauty of the water lilies alone. *The Secret Life of Salvador Dali* and his later book *Journal of a Genius* make important disclosures about childhood traumas. Before his birth a brother Salvador was born and died prematurely, his parents later honoring the memory of the dead child by giving his Christian name to Dali. Thus be became the double, and to exist he had to erase the other and compel recognition of himself as the only Salvador. He had to be born a second time. Henceforth all his efforts went into protecting his new identity. He could do so only by declaring himself to be unique. Since no one wanted to listen to him, his recourse was to draw a kind of magic circle around himself so no one could approach him and disturb his solitude. Dali's public actions are more of an effort to discourage importunate people by means of sarcasm, paradox and puns than a way to attract attention. He attacks to avoid suffering an indiscretion—the reflex of someone modest, of the irrepressible savage. Even his scatology is angelically inspired, the painful reflex of someone who is horrified by the mortal condition, by the excremental functions, otherwise he wouldn't discuss them so much, he would not turn round and round like a cat upon its droppings. One might say that the backward glance reassures him of his health and that he is still alive. Death dwells in him as it does in everyone. Dali has no love of death. Sickness and putrification fascinate him, he says, whereas, in truth, they obsess him.

What should be kept from so many writings, statements and gestures? That Dali is sincere, that he has a horror of banality and naturalism, that he distrusts exquisite sensitivity, that he wishes that intuition would discover its logic, that interpretation would occur on several levels, that repeating magic formulas would open the doors of the surreal. Bit by

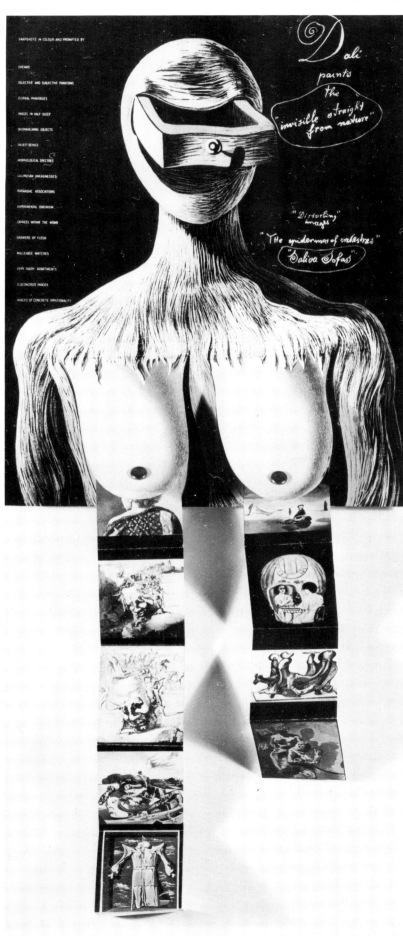

**Femme à la tête
de rose** (detail).
1957. (Kunsthaus, Zürich).

The Head of the Rose
(detail).
1957. Kunsthaus, Zurich).

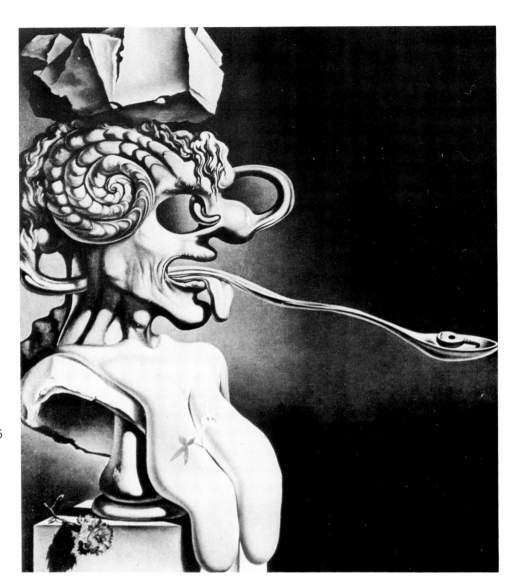

Portrait of Picasso
*1947. Oil on canvas.
64 x 54 cm.
(Private Collection).*

56

deteriorate and fall into a kind of apotheosis of the sewer"?

In fact, Salvador Dali never recovered from not receiving the consecration that he expected from the founder of Surrealism, the sacrament of ordination, one might say. Convinced that he was purer than the master, he suffered from seeing his liberality questioned and spurned. Breton accused him of trickery, and Dali was excluded from the family for having a poor revolutionary attitude, and for loving the theatre, and money—which should never be admitted. Unfortunately, the movement should have realized that Dali was preparing a ceremonial for the Surrealist movement, a service that would have been seen by people in the street and would have lived on in memory. From the infamous reputation that was made for him he accepted the challenge, but the wound never healed. From the bandarillos placed in his neck the blood is still flowing. The hurt is all the more profound because he received it during his youth and the search for absolutes. And everyone knows that nothing is slower to heal than an injury received at that time of life. No one ever recovers well from the brutal destruction of a friendship. Dali doesn't say it so plainly but none of his writings prohibit us from coming to this conclusion.

However, Paul Eluard never broke permanently with Dali, only episodically. This is particularly remarkable, for Dali had gone off with Eluard's wife, Gala. She became Dali's medium, and her fabulous presence in his life and in his work will never be boring. We can smile a little at the thought that people other than Dali—Eluard for example—were alienated from Surrealism. Was it because of their greatness? Every owner, even of a literary school, likes to prune the trees and shrubs of his own park. Salvador Dali had been reduced to nothing in Surrealism. With that affront and the one of his second birth the only thing left for him was to mount the pinnacle, believing himself unique and the sun of his era. The dead brother had been John the Baptist of the desert, heralding the second Salvador. It is understandable that he wants to live on and to look at the hour of destiny solely on the face of the soft watches.

Salvador Dali has tried everything: Theatre, essay, open letters to himself, and a novel or two, pleasant diversions that are a way of making fun of banality while attacking it. What provocations and rudenesses of supreme contempt for his adversaries! But it bears repeating, his contemners should be wary, for the compliments he offers them are often sulphurous. Ah, let us not claim that Dali is an entertainer. It is not certain that he ever knew laughter, joy, or humor. Nothing in his books reveals abandon or relaxation. His thought advances with implacable logic and pursues the conquest of the irrational according to its formula. We are far removed from a fanciful or diverting enterprise. The writer Salvador Dali is to be taken seriously.

GEORGES BORGEAUD

bit delirium discovered recipes—why not say it?—gave birth to tics, and often took a lead voice.

The Dalian enterprise, meanwhile, demonstrates an exemplary continuity. On the garment of light, and sometimes on cheap fabrics, reflectors gleam, but the nudity beneath is flayed raw, flagellated. Dali speaks and acts in vain. He cannot convince us that he is happy. The torments and joys he experiences send him, first toward asceticism, and then toward sensual pleasure, attached as he still is to the umbilical cord of Spanish Catholicism. *Les Metamorphoses de Narcisse,* which should be reissued, brings to us this singular being, this immoderate, solitary, and obliging "I."

Throughout Dali's writings one finds a jealous combativeness toward contemporaries, particularly toward Picasso, of whom he says, "Now that he is dead I am defending him. . . . The truth is that he was a complete genius, but a negative genius." Andre Breton was his favorite target. Their quarrels were fed by their mutual admiration. Neither one wanted to be treated as secondary. But was Dali justified in writing: "The Surrealist group will

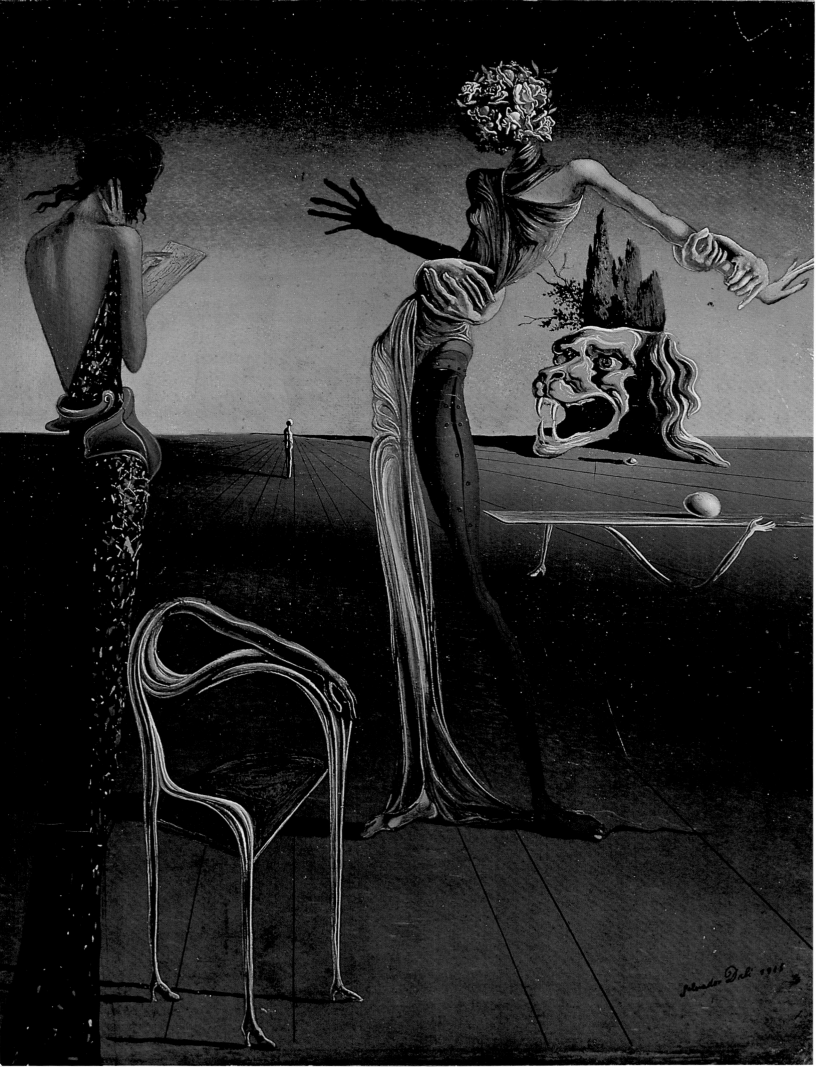

Echo anthropomorphique.
1936. Huile sur panneau.
30 x 33 cm. (Coll. A. Reynolds
Morse, Cleveland, U.S.A.).

Anthropomorphic Echo.
1936. Oil on wood panel.
30 x 33 cm. (The Reynolds
Morse Foundation, Cleveland).

58

Rose méditative.
1958. Huile sur toile.
36 x 28 cm. (Coll. Arnold
Grand, New York).

Meditative Rose.
1958. Oil on canvas.
36 x 28 cm. (Mr. and Mrs.
Arnold Grand Collection, N.Y.).

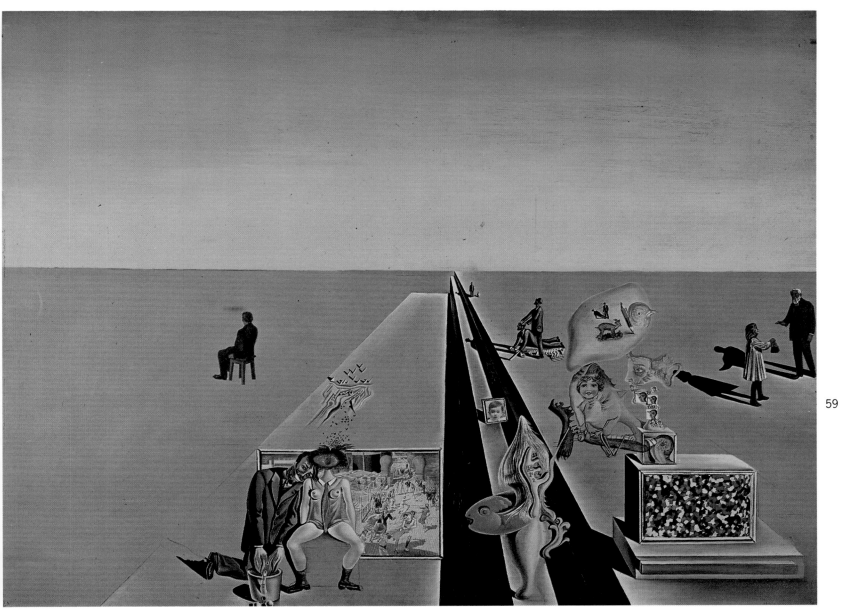

Les premiers jours du printemps.
1929. Huile sur panneau.
50 x 65 cm. (Coll. A.
Reynolds Morse, U.S.A.).

The First Days of Spring.
1929. Oil on wood panel.
50 x 65 cm. (The Reynolds
Morse Foundation, Cleveland).

L'œil du temps.
1951 / 1952. Montr-bijou.
(The Owen Cheatham Foundation).

The Eye of Time.
1951 / 1952. Jewel-watch.
(The Owen Cheatham Foundation).

60

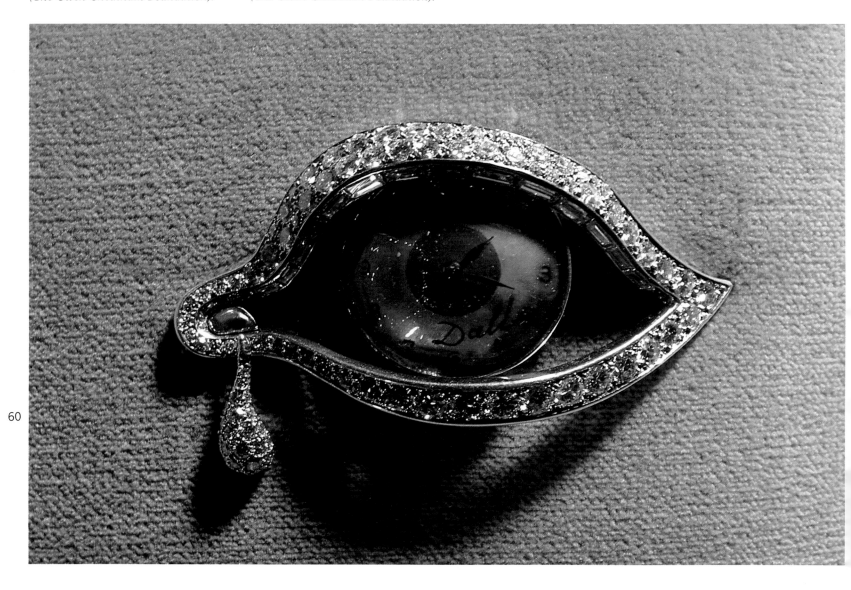

Torero hallucinogène.
1970. Plafond pour le
Théâtre-Musée de Figueras.
On aperçoit un fragment du
Torero hallucinogène.

Hallucinogenous Bullfighter.
1970. Ceiling for the Dali
Museum-Theatre, Figueras.
A stretcher is holding one
section of the painting.

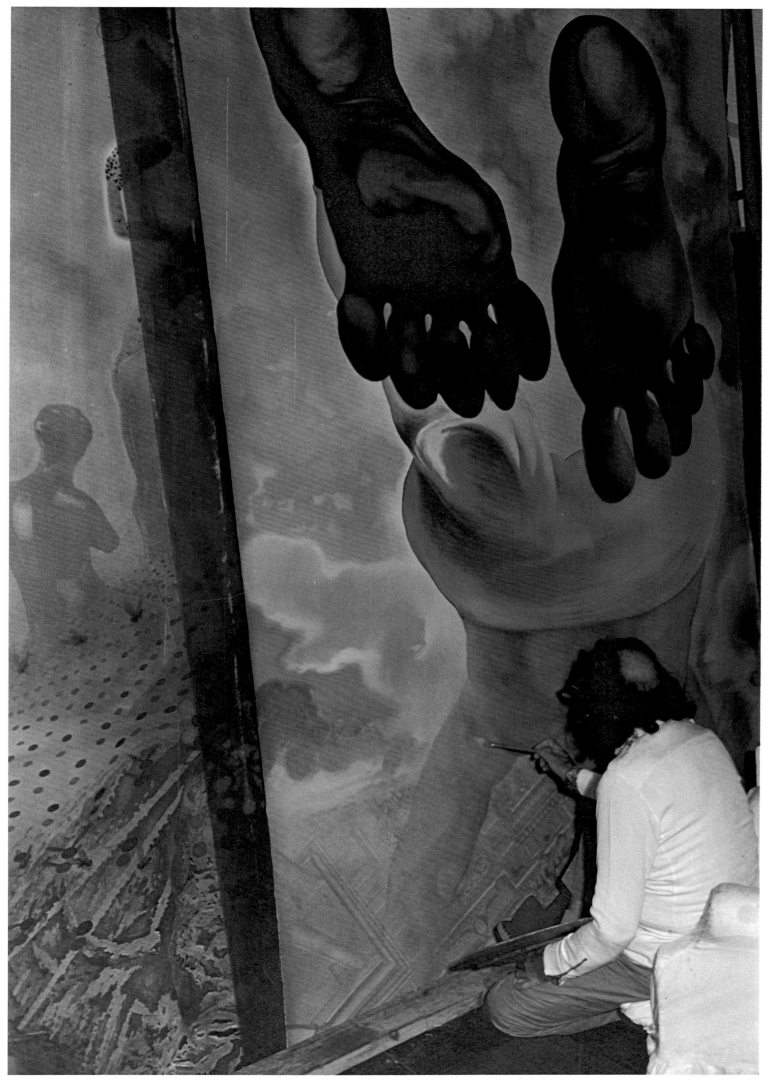

La charrette fantôme.
1933. Huile sur bois.
19 x 24.1 cm. (Coll. Edward
F.W. James, Sussex).

The Phantom Wagon.
1933. Oil on wood.
19 x 24.1 cm. (The Edward
James Collection, Sussex).

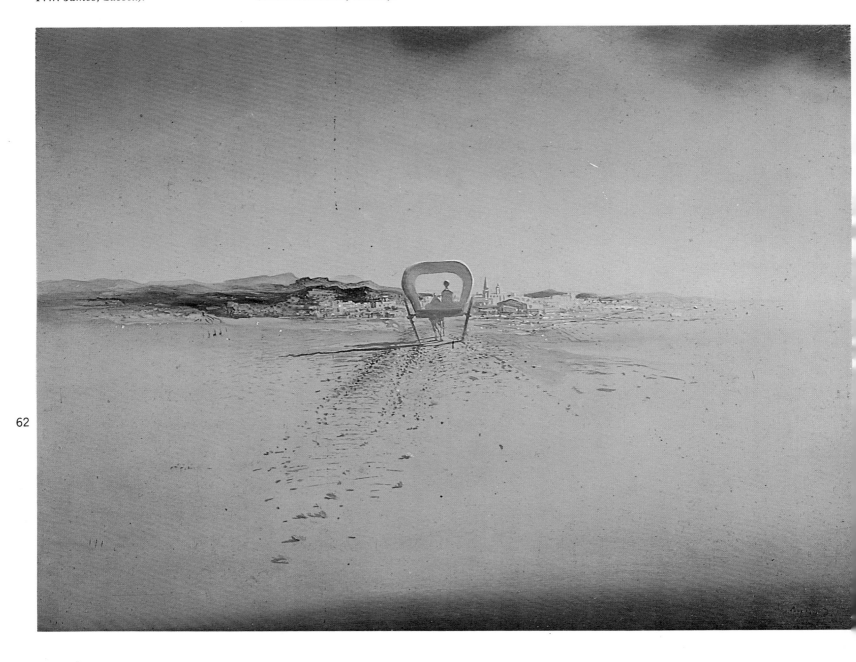

62

Torero hallucinogène.
1969 / 1970. Huile sur toile.
400 x 300 cm. (Coll. A.
Reynolds Morse, U.S.A.).

Hallucinogenous Bullfighter
1969 / 1970. Oil on canvas.
400 x 300 cm. (The Reynolds
Morse Foundation, Cleveland).

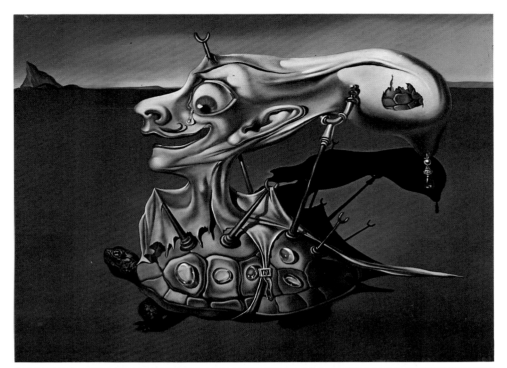

Dessins pour le film de Walt Disney "Mystere," *qui ne se réalisa pas.*

Color Drawings for a Walt Disney film "Mystery," *which was never completed.*

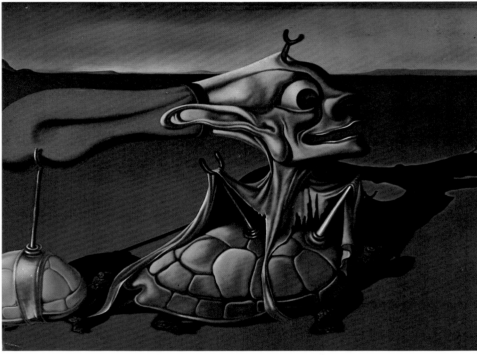

64

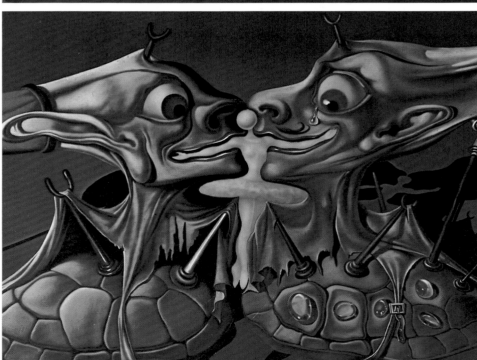

the drawings of salvador dali

by pierre volboudt

Pen and ink drawing
1932. 16 x 8 cm.
(Andre-Francois
Petit Collection).

"Shadows of my mustache and dust of my hands." This witticism describes not only a work but a man who, with a keen point, with an ink-dipped pen, with the scattered blotches from splashes of acid, engraved the shadow produced by his visions, by his "Caprices," creating a being, a swashbuckler, a dancing demon, an animalcule, the outline of a spectre, an armed living atom. In the sunlight of a mountain range, beating across an enclosed field swarming with larva and bullies, he crowds a world, a century. That artist was once called Jacques Callot. Today his name is Salvador Dali. But his universe is outside of time, devoted to the perenniality of metamorphosis.

Corresponding to the spears and halberds of Callot, to the thousand accents bestrewing, like a scattered beehive, the engraving plate, to his plumed *Reiter,* to his ragged hidalgos, to those insignificant decimal points crawling among the trees for hanged men, the windmills with loose vanes are Dali's emaciated knights, the withered and affected skeletons that he encloses in the magic circles of his drawing; but not those nudes mellowed in shadow, those bright faces of the impalpable; nor those agitated gyrations of line, nor his leaping finished designs. For Callot a vignette was enough to contain his tournaments and massacres, his legions from hell, and his troops of clowns. For Dali it is the spacious format of a two-page spread that is required by the declamatory gesture, the frantic venturing of line, for his grand manner, his staccato, his whirlings, his squirts of nervous outpourings flung at random and covering the sheet of paper with a starry shower of fireworks in black and white. Here the microscopic riddles the display with a monumental emptiness. Dali needs vast spaces so that he can expend there an ardour which spreads and which, eager to be that form standing before it, on which it is bent, and urge it into existence, accelerates its own rhythm, only to fade away, suddenly strangled, to end in the laconic and skillful calligraphy of delirium.

Drawing, "the loftiest temptation of the mind," according to Paul Valery, is the tension and relaxation of the artist's whole being as well. Through the image he projects from the other side of the imaginary mirror where he catches and copies his reflection, the act of doing combines the spontaneity of the initial impulse controlling it with the demanding rigor of the intellect. A graphic sense is but an equivalence. It transposes, it transcribes. It makes of form the abstract skin of a sensual body, bundle of its lines of force, of its lifelines. This reality that is invented and reinvented becomes a laying out of energy.

By that thin thread that unravels and becomes angled, breaks and pulls itself together again, by the fiat that he obeys, he lets himself be carried along. His hand guides him no less than he leads it, corrects it and submits it to his will. From these lines that are sometimes full and intricate, at other times

65

Confined: "Totally ruining
the debt" (?).
*1933. Pen and ink drawing.
28.2 x 21.3 cm.*

Hotel Meurice, Paris.
1973. (Photo by Magnum).

66

Consigne : "bâcher l'ardoise totale" (?)

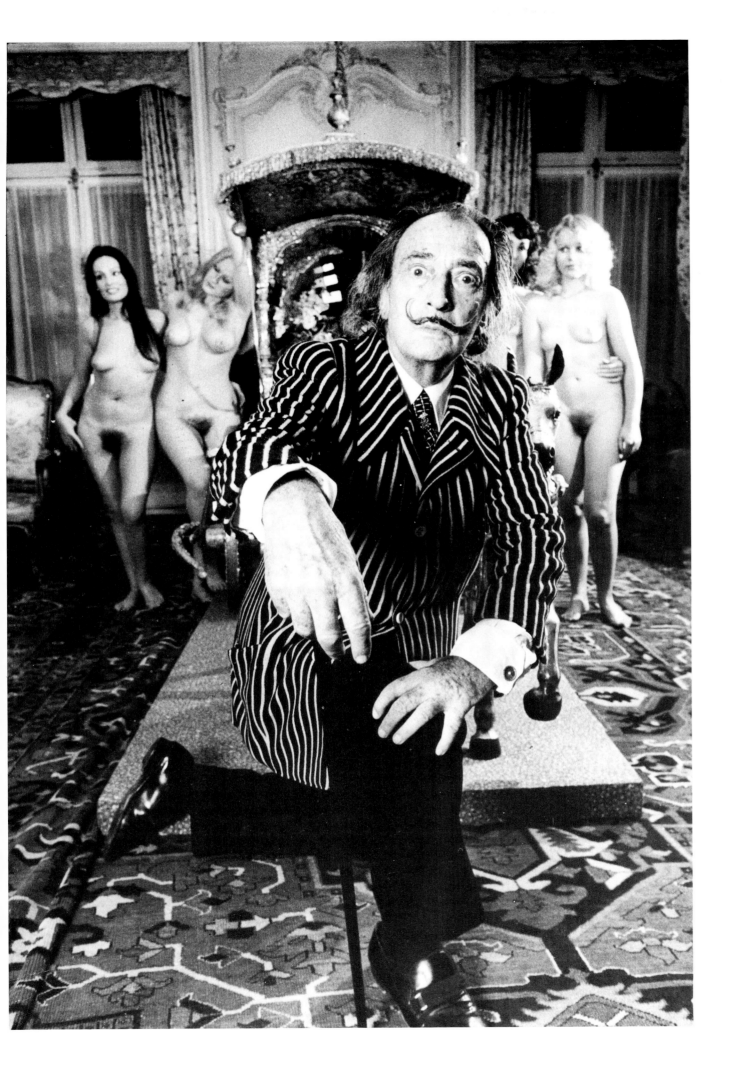

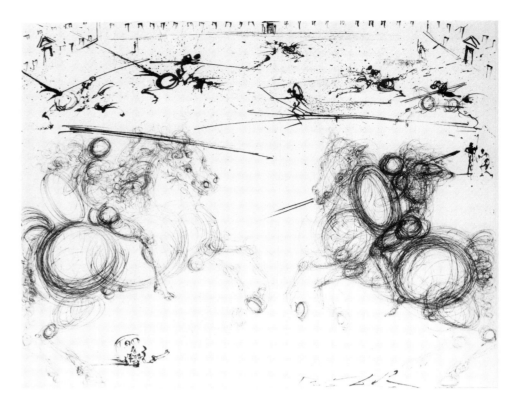

Pen and ink drawing.
1962.

short and blunt, are created those shadows of figures that abridge everything because they take the place of everything. The drawing, by nature, is ellipsis, scratching of life, perfection of the unfinished. One line potentially contains the infinity of possibilities coiled into the heart of the skein which unwinds and reknots itself constantly in a different way; suddenly disclosed by a brusque foreshortening, it weaves its own space. In the neutral field of the page, torn out haphazardly, what is inscribed from the most summary sketch to the fullest and most complex composition, extends beyond every margin, every frontier.

This immeasurable distance from which he draws his effects is nowhere more striking than in Salvador Dali's pictorial and graphic scenography. In his work, space beyond all dimension is an abstract desert marked out to the distant limit, with guiding lines so fine as to seem engraved on the whiteness by a stinger of some geometer insect. Upon the arid beaches of these thin sheets, each form exists separately, fixed in the immobility of petrified time. On the sands of time, on the scale of unlimited perspective, its shadow marks the moment when a fixed star eternizes, lights up with the dim fire of an unchanging solstice.

68 Whatever Dali's format may be, the scene of graphic action is an empty space in which crystallized mirages are the only setting for this *romancero* of crises and excess. On this timeless coast, along the smooth beaches of pure light, human vibrios, some concrete symbols, an unexpected object, are scattered about in the manner of milestones up to the fringe of a vaporized horizon A restless multitude pockmarks the page with its dark swarming. A Lilliputian land where the actors gambol, joust and vanish in smallness. A meticulous and infinite world dominated by a person or a couple of protagonists anchored in their own shadows, alone among the channeled stones, the angular geological formations, the protean rocks, the steles, the ravaged pyramids, the appurtenances of a life that ebbed, leaving behind, on the dazzling shore weighted down by a frigid stupor, nothing but the traces of an unknown cataclysm. But all of it— stones polished by an immemorial surf, crumbled flesh, mineralized bodies—seems stricken with a relentless perpetuity in these *inania regna*. These enduring statues, consumed by the secret pain of an incompleted metamorphosis, bear the wrinkles, the mysterious stigmata, the writing of decay that indestructible working plans are put together from.

Of this graphic delirium Dali has made his favorite exercise. All his resources are at work; speed and patience are applied to the tiniest detail, superior elegance and sharply delineated minutiae. A few traces of ink or of graphite and a whole world of powerful activity emerges from the transparent limbo of whiteness. It is undoubtedly in drawing that Dali excells at pitting himself against that *profundidad* to which the gesture adjusts its

Pen and ink drawing.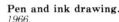
1966.

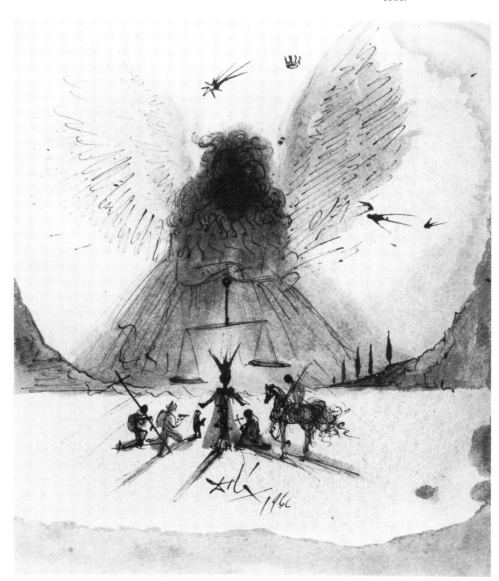

enthusiasm. In this *faena* of sparkling virtuosity there is a monster of empty space that the artist confronts and subjects to his whims, to the repeated intertwinings of his tortuous passes. For the draftsman, the arena, the theatre of these assaults becomes the bullfight ring where he persists and revels in fighting the form, fastening it with his pics in the very center of the vertigo of solar magic. Distinct, relentless, things are nothing more than ciphers for a solitude overwhelmed by the immensity of nothing.

"Unhappiness," Zarathustra said, "to whomever has within him the desert." Dali carries it inside of himself. He makes a pact with it. He fertilizes it with his visions. His inexhaustible formal imagination, with a kind of conquerer's greed, takes possession of those territories of virginal whiteness that each sheet before him opens to his eagerness. Pursuing a gesture, Dali alternates and mingles the most incredible fiction voluntary incoherence and the most bitter truth, ransacked up to its entrails, stripped to its bare bones, lacerated by lashes of ink which cut and thrash and then unexpectedly subside into the most delicate thin strokes, the sinuous arabesques of a body. The page becomes an enclosure in whose interior joust and spring forth—like airy tracings of the hand of a calligraphic enchanter—all the images of a harsh violence that sensual frenzy curves into intertwinings of gentle grace and of the most exquisite touch. These desperate ones, these living flayed beings posed on their iron legs, burning with all the fevers of a passion chained to its rage to stay alive, this implied sumptuousness, evanescent under the gossamer web of its contour remind us of the masters of the sixteenth century, of so many of their ardent and ferocious likenesses that a clear eye, sometimes, lights up with solemn, thoughtful ecstasy. What are they thinking about, Dali's heroes, these other "traversers of perilous roads," beyond their barren dereliction? Undoubtedly nothing but the obstinate will that is within them, forged by their unyielding and fruitless challenge to the perishable which consumes them without reducing them. Lookouts at the edge of a slope of forbidden seductions, terrors from recurrent dreams, they are all there, all fibers in the wind, splinters from which still hang the cast-off clothing of a time that is forever stopped upon an incandescent earth by the shadowy hands of an imperial noon.

Bound by double cords with good clean lines, tormented by the vehemence of the point that dissects it fiber by fiber, the shape stretches out, coils up its inner workings, contracts, bursts into convulsive explosions, curves and contracts in its haughty pose of living ruin. Its tumultuous transgressions upon the human nevertheless retain the whirling grace, the soft density, the plenitude of what Dali calls "the serene perfections of the Renaissance." If the rapidity of the hand sharpens and shortens the silhouette captured in its perverse slouching and the hip, the woman's figure never

loses the Venus-like grace of Madonnas, even the "corpuscular" ones, all in fragments and splinters of ambiguous nymphs, the voluptuous fullness that the pencil touches lightly and dusts with the impalpable. In the flexible harmony, the mobile balance of her walk, Gradiva is the equal of those immortal women who were brought into existence by the joy of creating and possessing them. Dali, too, knows how to detail her beauty, when he does not

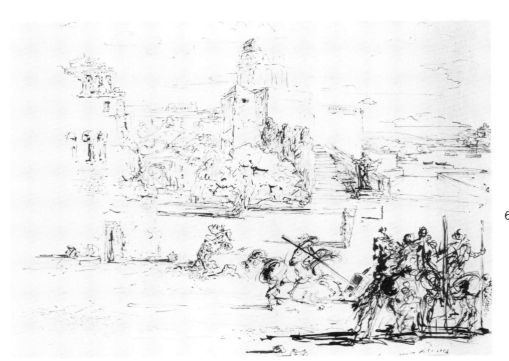

Pen and ink drawing.
1964.

Pen and ink drawing.
1964.

Between the fragile paper destined to all the blows and assaults of the hand and the flash of the idea that causes his charges, his rebounds, to run and get caught in the network of his act, a field of force is created. It is the space of a dual reality of which the states, the stages and, until the final outcome, will and indecision, are reversed. It is there that everything occurs and is given free rein. The eye and fingers concentrate on a single point, continually passed over, where everything converges, which is and which is no more. The artist's studio is reduced here to the small rectangle placed flat, upon which the rage to create spills out, becomes inflamed and is satisfied. To leaf through these pages scattered throughout the world is to attend some kind of barbarous fiesta given by the painter as if for himself, with no constraint other than the exigence of the "blind lucidity of desire." Definitive sketches, works pushed to the ultimate degree of high-spirited perfection, rapid sketches raised with an impertinent pen that gets drunk on its enthusiasm. What should be retained? What major assets should be gathered together that might surpass another which the chance of a half-open portfolio shows to be of an identical quality? Everywhere the stroke is supreme: it presses down hard, climbs, grows lighter, spreads out, becomes disorderly in agile wisps, bifurcates and disappears into the imponderable "En roccas de cristal serpiente breve."

They march by, at the pleasure of an indefatigable imagination all the themes, the artist's irresistible temptations, steep-sloped landscapes—as inaccessible as the mystical dwellings that Ramon Lull's Blanquerna tried to reach—images of a hallucinated bestiary, pandemonium that the fragile light of a vaporized profile exorcises from further and further away, in barely the trice of a lightning flash, excesses of great blotches of ink, dreams and shadows of the line that never gets lost or weakens among the most subtle snares of rigor, and that is finally immobilized in the resoluteness of its strength, captive of the labyrinth of which a clever hand has taken away the detours and, in the interstices, inserted a glimpse of the infinite.

So many of the contrasts in the sweep of this graphic record are astonishing. In each, Dali is unyielding, with his scruples, his haughty intransigence which caused him, in his apprentice years, to adopt Ingres's motto and to show, by his audacities and his insulting liberties with an order that he does not really reject, evidence of that integrity which is the rule of art. But he never meant it to be subservience to some canon of established dogma. The absolute, for him, is his scandalous independence, his humor, and that submission to the breathless dictates of an inspiration caught at the source of desire, like lightning at the tip of an iron rod. Is this the same hand that, from its first sketch, treated resemblance with that breadth and that accuracy that places him right among the descendants of the masters of linear expression? Is this the very same hand that, grasping the truth of form so closely, next strangles it, slashes it with violent, voluptuous lust? The face sculpted with a scumble of shadow in the youthful severity of the drawing, which will be softened later with a da Vinci-like modeling, tinted with all the mists of flesh and with the powdering of light, is treated in a manner that foretells the imperturbable ease and steadiness of work to come. The

hide it. Whether he veils it with transparent effects or exposes it to the shamelessness of daylight, he does not tire of squeezing between his fingers the pulp of that fruit to which he compares the body. With ardent patience the pencil passes and repasses, more intense here, evasive there, darkening, toning down, illuminating with whiteness, as if "in reserve," the glorious body that he exposes to the rays of that inner fire of which the page is a mirror.

But the artist does not stray for long from his aggressive virulence. From torn limbs, from the movement of folds and broken fragments, the bundle of coalesced tensions and discordant forces that the impetus of the stroke shoots in all directions picks up again with pen and burin. From that arrow of ink shot off with a pitiless confidence the constant attack redoubles. One might say it is an assault against an adversary who exists ultimately only as the target that is the artist's objective. Under the thrusts, scratches and flourishes of the point, the target rises up through the dazzling and airy play of this swashbuckler who fences with what he lacerates, devastates and creates. To the jumbled masses, soft undulations of downstrokes and upstrokes—phantoms that he loathes—Dali contrasts the upheaval of his bushes of thorns and vertabra—those angular and sensual spectres of form. He pins them down; tortured and lordly, they are like trophies from who knows what battle, plastered with scabs and pierced by all the rays of an aster in abysmal space.

Pen and ink drawing.
1963.

Pen and ink drawing.
1967.

angular rictus and the grimace of the stroke under the breadpan are followed by pure slashes and tiny emaciated masks on the background of Thebiades, diaphanous nudes hemmed with pale ashes, twins by the curve and the spiral, splintery masses of rock, hybrid machinery against nature, the conjunction of the genitals, impairment of the human and, trampling this circus of insane anatomies, that animal of fantastic gallopings, the lean-flanked steed of the world beyond, Rossinante neighing under the bridle and bit and the heel of this cavalier. Always some segment of the face is missing, avoided in the haste of drawing. Remaining accented to excess are the sally, the wrinkle, the harshness, the secret armature of the body, the make-up of shadow upon missing flesh.

These scratches, these scribbles, these caresses of the form, these arrogant breaches of space make each of Dali's graphic works an abridgement of the universe. The most microscopic accident takes on the value of a concrete symbol. He arranges the distance according to the strange and fleeting fantasy of a surveyor for whom a single inch of land is equal to the whole. This realistic cartography is painted as if on a theatre curtain, which sometimes is the scene itself and sometimes leaves the scene empty and recedes into infinity. It is superimposed according to the Dalian "projection," in the make-believe, on the views of holy reason. All the points of the map form a network of quasicabalistic relations, a series of perspectives hampered by riddles, by spaces on an elsewhere whose images of reality are scattered ciphers. Thus transferred onto the plan of form, the duplicity of the poetic image is lit up by a sudden ray emanating from a *focus imaginarius* which strikes down one of the terms of the Baroque metaphor and makes a magnetic pole out of the other. This dark light at the zenith of the Gongora sky, surrounds, accentuates the artist's elliptical brevity.

Perhaps other comparisons are plausible. But to venture to make them, isn't that to play the same game as the artist who admitted in a famous text

Decalcomania.
1977. 30.7 x 41.2 cm.

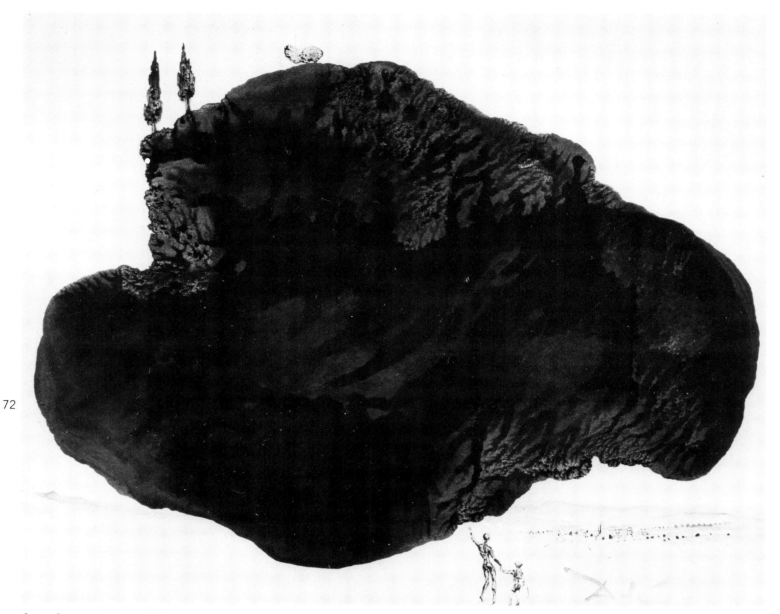

72

that the meaning of his works escaped him? His drawings are the repertory of all that the mind conceals in inaccessible disorder, of his confused affinities with latent models, products of absolute irrationality—of which he knowingly possesses the replicas, and in a sense the standard, within himself. Tragic rivals of the placid figureheads of desire, the armed creatures that Dali tosses ahead to populate his deserts take root in the abolished. The time of an infallible improvisation, the lines in bursts increase and diminish, sweep down, move straight up—torsos caught by a sudden swerve, truncated by endless gaps. His figures partake of trances, the whims of an exacerbated sensitivity. Brandished in a bouquet of spear shafts barbed with thorns and hooks, they branch out in arborescent vines, in labile ribbons, in mineral veins. The drawing here connects the inventions of the rudimentary. It has the need without the cause, the determination, the tumultuous violence that swells up, flares out, escapes, dwindles up to the margin to blend finally into the flawless arc of a

body. *Homo omnis natura.* Hasn't Dali taken the old adage from the Hermits, to whom his thought sometimes connects him, and made it his own? It is possible that he has found incitements, justifications for the most venturesome relationships, for the intentionally disparate incongruities, for the panicky insurrections of form to which his art owes its singular reputation?

The weave of Dali's "convergent universe" leads to the inaccessible. Woven of numbers and bows, of strange relationships and paradoxical analogies, it imprisons in "the cage of divine geometry" the visions, the dizzy spells that a captious and passionate pencil produces and reproduces, and raises to the rank of incoherent and insane games of material effects. But the artist, as is his privilege, goes further with the possibles in which chance tries its hand, goes astray and, with the slightest stroke, adds the flourish of his name.

PIERRE VOLBOUDT

Le sphinx de sucre.
1933. Huile sur toile.
73 x 60 cm. (Coll. A.
Reynolds Morse, U.S.A.).

Sugar Sphinx.
1933. Oil on canvas.
73 x 60 cm. (The Reynolds
Morse Foundation, Cleveland).

73

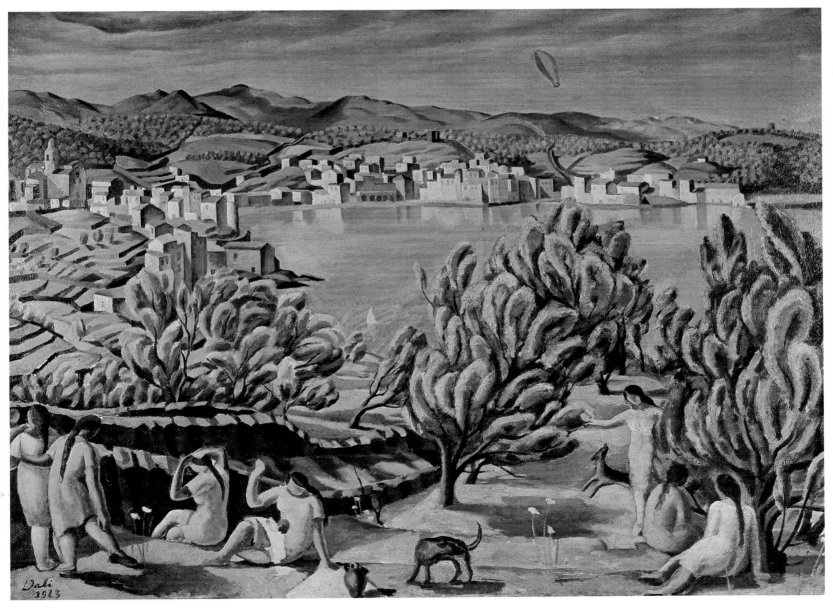

Dionysos crachant l'image
complète de Cadaques sur le
bout de la langue d'une
femme à trois étagères.
*1958. 31 x 23 cm. (Coll.
A. Reynolds Morse, U.S.A.).*

Dionysus Spits on the Image.
*1958. 31 x 23 cm.
(The Reynolds Morse
Foundation, Cleveland).*

Femmes aux têtes de fleurs
retrouvant sur la plage la
peau d'un piano à queue.
*1936. Huile sur toile.
54 x 65 cm. (Coll. A.
Reynolds Morse, U.S.A.).*

Three Young Surrealist Women
Holding in Their Arms the Skins
of an Orchestra.
*1936. Oil on canvas.
54 x 65 cm. (The Reynolds
Morse Foundation, Cleveland).*

76

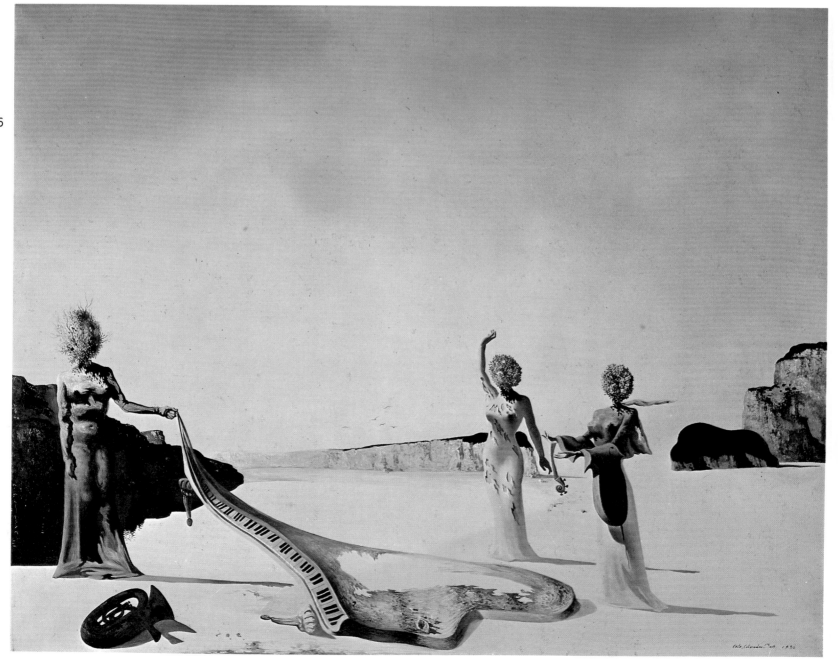

Violettes impériales.
1938. Huile sur toile.
100 x 142 cm. (Musée
d'art moderne, New York).

Imperial Violets.
1938. Oil on canvas.
100 x 142 cm. (The Museum
of Modern Art, New York).

78

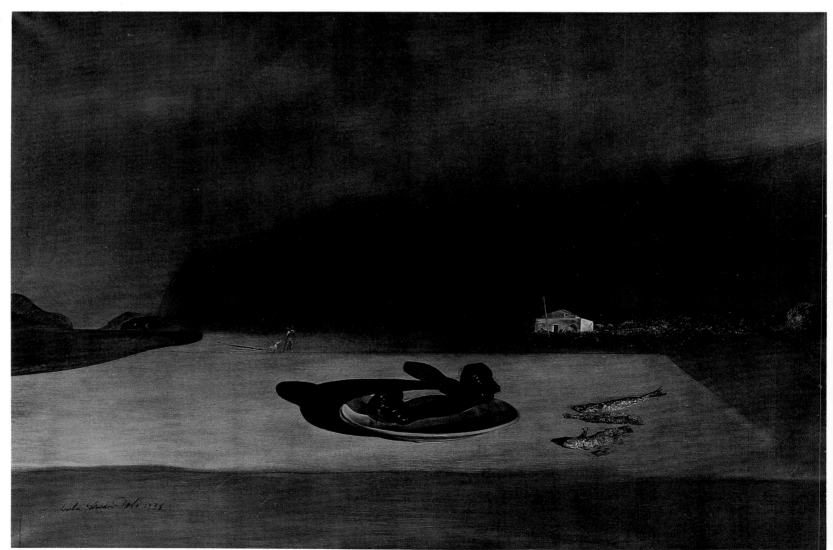

Téléphone dans son plat avec trois sardines grillées.
1939. (Coll. A. Reynolds Morse, U.S.A.).

Telephone in a Dish with Three Grilled Sardines at the End of September.
1939. (The Reynolds Morse Foundation, Cleveland).

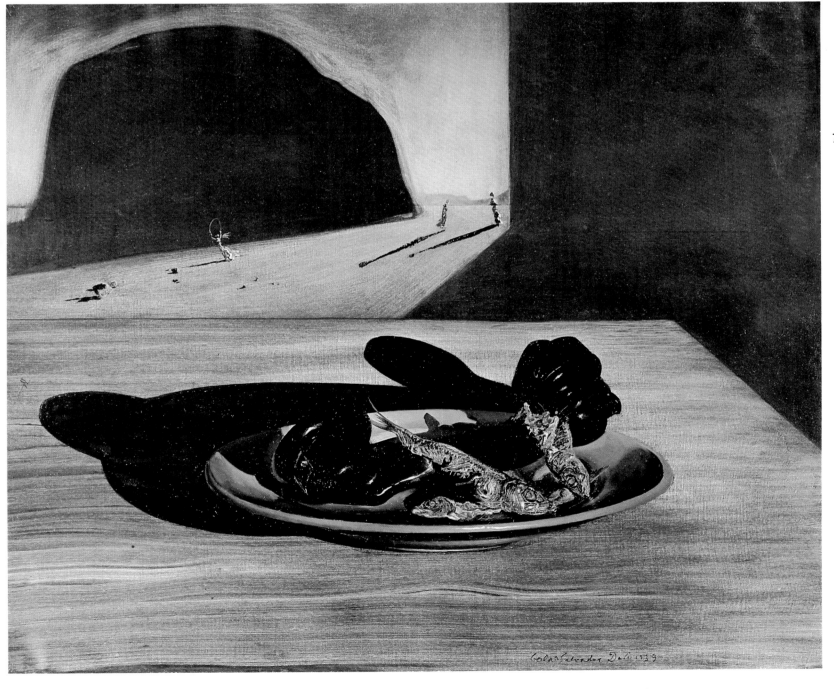

Réminiscene archéologique de l'Angélus de Millet.
1934 / 1935. Huile sur panneau.
32 x 39 cm. (Coll. A.
Reynolds Morse, U.S.A.).

Archeological Reminiscence of Millet's Angelus.
1934 / 1935. Oil on wood panel.
32 x 39 cm. (The Reynolds
Morse Foundation, Cleveland).

80

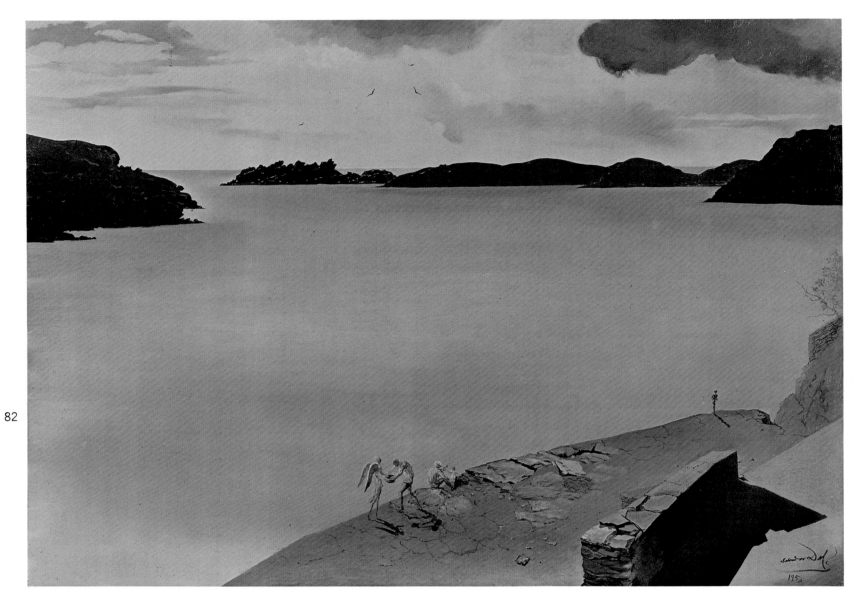

82

Paysage du port Lligat.
1950. Huile sur toile.
58 x 78 cm. (Coll. A.
Reynolds Morse, U.S.A.).

Landscape of Port Lligat.
1950. Oil on canvas
58 x 78 cm. (The Reynolds
Morse Foundation, Cleveland)

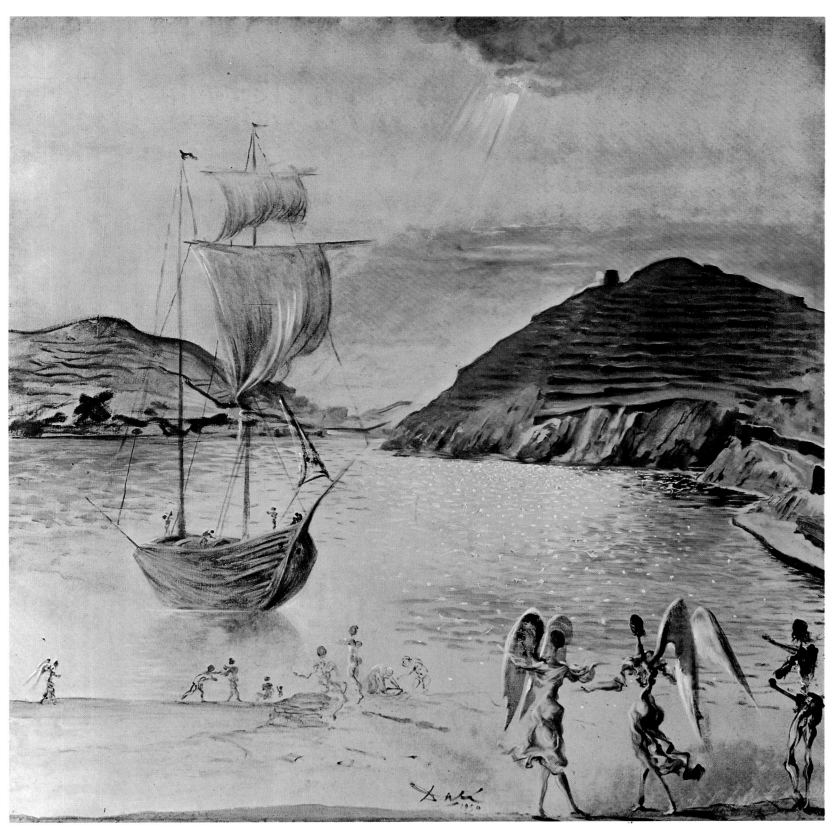

Moi, à dix ans quand j'étais enfant-sauterelle.
1933. Huile sur panneau.
22 x 16 cm. (Coll. A.
Reynolds Morse, U.S.A.).

Myself at the Age of Ten when I was a Grasshopper Child.
1933. Oil on wood panel.
22 x 16 cm. (The Reynolds
Morse Foundation, Cleveland).

L'ange de port Lligat.
1952. Huile sur toile.
58.4 x 78.3 cm. (Coll. A.
Reynolds Morse, U.S.A.).

The Angel of Port Lligat.
1952. Oil on canvas.
58.4 x 78.3 cm. (The Reynolds
Morse Foundation, Cleveland).

84

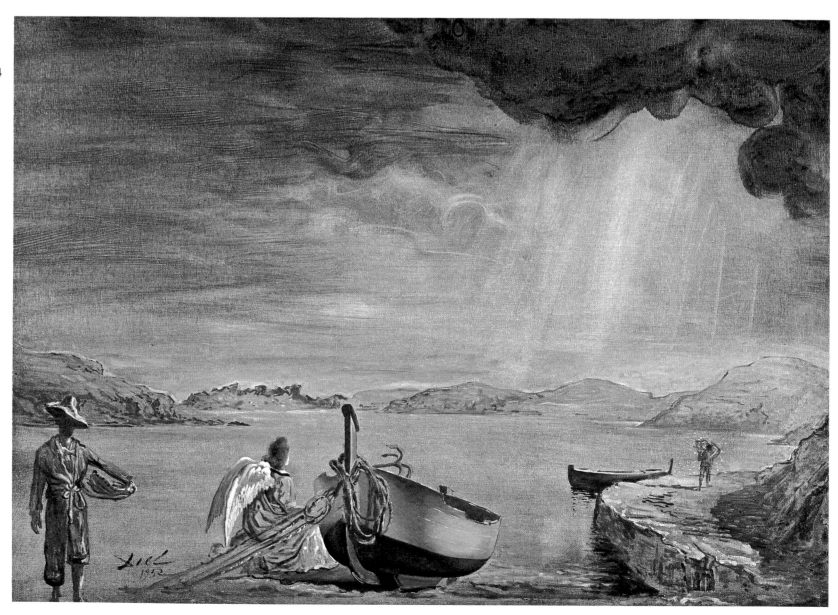

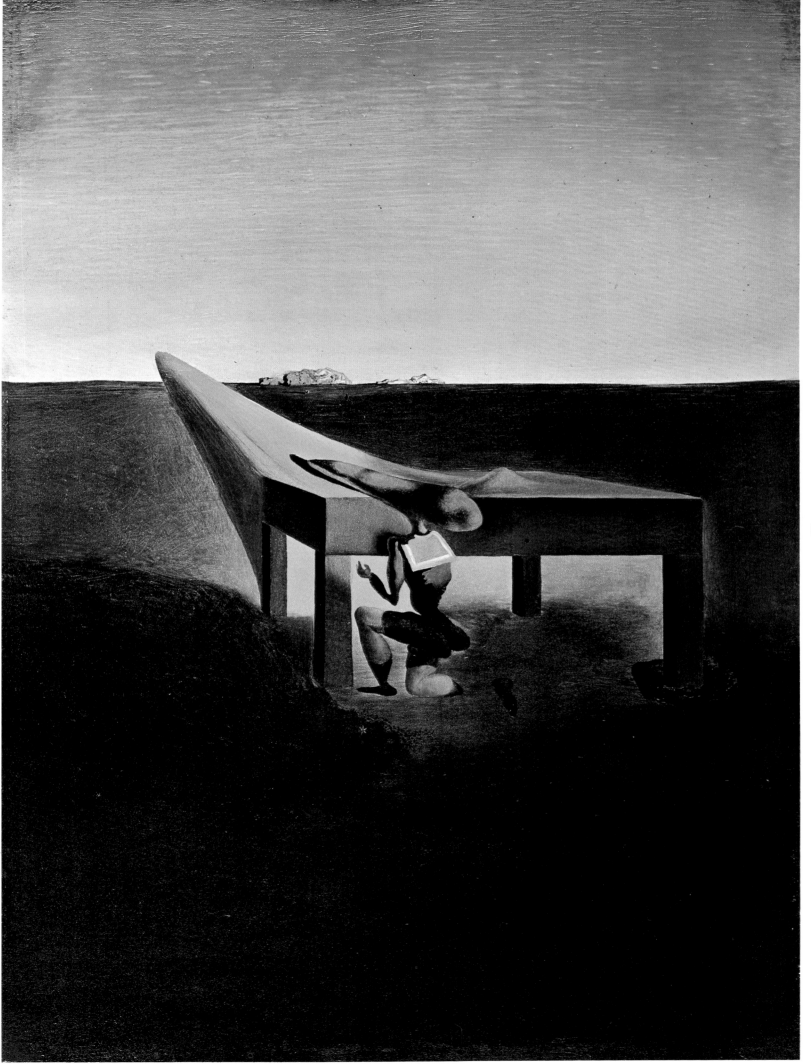

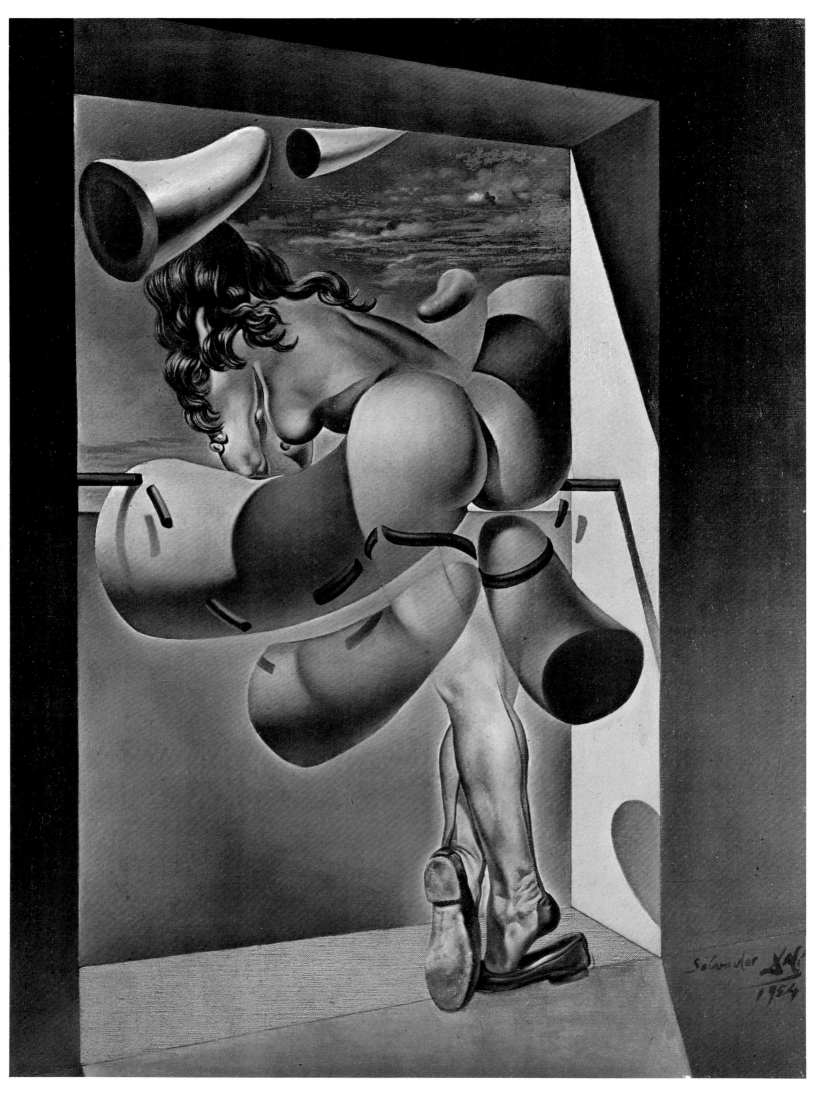

Désintégration rhinocérotique
de Phidias Illisos.
1954. Huile sur toile.
99 x 129 cm. (Coll. Privée).

Rhinoceros Disintegration
of Phidias.
1954. Oil on canvas.
99 x 129 cm. (Private Collection).

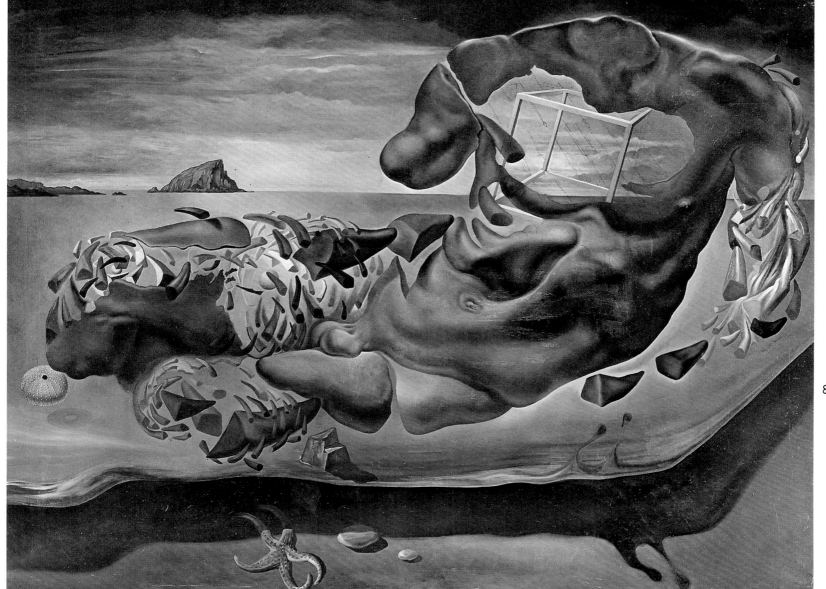

**Femme vierge auto-sodomisée par
les cornes de sa propre chasteté.**
1954. Huile sur toile.
*41 x 30 cm. (Coll. Carlos
B. Alemany, New York).*

**Young Virgin Auto-Sodomized
by Her Chastity.**
1954. Oil on canvas.
*41 x 30 cm. (Carlos B.
Alemany Collection, New York).*

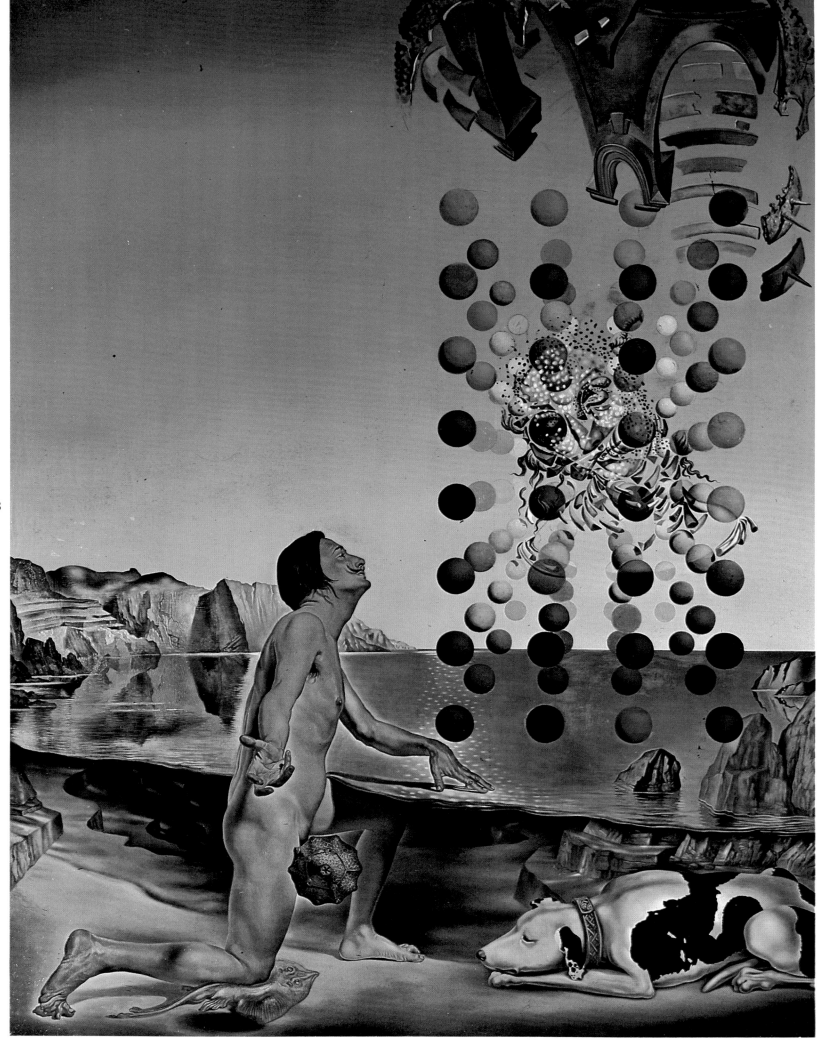

salvador dali, mythomaniac

by nicolas calas

Salvador Dali was born in Figueras, Spain, in May, 1904. His father, a native of Cadaques, was a notary. Rich and respected, this middle class man did not conceal his free-thinking anarchist opinions. The family spent long summers in Cadaques, a fishing village where they owned a home. Many of Dali's famous canvases show the Catalonian landscape that he cherished: the plain of Ampurdan, bathed in sunlight, the beaches of Rosas or the rocky crags off Cape Creus.

We cannot understand the complex, extremely personal, iconography in the best of Dali's paintings —those dating from the Surrealist period 1929-1936 —if we ignore his unbounded megalomania, his perverse, unrestrained exhibitionism, which impels him to reveal, in writing as in painting, the functioning of his disturbed ego. In this introduction we shall not try to distinguish fact from invention. The author of *Dali par Dali*[1] bitterly reproaches his parents for having "depersonalized" him from his infancy on by identifying him with his older brother, who died from meningitis three years before Dali's birth, and by giving him, in their sorrow, the name of the dead child, Salvador (Saviour), whom he resembled physically, according to them, like a "reflection in a mirror." In his parents' bedroom a large portrait of the older brother hung next to the portrait of another "cadaver," a reproduction of Velazquez's *Christ on the Cross*. Dali claims that because he was identified with the dead child throughout his childhood, his depiction of the body resulted in "that of a cadaver of soft flesh, putrified and in decomposition . . . of soft flesh and even of soft bone. The sexual obsessions are soft turgescences and not hard erections. . ."[2] Those flabby prolongations, those soft appendages require the support of crutches.

If we are to believe Dali's reminiscences, as pungently evoked in the famous *Secret Life of Salvador Dali*,[3] the child was a cauldron of perverse impulses and obsessions from his earliest years on: narcissistic, cruel, given to outbursts of hysterical rage, unable or unwilling to control his worst instincts, potentially and simultaneously homicidal and suicidal, he was, in addition, very intelligent and full of imagination. Many years later Dali would write: "From my early childhood, a depraved turn of mind made me regard myself as different from the common run of mortals. That still persists, and I have never failed to profit from it."[4]

Spoiled by parents who adored him, above all by his mother, he believed himself the ruler of the house, a belief reinforced by the gift he received of a splendid panoply including a cloak of "ermine," a gilded crown, a long wig, and a scepter. According to Dali, it happened that in the small room that served him as a "studio," a former washroom on the roof of the paternal home, the child, naked under his royal garments, contemplated his image in a mirror and became ecstatic because he found himself to be so handsome. He hid his penis between his legs to see what he would look like if he had been born a girl. (Dali recalls this fantasy in his painting of 1950 entitled: *Dali at Age Six when he thought he was a girl raising the skin from the water to see a dog sleeping in the shadow of the sea.*) Still, quite typical of the images he has produced of the child, Dali is the little boy dressed in a sailor outfit who is standing, with his back to the spectator, on a sunny beach next to his nurse, as in *Noon* (1936).

In the hottest weather, adorning his nudity with only a crown that he had jammed onto his head to the point of injury, he painted tirelessly, bringing to completion such ambitious paintings as *Jacob Blessing his Brothers,* and *Portrait of Helen of Troy.* (Dali's later drawings, which show him at work in the washroom tub, crowned but nude, exude a witty humor as in those generously sprinkled in his *Secret Life.* A few of them, however, are nauseating.)

Just for the fun of it, let us note that the child wet his bed until age eight. The series of his fetishes culminated in the omnipresent image of the crutch. The cicadas he loved in childhood suddenly inspired a phobia. His most persistant and most dangerous obsession attracted him to heights from which he could leap into space. Peasants have often spoken of the unbelievable leaps he used to make above the precipices; bruised and severely shaken, he nevertheless survived. But more difficult to control than his rural impulses, there dwelt in him a need to hurl himself from the tops of towers. We must add here that the transition to adolescence made an anarchist dominated by violently anti-social tendancies and a fanatical megalomaniac out of the "infant king": "My adolescence was marked with a conscious strengthening of all the myths, the manias, the talents and traits of genius roughed out in my childhood." And "I constantly repeated to myself: I alone! I alone!"[5]

The chapter entitled "False Childhood Memories" furnishes an initial link in that chain which, dramatically foreshadowed in the original account of "True Childhood Memories," ends with the crisis of imminent madness, criminal assault and the near miraculous salvation due to the only love in Dali's life: his Gravida in flesh and blood.

In the course of his only year of elementary school (which was of no value whatsoever to young Dali the dreamer, the arrogant loner), he had access to a kind of small optical theatre which provided him "a great measure of illusion." From the rapid succession of the images, Dali retained one that was unforgettable and destined to haunt him for years. It was a little Russian girl, swathed in white furs, fleeing on a sleigh through a countryside of snowy plains from a pack of wolves. Captivated by this character, Dali continued to think about her under the name of Galuchka—the diminutive of Gala, the name of his future wife. And the passionate wait for the miracle was rewarded: it snowed in Figueras. He saw snow for the first time in his life and, after walking with his mother, he saw, near the "discovered fountain,"

89

a young girl seated in the pose of Galuchka of the sleigh. The consequence was endless dreams of an encounter in Russia, including scenes of terror, trials, and bloodshed.

When he was barely nine, another feminine figure came to disturb his cherished solitude. He had only seen her from behind, among other friends, on the road to school. The nobility of her carriage, "a waist so slender and so fragile" that it seemed ready to snap at any second—that glimpse was sufficient; he had fallen under her spell. "The same sentiment of never-extinguished love that I had had for Galuchka was born anew; her name was Dullita, for that is what her two fervent and adoring friends called her constantly and in every tone of tenderness and passion. I returned home without having seen her face and without its having occurred to me to look at it. It was indeed she—Dullita, Dullita! Galuchka 'Rediviva'!"[6]

Back in his roof-refuge, Dali conceived the insane hope that she would come to join him there, free to imagine, in the extremes of contradictory feelings and bleeding from the nose as never before, acts of vengeance and remorse that he would feel. This hysterical reaction would not be worth mentioning were it not for its connection with events that followed immediately.

Concerned for the health of their son, whose nervous tension was increasing, Dali's parents decided a change would be advisable, and they sent Salvador to Muli de Torre, the family estate of the painter Ramon Pichot. From the moment Dali arrived, everything in that month of May and in the idyllic setting accorded with his fancy: the rite of awakening, knowingly well-ordered and carried out by a young girl adopted by the family; the exhibitionist Dali was completely naked when he welcomed her; the delicious late morning breakfasts that he took alone in the dining room that had walls covered with Pichot's impressionist paintings; the hours he spent in the large, whitewashed storage room that had been christened by Senor Pichot the studio of Salvador for the occasion. His precocious talent fully recognized, he enjoyed the greatest affection and

Accommodation of Desires.
1929. Oil and collage on wood panel. 22 x 35 cm. (M. Wright Collection, U.S.A. Photo by A. Frequin).

Dali, painting the image of "Medusa" on Gala's forehead. From series of photos by Philippe Halsman: Dali's famous mustache. *(Photo by Magnum).*

90

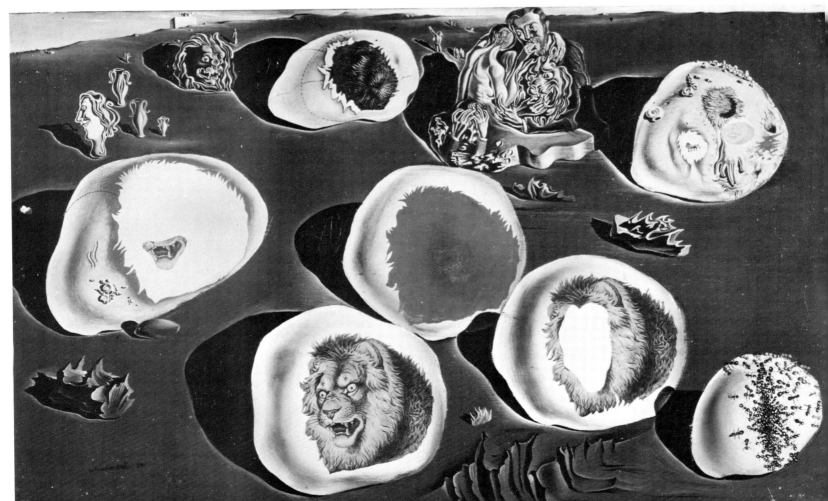

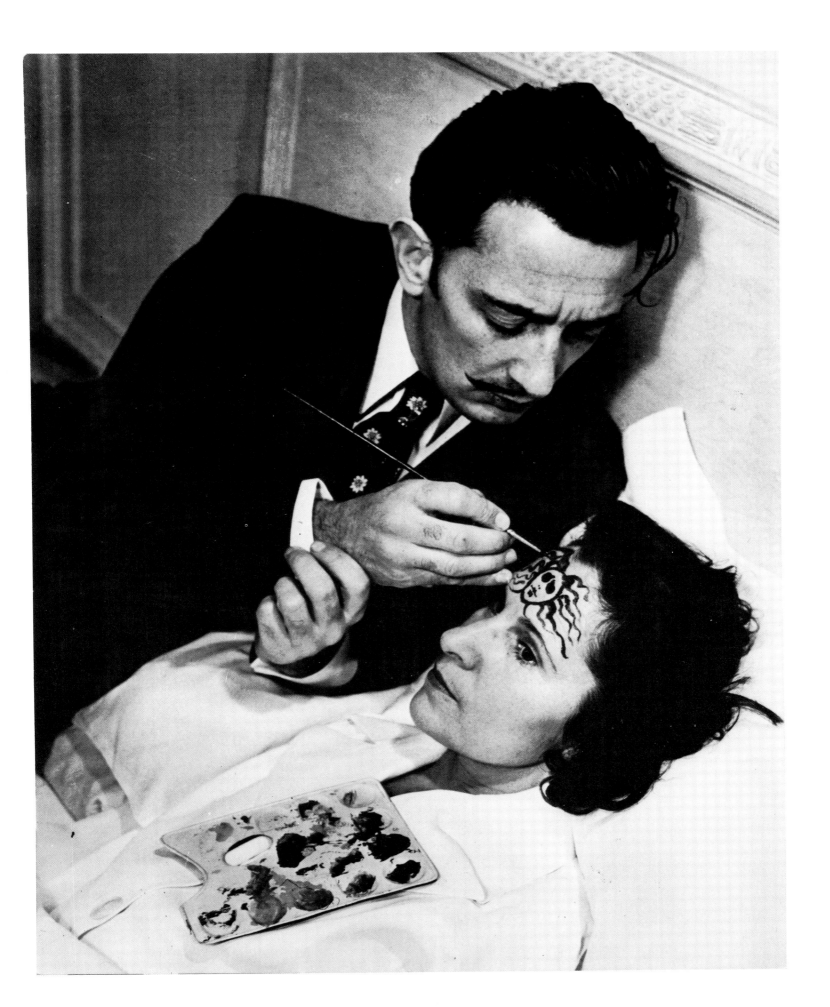

Crayon drawing.

complete freedom of movement. However, this period of serenity was only of short duration, for Dali was at the mercy of sado-erotic impulses that he had been unable to repress after his meeting with the little schoolgirl, Dullita, the one whose wasp-waist had so enchanted him that he had not even thought to look at her face.

It is impossible to unravel the maze in which Dali intermingles the real and the imaginary when recounting, a long while afterward, the three days that are the object of the chapter entitled "The Story of the Linden Blossom Picking and the Crutch."[7] In his account he takes pleasure in horrible and repugnant reminiscences. One morning Salvador found himself, for the first time, under the tower roof, having followed the workers in search of ladders for picking linden flowers. In the general disorder of the attic he spied a crutch: "I immediately seized it, knowing that for the rest of my life I would not be able to separate myself from it without explaining the reason why. The superb crutch! . . . The fork of the crutch where the armpit was supposed to rest was covered with a kind of fine cloth that was worn and scorched, on which I understood I could happily rest my caressing cheek or my pensive forehead. I went down to the garden . . . That object gave me an assurance and an arrogance that I had never yet been capable of."[8]

The women were already at work. The daughter of

one of them was there. Salvador approached her. The gamine turned her back to him. Instantly he thought that he was in love and identified her with Dullita. "The united images of Galuchka and Dullita had just become incarnate by the force of my desire for this other child . . . the three images of my delirium mingled in the indestructible amalgam of a single unique object of love."[9] Nevertheless, he terrorized her almost as quickly. "My first movement toward her undoubtedly betrayed such tyrannical intentions that I knew it would be difficult for me to regain her confidence." Noting with bitterness that his peace of mind, which had been gained with such difficulty, had burst into pieces upon the abrupt appearance of this new Dullita, Dali broke with daily routine and, instead of devoting himself to painting as he was in the habit of doing in the late morning, he went to inspect his "menagerie" of small animals in the chicken coop. Already extremely distressed at having committed this infraction of his rigidly imposed self-discipline, he had to face a vision in the henhouse, that was "one of the most frightening of its kind, of those that inhabit my memory," of a stinking, putrified carcass of a hedgehog. Possessed by a morbid obsession with putrification, he barely controlled his first impulse to trample the repulsive, decaying carcass all crawling with worms, and he began to hack at it with the forked end of his crutch. Too late the child un-

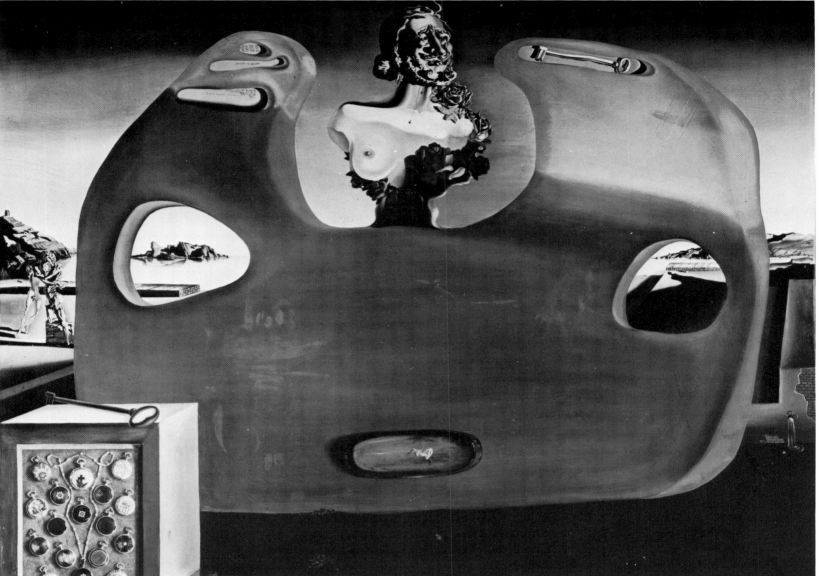

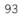

derstood that, in his frenzy, he had sacrificed his precious new fetish: the crutch in his hands had become an object contaminated by death. As he could not resign himself to that loss, he invented a series of complicated rites of purification which, the following day, culminated in the project of caressing with the forked end of the crutch—charming and foreseeable detail—the large globes of the "turgescent" breast of the most lovely flower of the linden tree, which was none other than the mother of the little girl. According to his personal conviction, if he were able to make the necessary maneuver, the desecrated crutch would again become his royal scepter. As this obsessional dreaming increased, the strategy increased in theatricality. He had to perform it completely in the nude, dressed only in his ermine cape, his crown and his crutch-scepter. The exasperation which grew as he waited for the right moment (the waiting seemed interminable to him), the increasing brutishness of his erotic sign language resulted not in the glorious satisfaction of his desire but in a confused defeat. But at least he was freed from the image of the turgescent breasts that had voluptuously obsessed him for two days.

It is the fragile waist of Dullita that had first caught Salvador's attention. It is that same waist he promised himself he would embrace and crush savagely when he concluded, at the end of three days of picking (linden tree flowers), that the young girl

was not behaving according to his desires. The episode, which tells of a narrowly avoided murder, begins at the moment when Salvador is skillfully displaying his dexterity at the game of diabolo and the girl, observing his prowess, begins to covet the object so she can try the game herself. The afternoon was disturbed by a spectacular storm during which the children took refuge in the attic and played an innocent enough love game, soon interrupted by Salvador's explosion of rage against Dullita, whose alleged crime was the attitude she had had while he was playing diabolo. He meditated upon the best way of punishing her and, more exactly, the best way of hurting her in the vulnerable small of her back. As the storm abated and the blaze of a picturesque sunset appeared, Salvador had another idea: persuade Dullita to climb to the top of the tower with him. She seemed intent on fleeing instead. Now dragged by the hair, now coaxed by the promise of the diabolo, she climbed the stairs leading to the platform and sat down on the parapet to look at the dizzying space that the sheer wall unfolded below her. With consummate hypocrisy, the boy covered his face with his hands, displaying such fright before her that the girl, as he expected, rushed to pivot and pass her legs to the other side of the parapet and dangle them in space. Surreptitiously, he came to stand behind her, the forked end of the crutch aimed at her waist. As she sensed the approach of the

Memory of the Child-Woman.
1932. Oil on canvas.
99 x 120 cm. (The Reynolds
Morse Foundation, Cleveland).

crutch, Dullita turned around and leaned her back against the fork. This movement so disoriented Salvador that he was spared liability for a murder. The girl was saved. Wracked with sobs, he tore the diabolo from Dullita's hands and threw it into space with all his strength. The sacrifice of substitution was accomplished. In a note Dali adds that, in this case, the crutch symbolizes the death of Dullita, Galuchka Rediviva, and the possibility of their resurrection as well *(Ibid.* p. 111).

In the spring of 1929, upon his return from one of his first trips to Paris, Dali had, under the rediscovered sun of Cadaques, the premonition, the conviction, that he would know love that summer. The loved one would be none other than the Galuchka of his early childhood dreams, Galuchka Rediviva, she who advances henceforth provided with a woman's body. All the fantasmagories and images of his childhood again possessed him, erasing all the intervening years as if they never were. He begins a painting (later known by the title of *Lugubrious Games*) that he devoted exclusively to the summing up of the images of this childhood, scrupulously reproducing each one of them and relying, for the composition, on the automatism of associations, without any intervention by reason or esthetic consideration on his part.

"The irrational to the aid of the irrational" becomes Dali's credo. Dali was fully aware of his growing psychological abnormality, but instead of striving to combat it, he welcomes and stimulates the phenomenon of madness. He abandons himself to uncontrollable and irritating crises of insane laughter. Among the interventions that provoke these outbursts of hysteria a little sculpted owl wins renown, perched on the head of certain people it knows and carrying on its own head a bit of excrement, a piece from Dali himself. It is in this state of quasi-dementia that Dali finally encounters his long-awaited, ardently desired Gravida. She arrives in Cadaques in the person of Gala, the wife of Paul Eluard.

Dali ran toward her but was taken by hysterical laughter every time he tried to speak to her. While the members of the little Surrealist group that had preceded Gala to Cadaques seemed resigned to their friend's abnormal behavior, *Lugubrious Games* again sowed trouble and consternation among them. They believed they saw in a detail of the painting a possible tendancy to coprophagy: a man was represented as wearing underpants spotted with excrement. It was Gala who undertook to establish the truth on this point. She proposed a walk to Dali, during which he restrained poorly his inclination to laugh. She greeted his protestations with great seriousness when he told her he was unable to repress his hysterical outbursts of mirth but that that did not stop him from listening to her or answering her as best he could.

This stroll alongside the rocks proved to be—retrospectively—the turning point of Dali's life. In-

tuitively Gala grasped the real significance of those painful paroxysms of laughter: they arose from the cataclysmic depths of terror and despair. He fell at her feet. She promised him that she would never leave him. When the Surrealist friends, Eluard included, decided to leave, Gala stayed at Cadaques.

At twenty years of age Dali had never made love and, in his mad desire for Gala, the idea of not being able to measure up to what she would expect of him plunged him into the greatest confusion. He felt that the "great test" of his life was approaching and that the hour of "sacrifice" had inexorably come. In a painting that he had already begun, *The Accommodation of Desire,* desire was represented by the terrifying image of lions' heads.[10] At the beginning of their relationship, Dali, tormented by unsatisfied erotic desires, was in a highly pathological state that threatened to destroy Gala's innate stability: to her self-assigned task of restoring Dali's mental health was opposed the illusory identification he was effecting between Gala and the imaginary Galuchka, the fear that the actual presence of Gala would bring about his own "depersonalization" and disturb the solitude that was so essential for him (a recurrence of his grudge against little Dullita); similarly, his insistence on excursions to the summits of the steepest rocks, where either he or Gala risked being overwhelmed by dizziness, an insistence that he had to admit was not free from criminal intent on his part. Gala sensed the danger. The culmination of the crisis was reached one evening when they were seated on the edge of a lonely rock ledge. Dali has recounted the episode: "I pulled Gala backward, grabbing her by the hair, and trembling with hysterical rage, I commanded: 'Now tell me what you want me to do to you. But tell me slowly, looking me in the eye, with the most ferociously erotic words that can make both of us feel the greatest shame!' "[11]

Calmly, resolutely, Gala asked to die by his hands. Instead of the ardent proposition he had expected, he received the offer to satisfy the depraved need that had secretly tormented him his whole life long, the need to respond to the call of the "vicious precipices." Baffled by such an assessment of the potentialities of his madness, he promised Gala the death she demanded, when in fact he felt himself totally disoriented. The criminal designs that had obsessed him disappeared almost immediately—for the rest of his days. Finally joined by the flesh to his Gravida, Dali emerged from his pathological state, entirely owing his salvation, as he recognized, to Gala's intuitive treatment, to the strength of her love—which he summarized seven years later, with all his lucidity regained, in these terms: "She was destined to become my Gravida, 'she who advances my victory,' my wife. But to do that, she had to cure me, and she did cure me!"[12]

At the end of 1929, Dali went to Paris for an exhibition of his work at the Goemans gallery which supported the Surrealists. The event created a sensation. (We shall not comment here upon Dali's

Lugubrious Games.
1929. Oil and collage on
wood panel. 45 x 37.5 cm.
(Private Collection).

95

Gala Nude from the Back Look-
ing in an Invisible Mirror.
*1960. Oil on canvas. 42 x 32 cm.
(Dali Museum-Theatre, Figueras).*

96

cinemagraphic output: *Un Chien Andalou* (1929),
and *L'Age d'Or* (1931), made in collaboration with
Bunuel.) Dazzled by his growing success, deeply
committed to his love affair with Gala, Dali
withdrew gradually from his family, although he felt
much remorse about it. Dali's exploits, and the
resounding echoes that accompanied them in the
press, in addition to his liaison with another man's
wife, had brought about a total revulsion in his own
family (his father and sister that is; his adored
mother had died several years earlier). After some
painful scenes, for which Dali some time later
properly assumed the blame, his father disowned
him and banished him from his childhood home.
The break was the logical outcome of the increasing-
ly serious disappointments Dali had caused his
father when Dali was a student at Beaux-Arts in
Madrid, by his provocative and uncompromising
behavior, his exhibitionist dandyism, his disdainful
attitude toward the money with which his family
was barely able to pay his debts and, finally, his be-
ing expelled from the Ecole des Beaux-Arts just
before obtaining the diploma. So he would not have
to stir up this not very bright past in public, Dali has
never given the exact reason for the final break.

NICOLAS CALAS

Luis Bunuel with a Bullfighter.
*Drawing. 18.5 x 23 cm.
(Fanny and Salvador Riera
Collection, Barcelona.
Editions Poligrafa, Barcelona).*

Notes:
1. Salvador Dali, *Dali by Dali*, Harry N. Abrams, New York
 1971, Introduction by Pierre Roumaguere, Pp. I-VII.
2. *Ibid.,* p. VII
3. Salvador Dali, *The Secret Life of Salvador Dali*, Dial Press,
 New York. Translated from the French by Haakon M.
 Chevalier. *La vie secrete de Salvador Dali*, la Table Ronde,
 Paris 1952, French adaptation by Michel Deon.
4. *Dali par Dali, op. cit.*
5. *The Secret Life of Salvador Dali, op. cit.*, p. 116.
6. *Ibid.,* p. 75.
7., 8., 9. *Ibid.,* Chapter entitled "The Story of the Linden Pick-
 ing and the Crutch," Pp. 89-111.
10. Salvador Dali, *Dali*, Harry N. Abrams, New York 1968. Adap-
 tation by Max Gerard. Translated from the French by
 Eleanor R. Morse (Draeger ed.). Unpaged. 150 pl.
11. Dali, *The Secret Life of Salvador Dali, op. cit.*, p. 243.
12. *Ibid.,* p. 233.

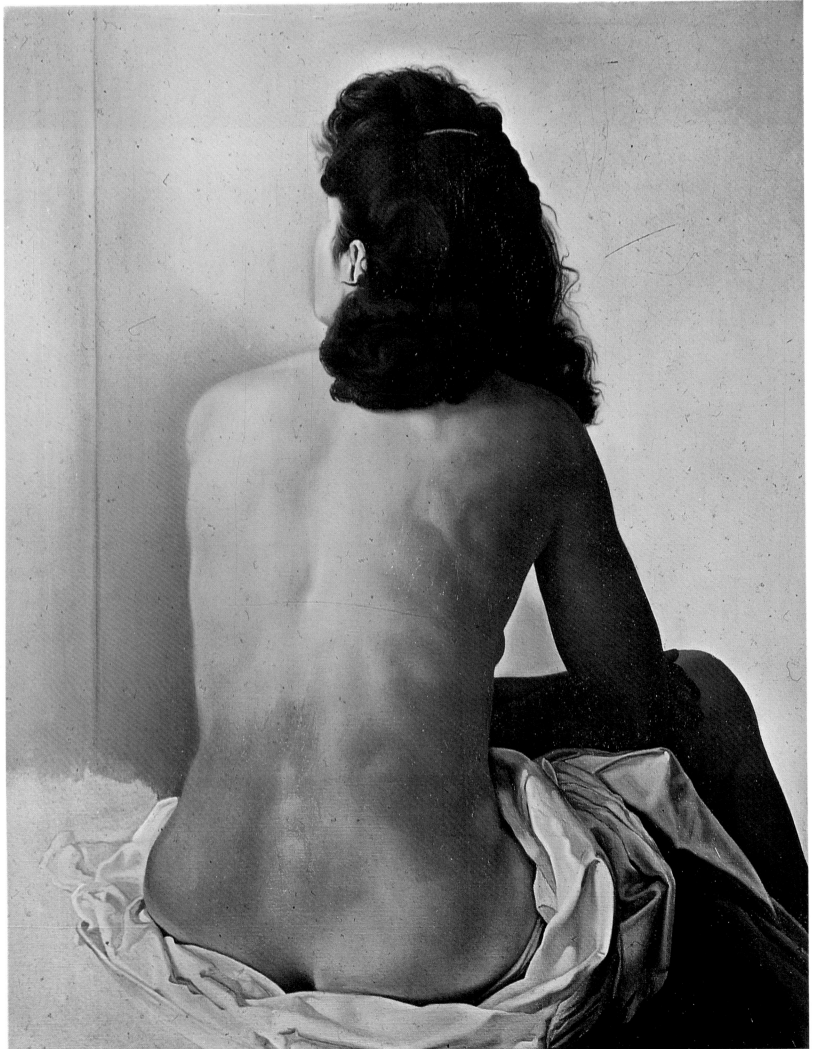

Abraham Lincoln.
1976. (Théâtre-musée de
Figueras. Photo M.W. Daouse).

Abraham Lincoln.
1976. (Dali Museum-Theatre,
Figueras. Photo: M.W. Daouse).

Galacidallahcides-oxyribonucléides.
1963. Huile sur toile.
305 x 345 cm. (Coll. N. England
Merchants National Bank,
Boston, U.S.A.).

Galacidalacideoxyribanucleic Acid.
1963. Oil on canvas.
305 x 345 cm. (N. England
Merchants National Bank,
Boston).

98

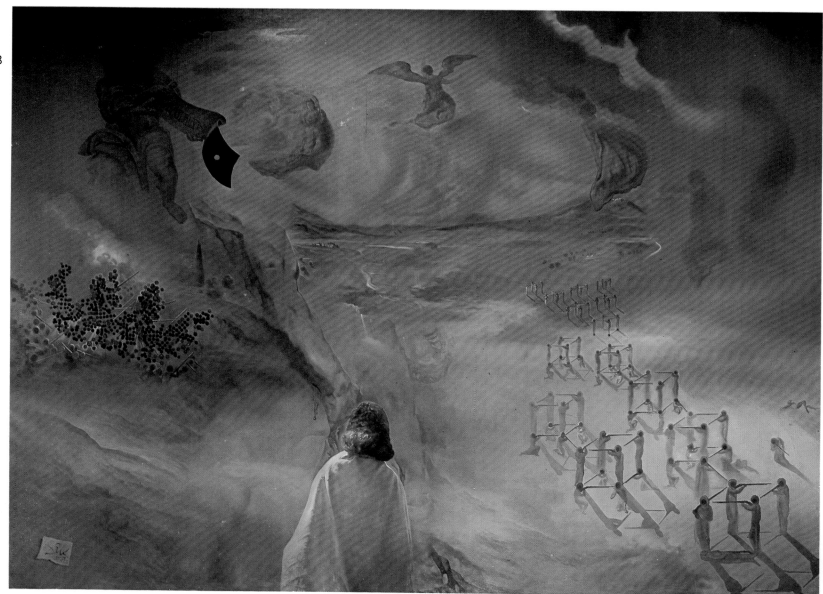

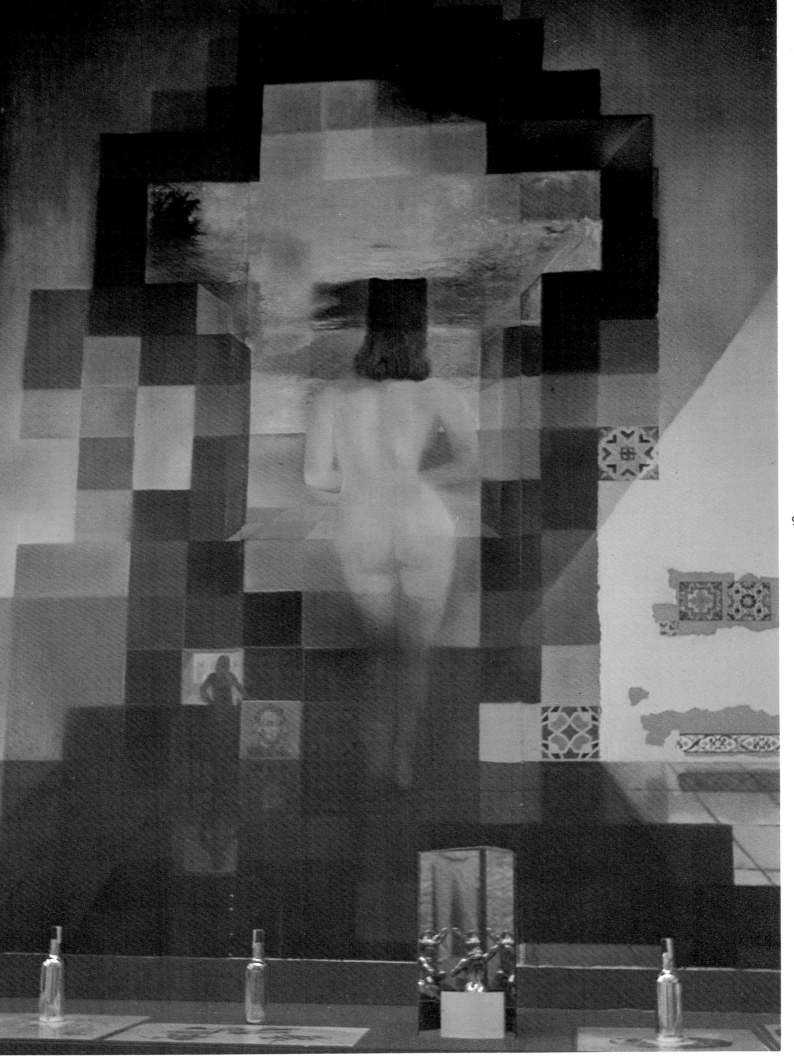

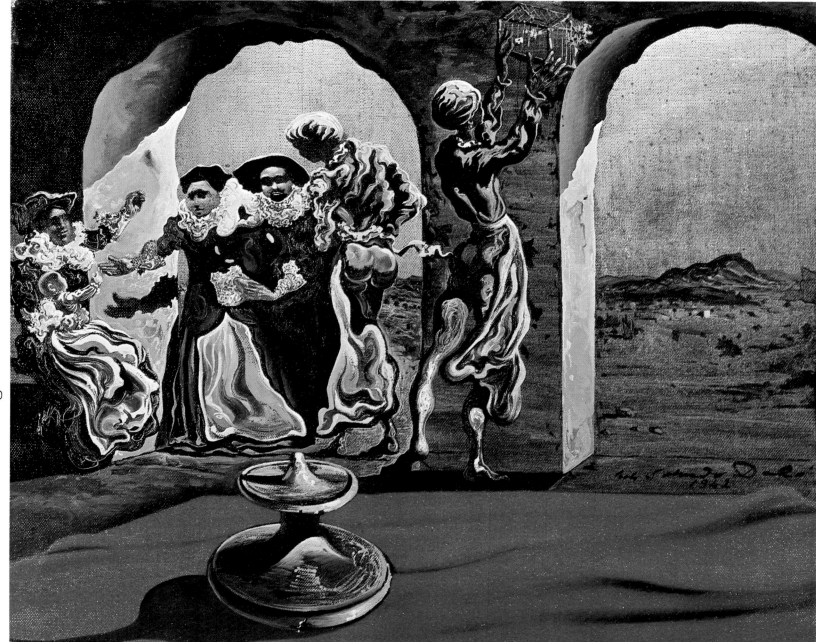

Le buste invisible de Voltaire.
(Detail). *1941. Huile sur toile.*
16.3 x 55.2 cm. (Coll A. Reynolds
Morse, U.S.A.).

Disappearing Bust of Voltaire.
(Detail). *1941. Oil on canvas.*
16.3 x 55.2 cm. (The Reynolds
Morse Foundation, Cleveland).

Le marché d'esclaves avec apparition du buste invisible de Voltaire.
1940. Huile sur toile.
46.5 x 65.5 cm. (Coll. A.
Reynolds Morse, U.S.A.).

Slave Market with the Disappearing Bust of Voltaire.
1940. Oil on canvas.
46.5 x 65.5 cm. (The Reynolds
Morse Foundation, Cleveland).

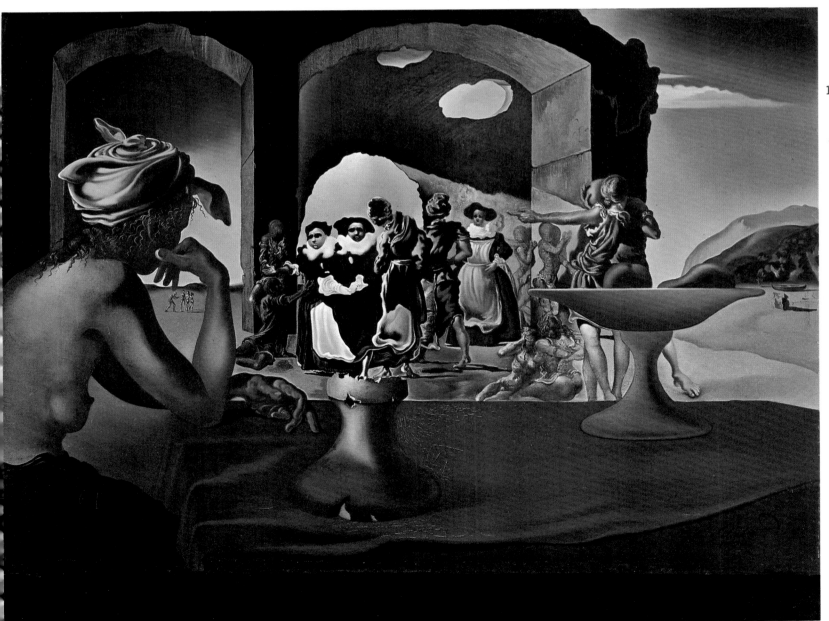

Vieillesse, Adolescence, Enfance.
1941. Huile sur toile.
50 x 65 cm. (Coll. A.
Reynolds Morse, U.S.A.).

Old Age, Adolescence, Infancy
1941. Oil on canvas.
50 x 65 cm. (The Reynolds
Morse Foundation, Cleveland).

102

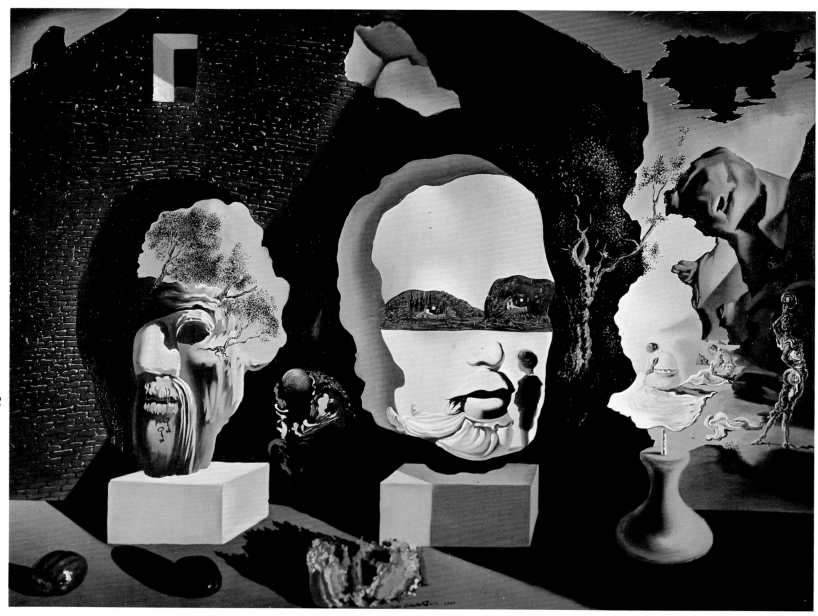

Décor du Musée-théâtre de Figueras.
1976. (Photo M.W. Daouse).

Detail of a mural in **Dali's**
Museum-Theatre in Figueras.
1976. (Photo: M.W. Daouse).

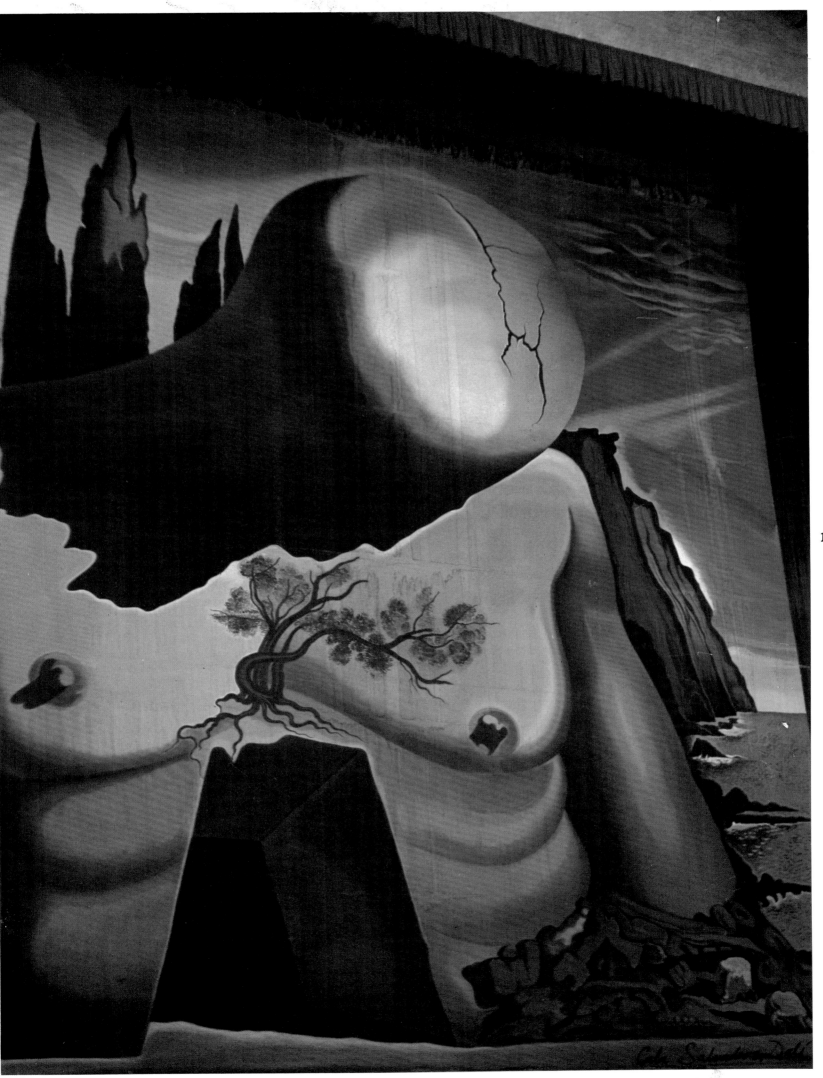

**Vitesse maxima de la
Vierge de Raphaël.**
*1954. (Coll. A. Reynolds
Morse, U.S.A.).*

**The Top Speed of
Raphael's Virgin.**
*1954. The Reynolds
Morse Foundation, Cleveland).*

104

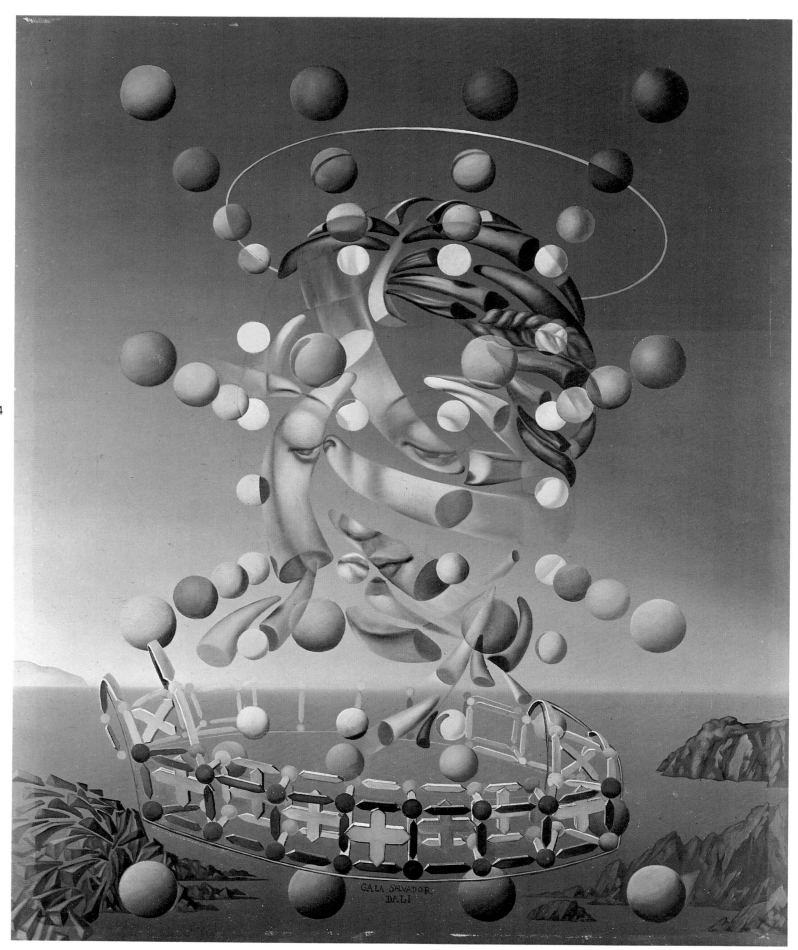

the great game of paranoia

by wolfgang sauré

From his earliest days, Salvador Dali was so profoundly marked psychologically by the death of an older brother that he had the impression he was able to live only because that brother died before him. The dead brother heavily aggravated Dali's castration anxiety and intensified his Oedipus complex, thereby helping to create a paranoid personality in Dali. In the lecture that the painter gave at the Ecole Polytechnique in 1961 he himself said in this connection: "All the eccentricities that I am accustomed to perpetuating, those incoherent exhibitions, are the tragic constant of my life. I want to prove to myself that I am not the dead brother but the living brother. As in the myth of Castor and Pollux, by killing my brother it is myself whom I immortalize." In this curious avowal, self-analysis and myth-formation are allied in a way that is quite characteristic of Dali's mind.

He feels able to consider himself an immortal genius to the extent that when he does so he brings to bear the proof that he is living, as opposed to his dead brother. This doubling of the ego is characterized by a narcissistic and hybrid overvaluing of the living ego in relation to the dead ego. And in the process, the brother's death is in some way transposed into the murder of the dead brother by the living one, then reinterpreted like the ancient legend. Thus Dali saves himself from the death wish generated by the situation.

This very early contact with death caused him a painful narcissistic injury with all the disorders resulting from an actual psychic imbalance. The brother, who also bore the name Salvador—a magic and fatal name—had died of meningitis at the age of seven, three years before the artist's birth in 1904. In his autobiography Dali writes, "Desperate, my father and mother found solace only upon my arrival in the world. I resembled my brother as two drops of water resemble each other: same aspect of genius, same expression of disturbing precociousness. We differed, however, in certain psychological traits and in the look in the eyes; his gaze was veiled with that melancholy of insurpassable understanding. I was much less intelligent, though on the other hand, I reflected everything."

The intellectual value of the dead brother stands out in the way Dali defines the values of his superego and, in this step, the idealized intelligence of the dead person is presented as unsurpassable. Dali then feels himself called into an intellectual competition in which he finds an indirect means of claiming a superiority in regard to his brother by styling himself as a mirror. The simile exists at several levels. Dali the mirror first reflects Dali himself by a narcissistic mechanism. But it also shows, for the same reason as that objective mirror gaze to which Freud compares the psychoanalyst, the dead brother as a double. According to Otto Rank, the double symbolizes originally a form of assurance against the loss of the ego, an "energetic denial of the power of death," (Der Doppelganger," *Imago* III. 1914) and in the primitive world of magical representations, the brother's immortal soul has inevitably also strengthened the castration anxiety. To protect himself, playing upon these two interchangeable egos, Dali lays claim to the role of the immortal double of his dead brother. The process unfolds at the stage of primary narcissism that dominates the inner life of the child as well as the life of the primitive. At later stages of development, the double, guarantor of survival, becomes, on the contrary, the disquieting harbinger of his own death. These broad principles of interpretation will perhaps allow us a better understanding of the way the death of the older brother gave rise in Dali to obscure and contradictory impulsive movements that he was not able to perceive so long as he was a child. This is the reason why he reacts in the most extreme and most violent way, with alternating phases of passivity and depression. It was only after he had reached adulthood that, with the help of Dr. Pierre Roumaguere who also helped assure the publication of writings on the paranoiac-critical method, Dali succeeded in retrospectively interpreting these psychological processes of childhood.

It could be said that Salvador Dali arrived in the world double. His birth was greeted by his parents with a joy mixed with sorrow. This newborn infant

Portrait of my Dead Brother.
1963. Oil on canvas.
175 x 175 cm.
(Private Collection).

105

Paranonia.
*1936. Oil on canvas.
38 x 46 cm. (The Reynolds
Morse Foundation, Cleveland).*

106

Birth of Paranoiac Furniture.
*1937. 62 x 47 cm. (Edward
James Collection, Sussex).*

caused the rebirth of the hopes awakened by the vanished older son. This son thus found himself faced with a difficult task, for his parents already possessed an invisible scale of values, hopes and comparisons, calculated to immediately cause deep feelings of guilt in his unconscious. Dali's desperate desire for self-affirmation is translated into an unbridled conduct that often goes beyond the limits permitted by society. The reverse side of these excesses is an unhealthy timidity engendered by feelings of insecurity, a timidity that leads him to tyrannize his entourage in order to be sure of dominating it. That did not stop his father from overwhelming him with an excess of love to the point where Dali the child must have had the impression that this passion was directed not only to him but to his dead brother as well: "It is because of that Salvador that I was the beloved who was loved too much. For the small child there can be no shock more catastrophic than too much love, and this too-much-love-because-of-another-self I was going to resent violently and to the extent that the symbiotic and indifferentiated world of the early years permits."

This excessive fondness on the part of the father suggests a certain neurotic disposition that the child perceived, confusedly no doubt, despite the love that he bore for his father in return. So he felt himself doubly plunged into insecurity. The fact that the parents spoiled him much too much causes in his distress a still greater anxiety about being abandoned if ever he happened to lose—as he fears—his parents' love. With the libidinous there also develop feelings of hostility toward his father, reinforced by jealousy of the presence of his transfigured dead brother. In this environment so favorable to incest fantasies, the young Dali attaches himself to his mother with all the impulsive force of his Oedipal desires, all the more so because he fears castration and feels threatened by that father who was perhaps responsible for the complete castration the death of his brother represents. The young Dali has only one solution: flight into regression and fantasies of the intra-uterine life. "I was going to become the prototype par excellence of the 'perverse polymorph,' phenomenally retarded, preserving intact all the reminiscences of heterogeneous paradises of the nursing infant. I clung to the pleasure with an egotistical relentlessness that had no limits and at the slightest annoyance, I became dangerous. . . . I was therefore capable of living, without a doubt. My brother had been only a first trial of myself, conceived in too great an absolute."

This youthful self-portrait is interpreted by virtue of the psychoanalytic expressions which he uses, however, in a very original manner, in a poetic-Dalian mode. He became interested in the works of Freud in the course of his art studies in Madrid, and psychoanalysis radically upset and considerably enriched his life. The first Freudian text he read was *The Interpretation of Dreams,* which exerted a deep

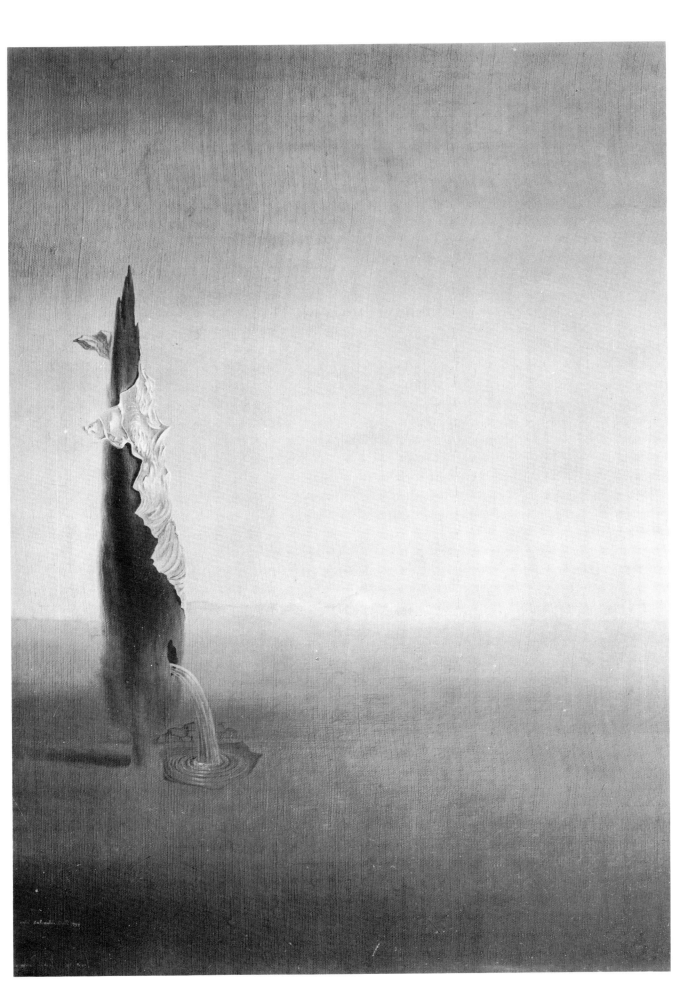

Birth of Liquid Anguish.
1932. Oil on canvas.
55 x 38 cm. (The Peggy
Guggenheim Collection).

107

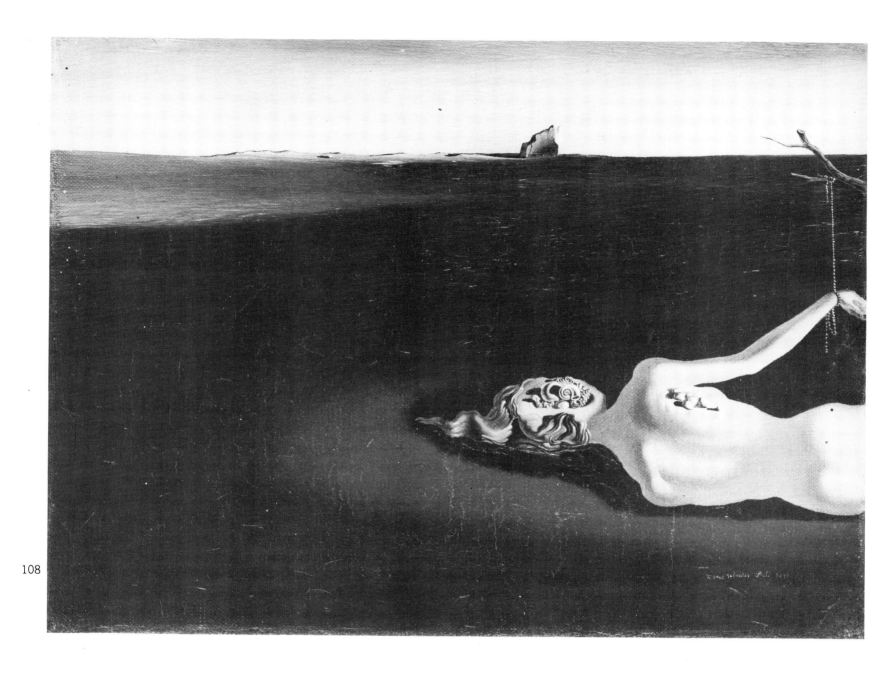

Woman Sleeping in a Landscape.
1931. Oil on canvas. 28 x 35 cm. (The Guggenheim Museum, New York).

and lasting influence on him throughout his lifetime. From then on he was in the habit of analyzing his dreams, interpreting them in order to establish possible relationships between his acts, his fantasies, his impulses and his creative undertakings. He acquired a certain mastery in this mode of investigation, and the results can be found in his writings, to the point that certain passages seem to be actual transcriptions of his introspections. Yet when he uses terms like "genius" in regard to his brother or calls him "the absolute"—key words in Dali's mythical universe—we get the impression that he is projecting his own megalomaniacal hallucinations. As a matter of fact, the rivals for their parents' favor arose above all ambivalent feelings of deference and hostility, love and jealousy. What is more, the exaggerations so characteristic of Dali, which are nothing more than hidden fears of latent homosexuality and of open glorification of the ego, do not exclude, in correlation with the anxiety of castration, a strong identification with the illness and death of the other brother. The cadaver of Salvador Dali I and its putrification pursue Salvador II in his dreams and have undoubtedly been at the source of the initial ideas of necrophilial representations that are so often found in the Dalian universe. The death also gives birth to fantasies of redemption further reinforced

by the fact that Dali bears the name of Salvador—the savior—and lives in a Catholic milieu where the image of the crucified Redeemer (by Velazquez) is present before his eyes every day. In the process of internalization, Dali resuscitates the dead child in the form of an imaginary child, and it is only one step from the identification with the child to hallucinating genius.

This death Dali's imagination relates through outbursts of melancholia, feelings of emptiness and morbid visions. At school he attracts the attention of his entire class by an absentmindedness that lasts for hours and is the product of the gloomiest daily dreams. He amuses himself by jumping from dangerous heights, takes pleasure in throwing himself into space and placing his life in danger. He lives entirely in the imagination and seems to have almost no contact with reality. In the eyes of his classmates, he is a phenomenon full of contradictions, heroic, inveterate eccentric, pathological liar, or quite simply ridiculous. They make fun of him but can't help admiring him.

Dali's pictorial universe, with its arsenal of phobic fetishes—the soft watches, the crutches, the grasshoppers, the teeth, the excrement, the flies or the stairways—with its myths and its themes of fear and anxiety—William Tell, Millet's Angelus or the

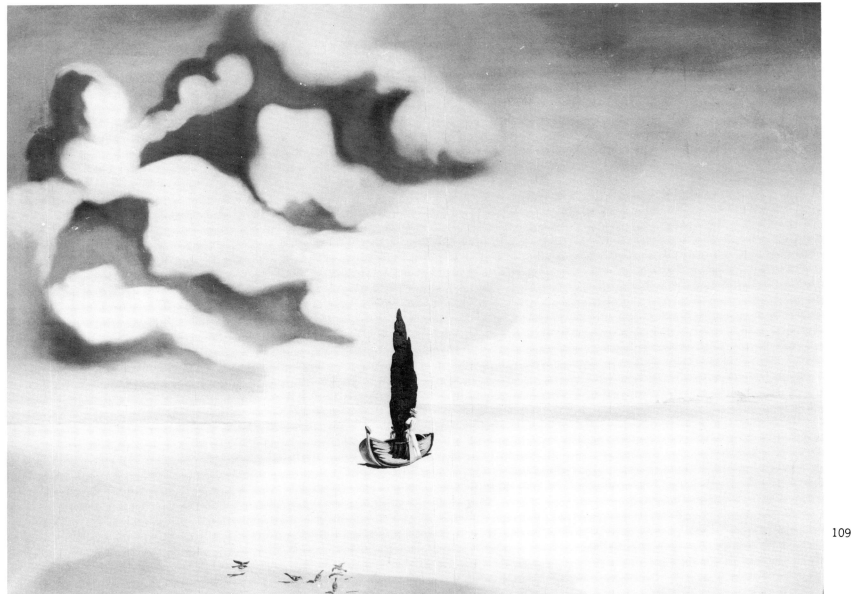

bifurcation and even the deserted lunar landscapes whose empty and infinite horizons express the nostalgia of some lost paradise—all these pictorial themes can be interpreted as delirious projections of Oedipal desires, of traumatism from the duality between the dead brother and the living brother and of castration anxiety. But what about the form and the nonpsychological reality of the paintings? For a work of art cannot be entirely explained by psychoanalysis alone. The manifestation of the unconscious and of its projections in the work of art is but one aspect and should never be considered anything more than a useful accessory in the esthetic study of form, which is not within the scope of our study here. In *The Persistence of Memory* or *Agnostic Symbol* the soft or liquid watches evoke intrauterine forms: they are simultaneously symbols of timelessness of the unconscious and pictorial archetypes. As Oedipal signs of the dream universe, they form a magical contrast with the broken lines of the background of rocks, translating the menace that weighs upon life after the trauma of birth. The theme of "William Tell" shooting at the apple placed upon his son's head is an expression of all the difficulties that put the notary, Dali's father, in opposition to this son. The pictorial motif of the grasshopper is simply born of the fear experienced by

the child Dali in the face of this animal. Considered as an insect, by all that it has in common with the spider, the image of the grasshopper can be interpreted as the symbolic representation of the phallic mother in the dream world. Perhaps then Dali's phobia masks his terror of incest with the mother and his horror of the woman's genitals. Shouldn't the same motivation then explain the image of the head of Medusa that Dali recaptures in multiple forms in his work.

The myth of bifurcation, which came to mind quite early, following Dali's observation of a lizard with two tails, one very long and normal, the other atrophied, embryonic, "leaving between them that void which only the madness of my imagination would one day be capable of filling," is a veritable crossroads of all the Dalian deliriums. The two tails may symbolize the two brothers separated from each other by the void and by the silence of death. But this void may also be interpreted as the expression of Dali's own sexuality, which he perceived to be castrating, as perhaps confirmed by one of his simultaneously morbid and autoerotic experiences: one winter day, after swimming at Port Lligat (on the Costa Brava, near his house in Cadaques) he was seized by trembling and upon leaving the water he instinctively placed one hand over his heart and the

Apparition of my Cousin Carolinetta on the Beach at Rosas (detail). *1934. Oil on canvas. 73 x 100 cm. (The Martin Theves Collection, Brussels).*

other over his genitals, which gave off "a pleasant odor that seemed to me to be that of my own death," he wrote.

The themes of magic, of emptiness, and of the enchantment of infinite space painted in red, orange, yellow and blue, soft and supernatural colors symbolizing for Dali the intrauterine paradise, give their title and their meaning to two important paintings of neo-greco Surrealist style, *The Echo of the Void* (1952) and *The Birth of Liquid Anguish* (1932). In the first painting the image of the void of space is provided by a massive rock and some cleft cypress trees. A woman in a long dress walks like a phantom at the edge of a chasm. It is possible to see in her an allusion to the character of "Gradiva," the survivor of Pompei whom Dali knew through the famous in-

terpretation that Freud gave to the German novel of the same name by Wilhelm Jensen. The fascination rests in the contrast between the beauty of the perfect harmony of the world and the threat of destruction forever imminent, symbolized by the lightning-struck cypress trees. The other composition, *The Birth of Liquid Anguish,* shows a cypress tree covered with a yellow veil in front of which a stream of water flows to a basin. In the background, in an iridescent whitish light, there appears a mountain with a woman's bosom, the primary object of the infantile libido, fantasmatic transformation of incestuous desires. The painting is bathed in an aura of great sexual anguish. The motif of the spray of water escaping from the tree stems from urethral eroticism. The vagueness in this image further accentuates the romantic atmosphere that is created by ideas of mourning and of escape from the world, born of a psychotic dissociation in the search for themes that the artist uses next, in a very deliberate way and for clearly-defined ends. The alliance of fantasies from infancy with an accomplished technique likewise constitutes one of the fundamental traits of this technique of association: it is not a clear and conscious content but a repressed material that art expresses in an elaborated mode.

Space, which occupies such a crucial place in Dali's work, is a projection of the extension of the individual's mental apparatus. Thus the inner tensions find the means of spreading out. The fear of nothingness experienced through the voids of space was already displayed by the young Dali when his parents took him to visit the Guell Park in Barcelona. This park contains huge cacti made of stone, somewhat reminiscent of large exotic insects (grasshoppers). The child was four years old and the spaces left between these trees of stone inflicted upon him "unforgettable terrors" that might be connected with an agoraphobic form of hysterical anguish. It must be supposed that an impulsive Oedipal need transformed into a self-destructive impulse tinged with masochism and taking on a hidden feminine meaning is expressed through this anguish.

Several years later, at Figueras, Dali at the age of six is literally fascinated by two large cypress trees that he looks at and observes for hours at a time from the classroom window. It is like a fixation that can be interpreted by the fact that the two trees cause him to relive the transformation of the living brother and the dead brother. In addition, as we have said, there appears later in Dali's painting cypress trees that unfailingly symbolize the erection but are almost always struck by lightning, which expresses the anguish of death and castration. Dali especially enjoys the sight of cypress trees at the end of day, at sunset, when a play of shadow and light vibrates in slender vertical silhouettes. The extreme tip of the cypress on the right takes on a yellow-orange coloration in the gloomy light of the evening, a light such as is found in many of Dali's paintings of the thirties. Of the cypress trees on the left nothing more than a

Ambivalent Image.
1933. Oil on canvas.
65 x 54 cm. (Andre-Francois
Petit Collection, Paris).

110

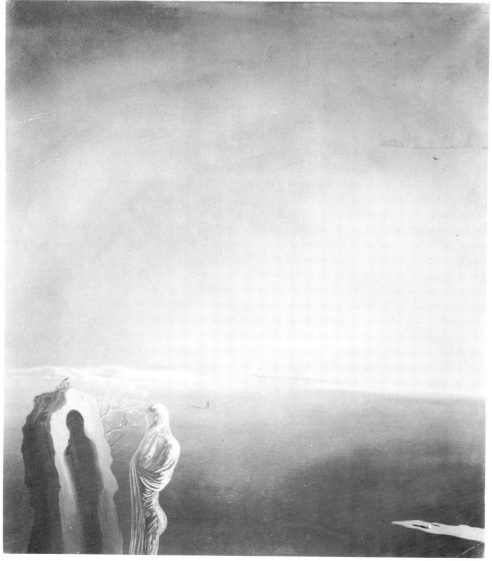

shadow of a dead tree is visible. This vision is solemnly crowned by the ringing of the Angelus. This memory of Figueras leads by an act of association to the paranoiac-critical interpretation of the famous "Angelus" by Millet, which Dali considers one of the richest and most delirious paintings. Over the years, the thought of the space separating the two praying peasants stays with him—he attributes their fervent posture to a secret eroticism—and he imagines the presence of a dead son buried between these two characters. In fact, Dali had an x-ray made of the painting in the Louvre on the strength of his suppositions, and it reveals at the area in question a drawing of a kind of case that Millet had concealed and covered with paint. In this confirmation Dali sees the proof of the value of the irrational intuition that presides over his paranoiac-critical analysis.

The two cypress trees of Figueras inevitably bring to mind the self-portrait of 1921 in which the right side of the face is emphasized with a luminous blue while the left side shades off, empty and almost lifeless. The dead brother follows the living brother like his shadow.

Along with a great sensitivity—we could say that the painter is, just like his dead brother, a decadent in the Nietzschean sense of the term; that is, he is endowed with a subjective differentiation approaching depersonalization—the young Dali manifests abnormal cruelty. Freud interprets cruelty as a component of the sexual drive, above all at the stage of pregenital development, traces of which are found in the adult. With Dali there is undeniably a

Young Dali with his Father.
About 1971. India ink.
(Editions Poligrafa,
Barcelona).

111

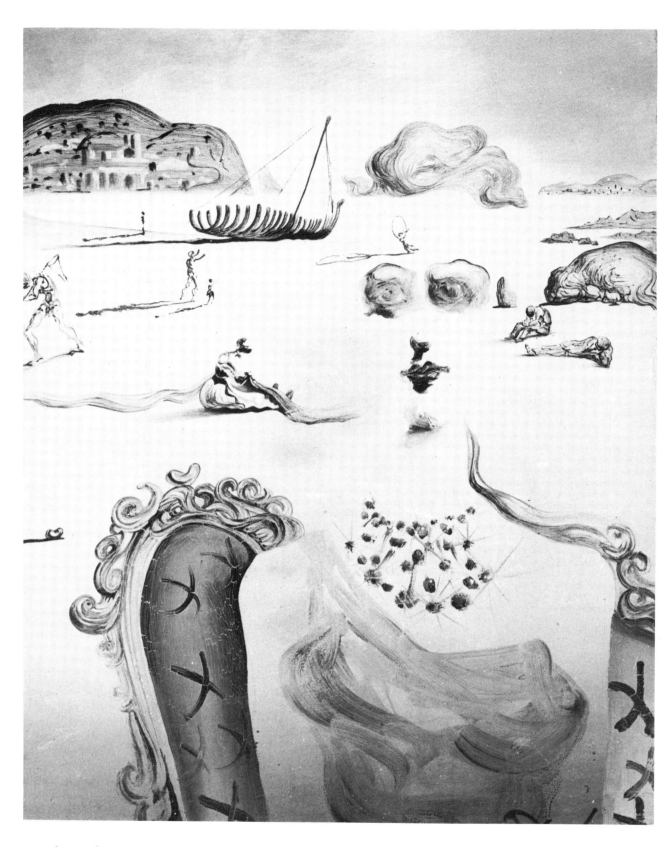

112

very close relation between sexuality and sadism, both linked to the desire for power. In his youth, the artist was so successful in attracting the love of a young Spanish woman that her feeling for him assumes mystical proportions. During the five years that the two young people keep company, Dali deliberately excludes sexual intimacy from their relations in order to discover all the variants of what he calls "sentimental perversions." He doesn't fail to stimulate the young girl erotically but he is very careful not to touch her, thus driving her to the edge of hysteria. "Unsatiated love seemed to me, since that experience, one of the most hallucinatory themes of sentimental mythology. To me Tristan and Isolde seem the prototypes of one of those tragedies of unfulfilled love as fiercely cannibalistic

in emotion as the praying mantis devouring her male during mating."

Compassion for others? Dali doesn't know what it is. At the age of six he seriously injured his sister with a violent kick in the head. Later he painted her from the back, a view that is not particularly flattering. While doing this he suddenly had a vision of a horrible rectangular opening in the back of her neck. It would be hard to see this as the hallucination of an amorous desire, and it might even be said that as far as the brother's incestuous desires are concerned the little sister has nothing to worry about. At the age of five, taking a walk with a friend who is smaller then he, Salvador pushes the child from the top of a parapet into a ditch several meters in depth. It is a wonder that he did not kill the child. Later, meeting

a music student, he snatches his violin, jumps on it with both feet, and breaks it into a thousand pieces. Dali explains to the professor, who has appeared unexpectedly in response to the noise of the incident, that he wanted to provide irrefutable proof of the superiority of painting over music.

This scene, as brutal as it is grotesque, shows with what violence Dali fights to attain his ideal of the Self as artist. For the young man, painting represents that bulwark of self-affirmation and pride that must permanently suppress all secret doubts. From puberty on, there develops in him a quasi-systematic megalomania which already constitutes in his eyes an expression of the paranoia, that is to say, a way of turning away from the real object with all of the difficulties implicit in the transfer provoked by a fixation on one of the first stages of autoeroticism. Nevertheless, the subject is still exposed to fantasies of persecution and anguish, so he often needs to seek refuge in the authority of that father who, although convinced of his son's talent is nonetheless troubled by his eccentricities. "I was going to erect the gelatinous fortress of paranoia on the edge of that abyss with, as a rocky support, the massive presence of my father, so keenly experienced; when I did his portrait, I burdened it with several layers of paint, obsessed by the need for such a portrait to weigh more than any other. Now, if I am a hero according to Freud, it is because I appropriated my father's vigor. The hero is the one who revolts against the authority of the father, ends up by conquering it, devours his father, absorbs the guardian law, the all-powerful, becomes himself the law, the great phallus."

This description abounds with symbolic meanings. The very gesture of the painter which he stresses expresses something like a conjuration of the paternal omnipotence that Dali would like to appropriate by the sado-masochistic step that consists of portraying the father. The painting in question, which dates from 1925, shows the notary Dali with a massive physical presence, like a bull that is awaiting the battle and measuring himself with a glance against the painter-matador. The face and the bald head remain in a mystical chiaroscuro which contrasts with the predominantly realistic style of the whole. In the energetic penetrating gaze the sense of the tragic burns like a smothered flame. The painter pits himself against the father whom he deeply admires for "his firm character and his Spanish cruelty." Their understanding of each other is so profound that it suggests ambiguous feelings. The portrait is a genuine declaration of Dali's love for his father but it also embodies, concentrated, all the signs of the relentless battle in which both of them joined over the years and which marked Dali for a long while: ". . . when it happens that I masturbate, I almost always see, at the last moment, a violent family image, for example, my father dead."

When Dali speaks of his mother, his discourse automatically changes to hymns: "I idolized her. . . . I knew the moral value of her saintly soul so above everything human . . . " He raises his mother above the community of feeble mortals to situate her in a sacred order, for Dali's love for his mother is linked to his conception of the ideal self, indelibly marked with Spanish Catholicism. It is based on archetypes of the cult, of the madonna and representation of virginity, primarily characterized by as assexuality that is coupled with latent capacities for redemption. But in the tone of these eulogies, almost overly lyrical, overly charged with emotion, we also hear the imperceptible lament of unconscious renunciation of incest. In this carefully devised set of complications, the encounter of the libidinous impulses with the foundations of morals and religion gives rise to painful tensions. The mother and father, despite themselves, become actors in an endless ritual psychodrama, perpetually oscillating between blame and forgiveness. The artist's eccentricities mask hidden impulses of seduction and possession that are oriented toward his mother and assume a very marked sexual tonality. Salvador complains that in her presence he feels "guilty of faults of the soul," a rather ambiguous phrase, not to say ambivalent. Or else he declares, "My malice must have also been something marvelous!" and it certainly seems that a certain pleasure enters into the admission of that

Portrait of the Father of the Artist (detail). *1925. Oil on canvas. 100 x 100 cm. (Museum of Modern Art, Barcelona).*

113

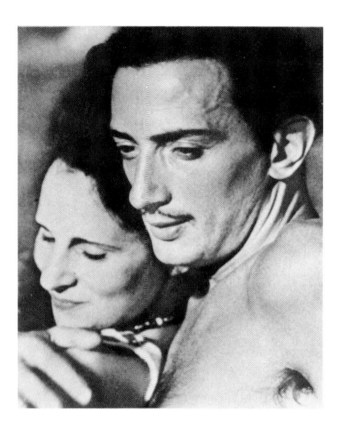

The couple Gala-Dali.
About 1933.

turpitude to the extent that it can become a means of seduction. Thus, he adds, in regard to that adored mother, "She was so good, that it was enough for two . . ." Salvador Dali is truly his mother's happy choice, the one who was preferred over the dead son. For she adored him "with a sacred and absolute love." The mark of this love has merely reinforced the victorious and conquering image that Dali has claimed for himself and it is expressed in an unshakable optimism that has never left him. His mother's death is the first great sorrow in his life, a terrible event that he senses as an actual challenge by destiny: "One couldn't do such a thing to her, not to her, not to me. Ideas of revenge possessed my soul. With teeth clenched, I swore to myself that I would tear my mother away from the death of fate, even if I had to use swords of light that, one day, would shine wildly around my glorious name."

Despite all of Dali's inconsistent statements and the multiple aspects and diverse levels of his development, it certainly seems that he experienced intrauterine life and the first phase of infancy as a kind of harmonious and peaceful continuity in which one cannot even say that birth constituted an overly violent break. And if this was so, it is thanks to the maternal care obtained for him until a period well after the oral phase, care which enabled him to progressively substitute for the biological situation of the fetus the psychological rapport with the maternal object that played such a decisive role in the development of his feelings of success. There is nevertheless a break caused by the maternal instance forbidding incest and marked by the most violent castration anxiety throughout the Oedipal period (from age three to five). The image of the mother that Dali constructs with a melange of elements of tenderness and hostility is an association of the Oedipal desire with the prohibition of this desire. It is only when he becomes an adult that, in a retrospective fantasy, Dali discovers the repressed memory of the crucial scene. "It is to my mother that I owe my terror of the sexual act and my belief that it would lead fatally to my total annihilation. One would discover at the origin of that terror a critical traumatic incident, of an exceptional savagery, happening in my early infancy and directly connected to the Oedipus complex. It is specifically a matter of a memory, or a 'false memory,' of my mother sucking, devouring my penis. . ." Under the effect of the sexual anxiety from the guilt, the image of the pure mother changes into that of a fury devouring the penis, so that she can fulfill her castrating function by accomplishing the act that is both sacred and brutal, the ritual charged with sadistic and oral pleasure. In Dali's case, the prohibition of incest is emphasized in a way that is exceptionally violent and traumatizing, by the threat of castration. On the narcissistic level, it does not affect solely the phallic experience. The threat of castration produces a total reversal of the libido determining a complete sexual inhibition, which will be prolonged for years. The infantile representations and the masturbatory practices are constantly reactivated. The fantasies of the intrauterine life replace copulation and provoke symptoms of impotence. These phantasmatic returns to the maternal body are expressed in a nostalgic mode in Dali's work.

It is in this state of mental confusion which, by the mere fact of instinctive regression, excludes all adaption to reality, that Dali meets "the healer of terrors," Gala Eluard. The year is 1929, in Cadaques where, with her husband Paul Eluard, Gala is visiting some friends, among them Bunuel. This is an important year in Dali's life. He becomes acquainted with the Surrealists, exhibits for the first time in Paris, meets the woman who will be his lifelong companion—"the conquerer of my deliriums, the loving lover, magnet of my vertical vigour"—and discovers that he is a "genius"! But 1929 is also the year during which his imbalance takes alarming forms. Always eccentric and extremely nervous, Dali is overcome by fits of mad laughter and outbursts of violence. At the time of his second meeting with Gala Eluard, he presents himself to her, as he describes it: "Drunk with the desire to hold her gaze I shaved my armpits and painted them blue, I cut up my shirt, I smeared myself with fish glue and goat excrement, I adorned my neck with pearls and my ear with jasmine. When I found her, I was unable to talk to her, shaken by a demented laugh, cataclysm, fanaticism, chasm, terror."

In the course of walking with Gala on the cliffs that rise abruptly from the sea near Cadaques,

dazzled by the grandeur and the emptiness of space, Dali is seized by a violent desire to throw himself or to hurl her into the abyss. Gala notices the aggressive forward movement of his hand, then his startled backward movement. She becomes silent, then takes that hand and says, "My dearest, we are never going to leave each other." Dali gives Gala the surname of "Gradiva," the principal heroine of Jensen's novel, which we have already mentioned, who is successful with the psychological cure of the central male character. Gala-Dali becomes "Leda the mother." She is "Helena, immortal sister of Pollux-Dali, whose Castor is that genius brother that I had and whose given name was also Salvador," says Dali. By a transposition of characters, Dali's mythological universe, up until now severely damaged, becomes intact and viable once more. The earlier triangle formed by Salvador I, Salvador II and the dead mother changes into the duo Gala-Dali. Gala concentrated within herself all of Dali's former fixations; she becomes the redeemer who makes Dali rise from the dead. She is the mother-wife-brother-healer by whose efforts he comes to the world for the second time.

Here again the discourse changes into hymns: "My love for Gala is a closed world, since my wife is the indispensable closure of my own structure." The infantile feelings of omnipotence that Dali had once experienced, he finds transposed within the new form of genuis and of myth. He enjoys painting Gala with the features of the madonna in a kind of celestial serenity pursuing and going beyond the earthly pleasures of the senses. He feels himself enveloped by the aura which hovers around Gala, his "antigravitational Nietzschean superwoman." The ancient myth of the protection of the fetus by the mother is replaced by the myth of Gala who, in addition, helps him to bear a share of the resignation which accompanies every life of two beings together. The marriage to Gala puts an end to the relationship between Dali and his father, or more precisely the father silently disappears from Dali's life like someone who has been forgotten.

Gala cures Dali by the "unconquerable and unfathomable power" of her love, of which "the profundity of thought and practical skill surpass the most ambitious psychoanalytical methods." In fact, in his narcissistic choice of object, Dali pursues the dual aim of being loved and being cured. He openly reveals to Galva his whole pathological psychology and at the same time his intention to break the resistance in order to orient himself toward a positive transference which will permit the rediscovery of his repressed impulses. The unfolding

115

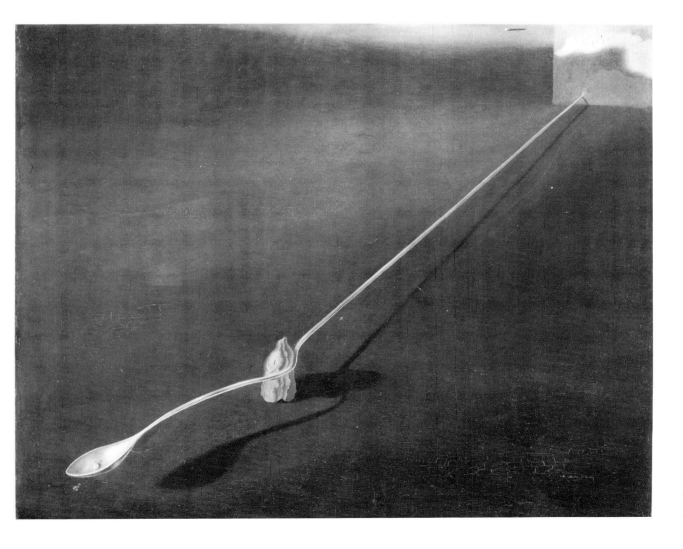

Agnostic Symbol.
1937. Oil on canvas.
55 x 65 cm. (Louise and
Walter Arensberg Collection,
Philadelphia Museum of Art).

Salvador Dali in front of a monument.
(Sals-Narbonne, France).

116

of this process is continually favored by the fact that on the physical level as well as the intellectual Gala fits into the category of virile women—and represents perhaps even in Dali's imagination an ambiguous, bi-sexual being—whose evocative force makes easier for the artist Dali the firm step of detaching himself from his fixation on his mother and his dead brother. To her union with Dali Gala brings the exceptional psychological experience that her intimacy with Paul Eluard and Max Ernst gave her. She had immediately grasped Dali's morbid symptoms, perhaps because she herself was predisposed to that death wish that shows through when she declares: "The day of my death will be the most magnificent!" It is thanks to Gala that Dali succeeds in becoming aware of his inner conflicts, in overcoming them and transforming them into creative energy. "Through love she knew how to compel my intellect to the relentless practice of criticism. Through love I accepted changing a part of my personality into a self-analyzing apparatus and thus I could change the Dionysian torrent to Apollonian performances that I want to make more and more perfect. My method, which I called paranoiac-critical, is the constant conquest of the irrational."

The understanding Dali had attained by the observation of his own tendency to paranoia was deepened still more around 1933 through his reading of the works of Lacan on paranoid and neurotic disorders. He exploited whatever positive material he could get out of his paranoiac facility of association which he used as an instrument of inspiration and creation. He cultivated it to perfection and developed the critical-paranoiac activity by which he discovered some "new and objective meanings of the irrational." He even found in it a means of "making the world itself pass tangibly from delirium to the plane of reality," which amounted to saying, more simply, that ". . . paranoiac delirium already constitutes, in itself, a form of interpretation." Dali had barely discovered Oedipus when he passed into the anti-Oedipus camp, even before it had been defined.

He also turned against Freud, the father, the Big Phallus whom he calls "the great mystic inside out." When Dali visits the founder of psychoanalysis in London, in 1939, he makes a drawing of Freud with his head in the shape of a snail: it was both a way of killing the father and of settling accounts with him. The painter doesn't hesitate to explain himself in this connection: "The brain of Freud is par excellence the brain of earthly death . . . the quasi-ammoniacal snail of death . . . his brain heavy and seasoned with all the viscosities of materialism. . . ." Dali wants, at any price, to give Freud a copy of his paranoiac-critical theory. Freud, for his part, is not the least bit interested in it and is content to state, "I have never seen such a perfect prototype of the Spaniard. What a fanatic!"

WOLFGANG SAURÉ

dali and sub-realism

by stéphane lupasco

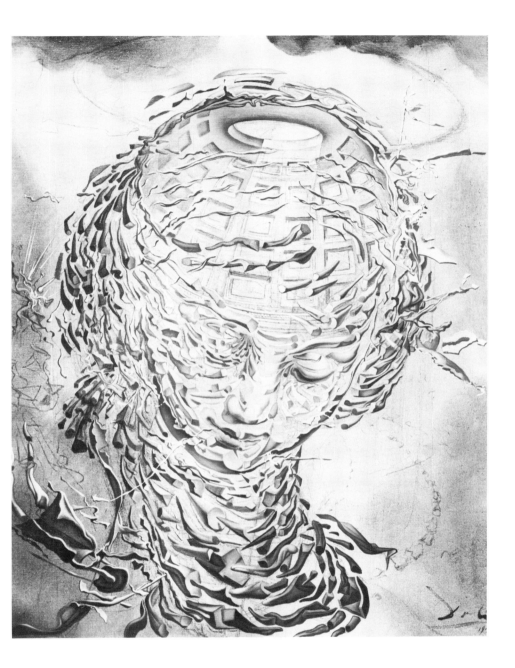

Raphaelite Head Bursting.
1951. Oil on canvas.
65 x 57 cm. (Nast
Collection, England).

From the most remote time, the knowledge that man worked out about the objects and beings that surrounded him and about himself, empirical knowledge at first, and then generalized and refined, showed him that everything was controlled, generated, acted, by forces and entities, personified or abstract, that came from on high, from beyond the facts that came within the range of his experiences: from the sun, which brings warmth and makes the fields fertile or scorches them, from the clouds which give him their beneficial water or floods, from the stars where fate set down his fortunes. He clearly sensed inner powers, instincts and passions, but they issued from the soul, which was found beyond the body, which is controlled and directed, itself subject to ethical directives, good and bad, vanishing after death into the sky or quite simply annihilating itself in the physical universe. The material making up reality, insofar as it is inanimate, was organized and driven, either by transcendant spiritual ends, to create plant and animal life, or by chance and rational mechanical laws beyond the governing phenomena.

Thus everything appeared as if *surreal*, proceeding from something transcending reality.

Those astonishing revolutionary poets, the Surrealists, had sensed that there were more important currents beyond that daily reality stereotyped by perception and pragmatic technological activity. But they could not tear themselves away from that powerful tradition of the *sur*. They even found in Freud, on the one hand, the imperatives of the phylogenetic bio-sexual unconscious that dominate the ontogenetic unconscious, and in Marx, on the other, the historical materialism that brings man into subjection from the height of his external needs.

Twentieth-century science, in its subtlest microphysical inquiries (as in the genetic and microbiological research in the middle of development) effects a complete reversal of this knowledge polarized by the *sur*. Everything turns out to originate from within, as Henri Michaux would say. It is in atomic and subatomic energy, in the invisible particles, that everything is elaborated, formed, made and unmade. The planets, the stars, and even the galaxies—as numerous and vast as they may be —depend on what happens above, in the surreal.

Dali first allowed himself to be caught up by Surrealism. However, he was not long in sensing what is working the world in its remotest depths in the direction of its break-up and its arborescent expansion; that is to say, those two antagonistic and contradictory dynamics, the one of homogenization, of the identical, of sameness, of repetition, of equality, and the other of heterogeneity, of differentiation, of diversification, of inequality. . . . Let one of them increasingly dominate the other and the first succumbs in a sort of insatiable death by physical energy; the second in a monstrous proliferation, exhausted and empty of life.

It is that these elementary particles are the

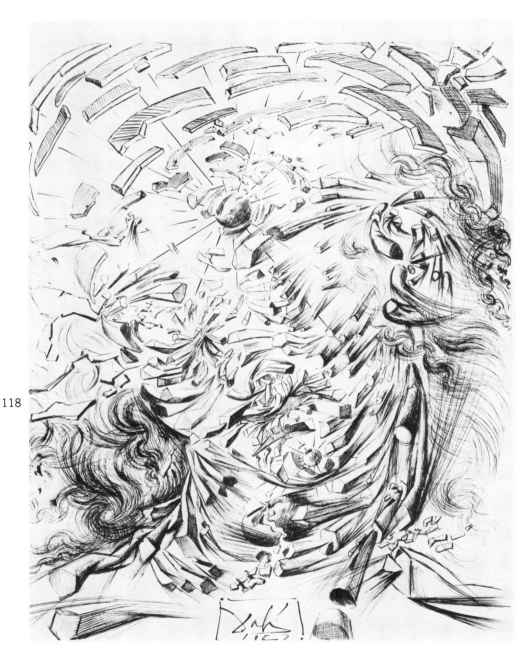

Nuclear Head of an Angel.
1952. Pen and ink drawing.
56 x 43 cm.

118

carriers of strange physical energies: electrons and protons possess the power to exclude each other in an atom, a molecule, a gas, from the energizing state they occupy. In other words, as numerous as they might be, in their millions of billions, they assume individuality and become particularized; no one of them can be identical to any other. And so it is that the atomic nucleus is constituted, an atom, a molecule, and thereby all the substances and different objects we know, up to the planets, stars, galaxies. . . .

On the other hand, photons, those constituent particles of light (as of all electromagnetic radiation), can accumulate in the same quantum state and so progress toward a final state that would be the one of an ultimate homogeneity, or death in light. This then is the mechanism that microphysics discovers in the celebrated and mysterious second law of thermodynamics, worked out in the twentieth century, by virtue of which every isolated system, through its transformations, loses its diversified energy, and advances irreversibly toward a homogenization (molecular motion or heat) that is called the increase in positive entropy.

Now let these two fundamental dynamic mechanisms inhibit each other in a conflicting antagonistic coexistence that is ever-increasing, and a third universe, that of the psychic mechanisms of the soul, is going to open and give free rein to the creative imagination. This is certainly the imagination of Dali's extraordinary inventions. One sees in them mineral and living forms, prey to a heterogenization unrestrained by life, forms attacked at the same time by disintegration, sickness and death, joined in a dazzling pile-up of order and disorder of physical and biological universes which the strong talent of the painter knocks together in some kind of original genesis, for the unconditionality of the materializing and dematerializing powers of a life-giving liberation and of a freedom of the senses and essences.

This is what explains Dali's increasingly passionate interest in contemporary scientific research and the fact that, around 1950, he made my book *L'experience microscopic et la pensee humaine,* as he told me, his bedside reader.

He understood, before so many others, all that the dynamic logic of the contradictory could mean, with its incalculable consequences.

Furthermore, drawing is also the main weapon of this fabulous creationism by Dali. And rightly so, because drawing, to a painter, is the music of the intellect.

STÉPHANE LUPASCO

the anamorphoses of the verb

by pierre volboudt

"Paint and shut up." To whom is this injunction that Dali jotted down in his journal addressed? Surely not to himself. That would amount to the self amputating half of itself. Let one Dali talk seriously to the other and send him back to his brushes and the prohibition lasts only long enough to write it. He may readily admonish himself, pen in hand, and the words carry him away. Already another line is coming. Innumerable lines will cover the pages and make volumes, a load of day-to-day confessions. How can he resist when so many things are subjects for reflection, covetousness and curiosity, passionate conviction? How can he keep his word? To him the canvas covered with colors, the paper charged with ink, an audience under the blow of the hammering of his peremptory syllables, are parallel mirrors where, in the same image, the one who speaks and the one who paints blend. Inseparable, they are complementary. The first presents his riddles; the second attempts to resolve them in order to make of his dark phantasms the illustration of his personal dogmatics.

In his writing Dali makes all the facets of his mind sparkle. He touches upon all subjects. He speaks and talks to himself, thinking out loud. He reveals, he holds forth, turning an article or a dialogue into a pro domo speech for the defense. He passes from a doctrinal lesson to a lyrical flight, from visual problems to the sequences of a film scenario, from the outline of a ballet to the obvious, from the most haughty avowal to the most pertinent and daring reflections on the prophetic relations of the art and the image of the world that science puts into equations. All these marginal texts on the genuine oeuvre constitute a

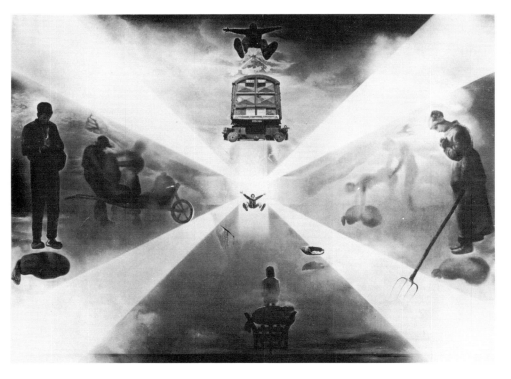

The Station at Perpignan.
1965. Oil on canvas.
295 x 406 cm.
(Private Collection).

Defense and Illustration of an unusual Ego that wishes to be exemplary and unique. Long or short, they are so many variations on his favorite theme, a type of fugue for solo voice on the name of Salvador Dali.

"Renouncing is what completes the work." This lofty maxim that Dali gives as a kind of artist's slogan, he would not be able to apply to his own person. The lover of "phoenixology" never relinquishes the tiniest fragment of that hero in the process of developing, according to that ideal of Baltasar Gracian, of that "universal prodigy in search of excellence and virtuoso in the art of fame." What he writes is an account of the states of that furious passion never fulfilled. He sees himself reflected there and compares self with self, assuring himself of the similarity, perfection to the point of exaggeration. He leaves himself constantly, but without losing sight of himself.

Let an idea come into his head, or an inadvertent gesture escape him, he takes them as revelations, as gifts of his guardian spirit, that "evil genius" who prompts him to commit his most ludicrous indiscretions. Forever yawning to either side of him, the abyss of the absurd could not make him dizzy. He flings himself into it, and at the bottom discovers his truth. With a dash of wit, and a flourish of the pen, he regains his footing. Again, the small events of everyday life, even the most insignificant—but is there a single act that is normal and meaningless for Dali?—take on a conspicuous importance in his eyes. He scrupulously jots them down, magnifying them to the dimensions of incidents. It is no longer an anecdote that he is telling; it is a prodigious story with tremendous consequences. For him the slightest whim is a signal and light on the zig zag line which he is following and which branches off to infinity, among the crazy switchings at the railroad station at Perpignan.

Dali is the most authoritative and the most faithful of his hagiographers. The very excess of his panegyrics guarantees a candor that no hyperbole casts aside. He has created his own "saint's life." He lives it. That incense he distills, those flatteries in regard to himself, perfume the man in the banners of which the rambling stories about the merits of the builder of his glorious pyramid are unfurled. Never is the Dalian prosecutor at a loss. He shapes this sort of philosophic stuff that to him is succulent and, a quality that is first rank in the writer's vocabulary, "comestible." The pen and the brush dive into their substance, diluting in ink and color the grain needed to elevate the smooth, flat uniformity of prose and painting.

Inured to the *haute-ecole* exercises of the most delirious rhetoric of the ego, Dali is, in the most widely accepted sense of this protean term, Baroque. He is Baroque in his manner, in word and gesture, in the anachronistic display of the persona that he assumes. He is the last and most perfect of the poets of the limitless variability of reality, and of the sub-

119

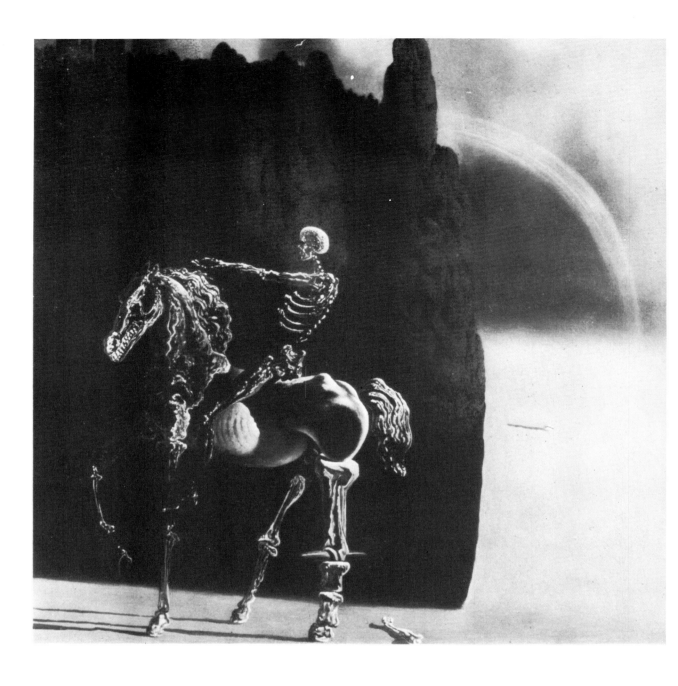

120

limated primacy of appearance. Actor and spectator enchanted with himself, he projects himself in all the dimensions of the mind. He comes together at the central junction of his extremist virtues. From their clash of display, he clothes and disguises himself; then, flinging it at his feet like cast-off clothing, he now wishes to be nothing more than the indomitable flayed man miming, in his ostentatious stripping, on the stage where all the lights of accessory spotlights riddle him, the hieratic contorted statue in which he becomes embodied, a dazzling target, pierced by his own arrows and phantasms, by his torments and trances.

A halting monologue broken off, resumed, interrupted by stage whispers, by silences, by cues reserved for other scenes of those *self-sacraments* of Genius, played behind closed doors for the benefit of posterity, unreels its misleading mazes around an ego strained to the extreme, in gyroscopic equilibrium on its point. He comes and goes, from one pole of the Baroque soul to the other. He oscillates between flight from an anxiety that is satisfied and allayed only in the unstable person, and the frantic exaltation of a "glory" that gathers

in glittering disorder the contradictions, the relentless axioms of an existence proudly identified with the tumultary act from which the work arises. One might say an anticipatory echo of the voice of Dali is that of a poet who wrote three centuries ago:

Knowingly I lose myself in roads obscure
Wandering in my night where gleam the Dioscuri
I rise upon awakening from that bitter abyss
Before which with its fire my astre illuminates
The solar ghost at his divine task
Of pulling some monster from the gulfs of the sea.

Whether he speaks or writes or his unleashed graphic impulse suddenly decorates the white page, assailing it with the convulsive and fine conciseness of his strokes, Dali is master of his passions. He liberates them; he checks their excess; he bends them to his haunting memories rising from that breeding ground of dark forces where the idea constantly pursues the very shallows, lairs of fabulous species, his game animals. "Let them be reduced to monsters!" he one day exclaimed. For him a germ of metamorphosis breaks through in each shape. No

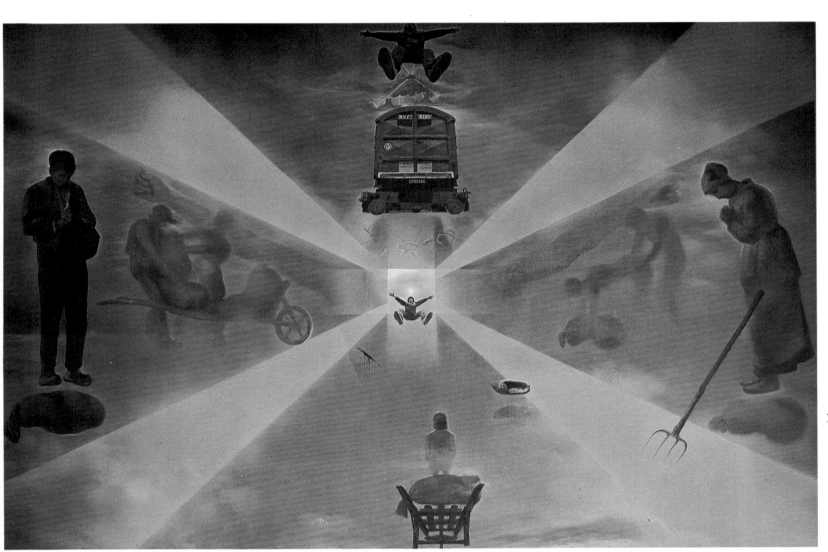

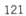

La gare de Perpignan.
1965. Huile sur toile.
295 x 406 cm. (Coll. Privée).

The Station at Perpignan.
1965. Oil on canvas.
295 x 406 cm. (Private Collection).

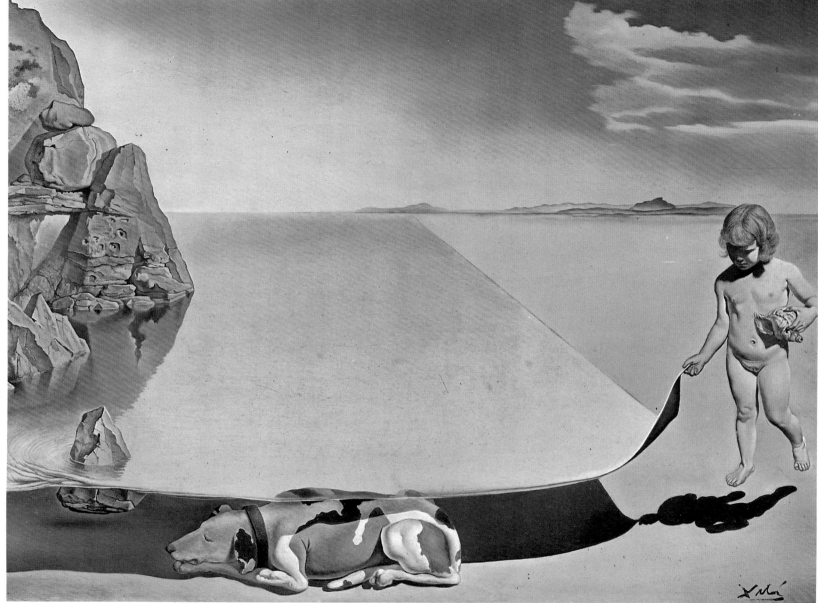

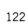

Dali à six ans quand il se prenait pour une petite fille, soulevant la peau de l'eau pour voir un chien endormi à l'ombre de la mer.
1950. Huile sur toile.
80 x 99 cm. (Coll. Comte François de Vallombreuse, Paris).

Dali at the Age of Six, when he Thought he was a Girl, Lifting the Skin of the Water to see a Dog Sleeping on the Sea Bottom.
1950. Oil on canvas.
80 x 99 cm. (Count Francois de Vallombreuse Collection, Paris).

Couple aux têtes pleines de nuages.
1934. Huile sur bois.
91 x 61 cm. (Coll. Edward F.W. James, Sussex).

One section which is included in **"Landscape with the Head Filled with Clouds."**
1934. Oil on wood.
91 x 61 cm. (The Edward James Collection, Sussex).

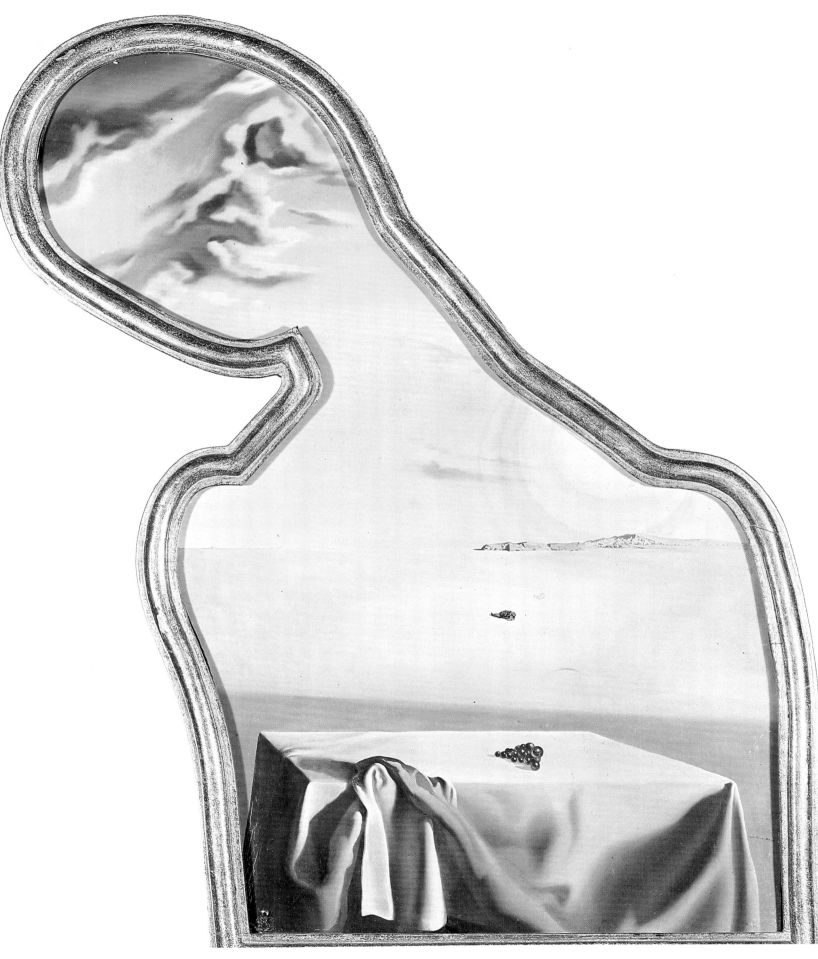

**Velasquez peignant l'infante
Marguerite.**
*1958. Huile sur toile.
153 x 92 cm. (Coll. A.
Reynolds Morse, U.S.A.).*

**Velazquez Painting the
Infanta Margarita.**
*1958. Oil on canvas.
153 x 92 cm. (The Reynolds
Morse Foundation, Cleveland).*

L'homme à la tête d'hortensia.
*1936. (Coll. A. Reynolds
Morse, U.S.A.).*

**The Man with the Head of
Blue Hortensias.**
*1936. (The Reynolds
Morse Foundation, Cleveland).*

124

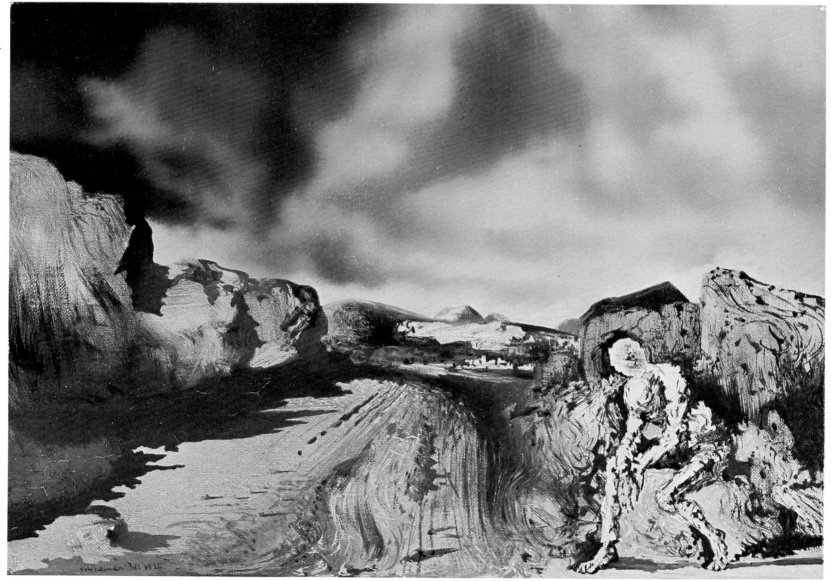

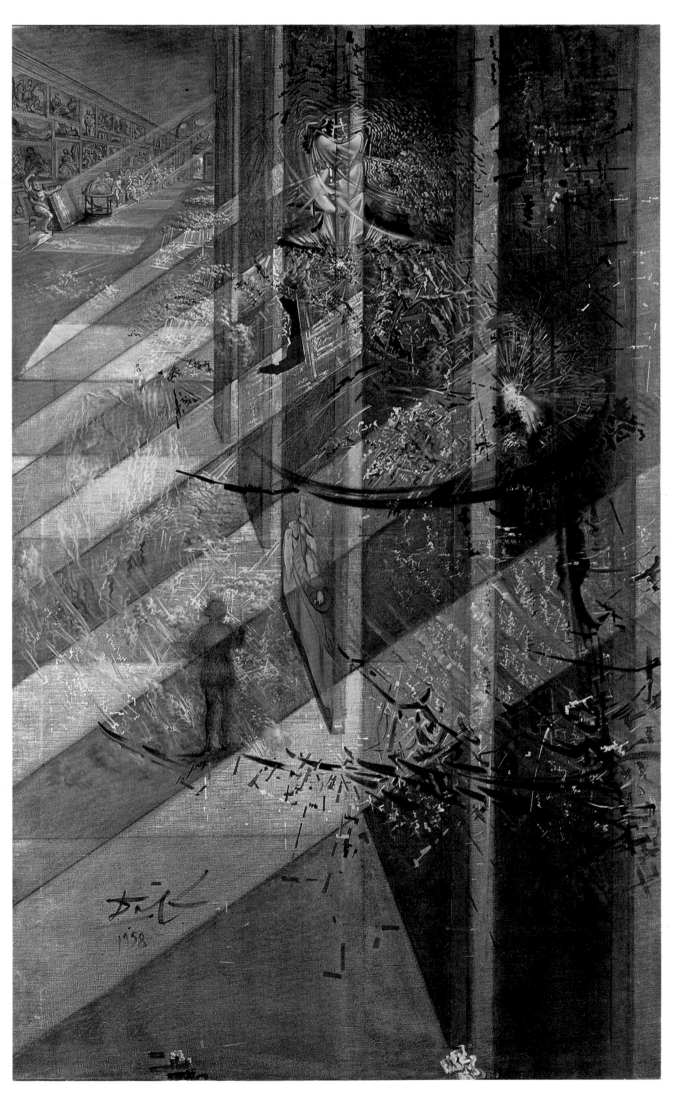

Mémoire de la femme-enfant.
1932. Huile sur toile.
99 x 120 cm. (Coll. A.
Reynolds Morse, U.S.A.).

Memory of the Child Woman.
1932. Oil on canvas.
99 x 120 cm. (The Reynolds
Morse Foundation, Cleveland).

126

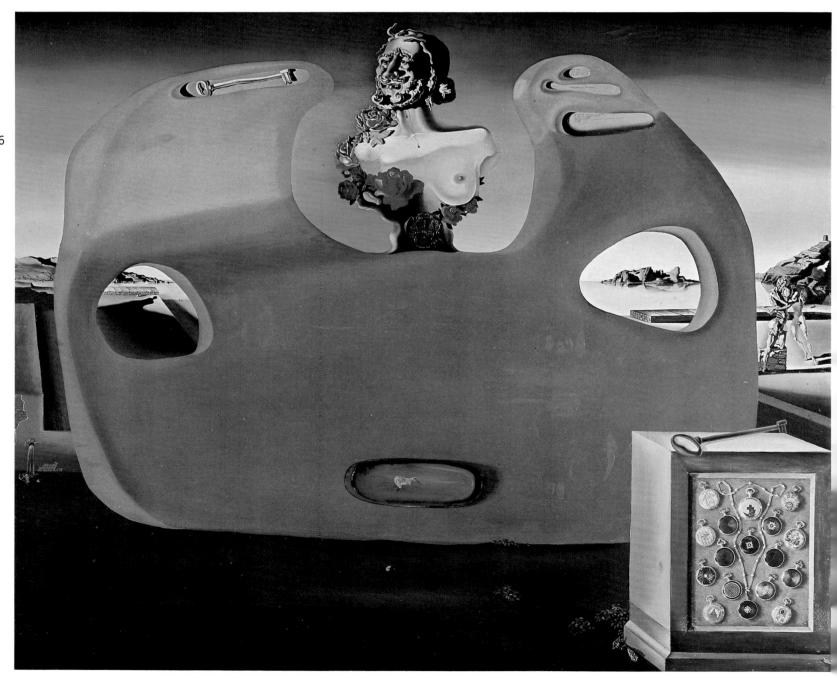

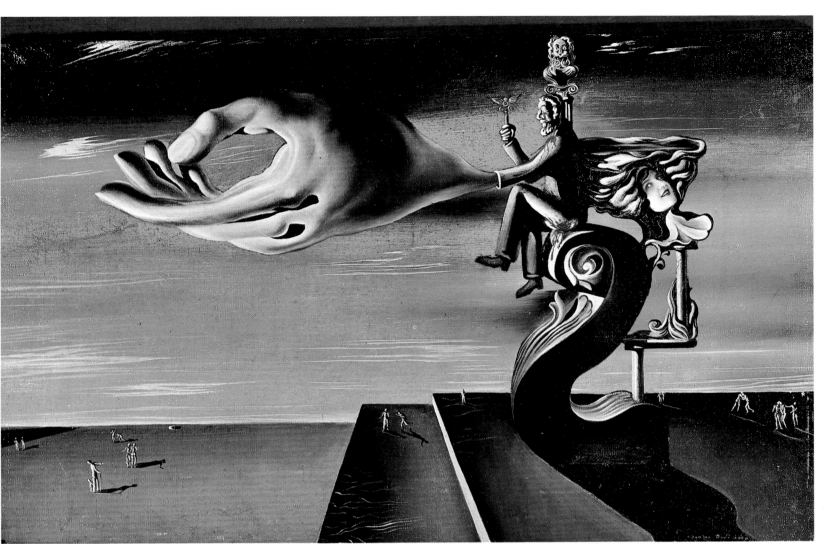

La main.
1930. Huile sur toile.
41 x 66 cm. (Coll. A.
Reynolds Morse, U.S.A.).

The Hand.
1930. Oil on canvas.
41 x 66 cm. (The Reynolds
Morse Foundation, Cleveland).

Bureaucrate moyen atmosphérique en attitude de traire la lait d'une harpe crânienne.
1933. Huile sur toile.
22.5 x 15 cm. (Coll. A. Reynolds Morse, U.S.A.).

The Average Bureaucrat.
1933. Oil on canvas.
22.5 x 15 cm. (The Reynolds Morse Foundation, Cleveland).

128

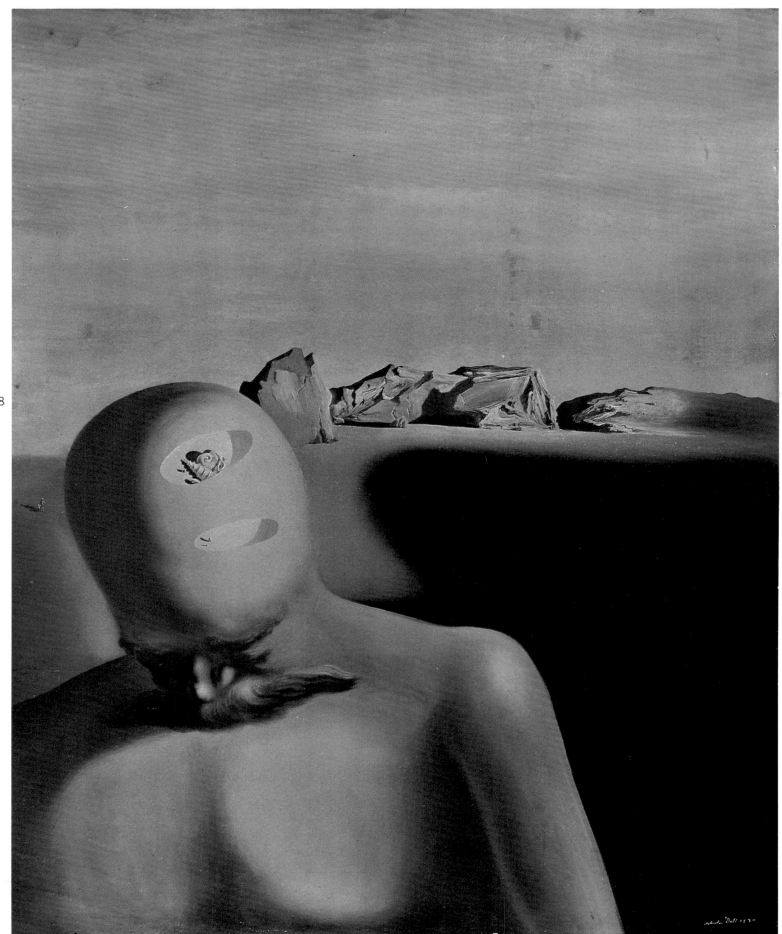

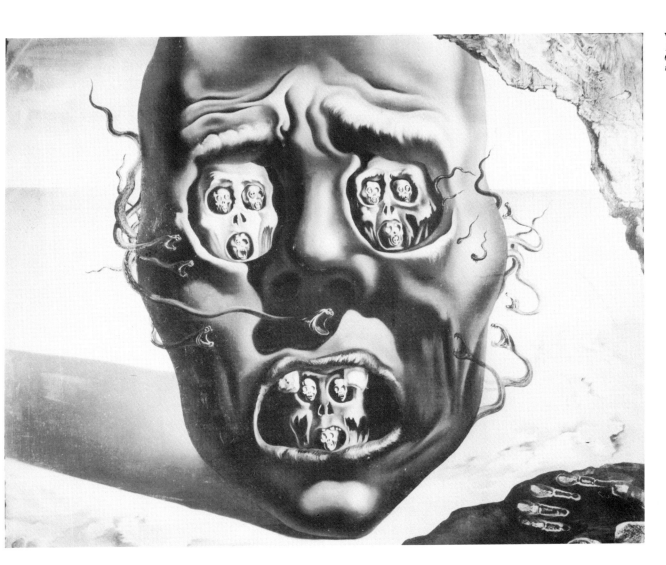

Visage of War.
*1940. Oil on canvas.
64 x 79 cm. (Museum Boymans Van Beuningen, Holland).*

mental image is exempt. An unforeseen analogy is a springboard for this acrobat of the trapeze of the intellect. He spins above the track of platitudinous and banal truths. He alights there at last, surefooted, and his head, in the course of the exercise, has not spun for an instant.

Whatever the subject Dali begins, he obstinately returns to the credo of his personal absolute. The "objective delirium" that he cultivates with a particular dilection is the common denominator of all the pages that he devotes to Paranoia, that theological virtue which he observes with fervor. At this word, as if in rapid recall of his egotistical powers, all his obsessions and fixed ideas are stirred up again, in an endless re-examination. Systematic disorder is the mainspring of his deep-seated proceeding. He follows the very forms of a vision susceptible to as many combinations and alliterations as Ramon Lull, whom Dali reveres, was able to extract from his dizzying computation tables. From them he constructs the basis of aberrant logic, a formal order of hierarchical thought, daring conjectures, and perilous deviations.

From the most innocuous established fact he deduces mysterious correspondences and all sorts of incongruous relations, ending, by the logic of irrationality, in a scandalous truth. He builds his system of them; he buttresses precarious balances with them; he constructs his thesis with an infallible assurance with them. The intricate web of a metaphysical Ariane he uses like a plumb line that assures him of the verticality of his composite edifice, a temple erected in honor of the oracular voice.

A monomaniacal thought carries the mass of words off in a kind of hypnotic gyration. With a sententious gravity and a vainglory that betray neither doubt nor irony, it establishes its indisputable truths. Never surfeited with glut, it takes pleasure in verbal rhapsodies, feeding on itself. These long recitals, these short spurts of concealed aggression, are joined to the grand airs of the Dalian repertory. From the highest point of what one writer calls "the sublime hierarchy of the mind," he issues his decrees, fulminates his explosive bubbles, distributes praise and blame, excommunicates and rehabilitates with no appeal. One might call it some seraphic dominion surrounded by its quasi-mystical mania for the elect and trampling the damned. The former, by his orders, are promoted to the rank of harbingers of his word and his art. The latter are held up to public obloquy. But those who have deserved to escape this disgrace are assigned the most dazzling and the most unforeseen merits. Surrounded by the immaterial coterie, Dali writes out his reasons.

With lapidary maxims, learned and abstruse glosses, he composes, between two sessions of work, this anarchic organon of a philosophy centered on solid concepts. His style is the reflection of his thought, extreme and domineering. Like his painted forms, convulsed with enormous tensions,

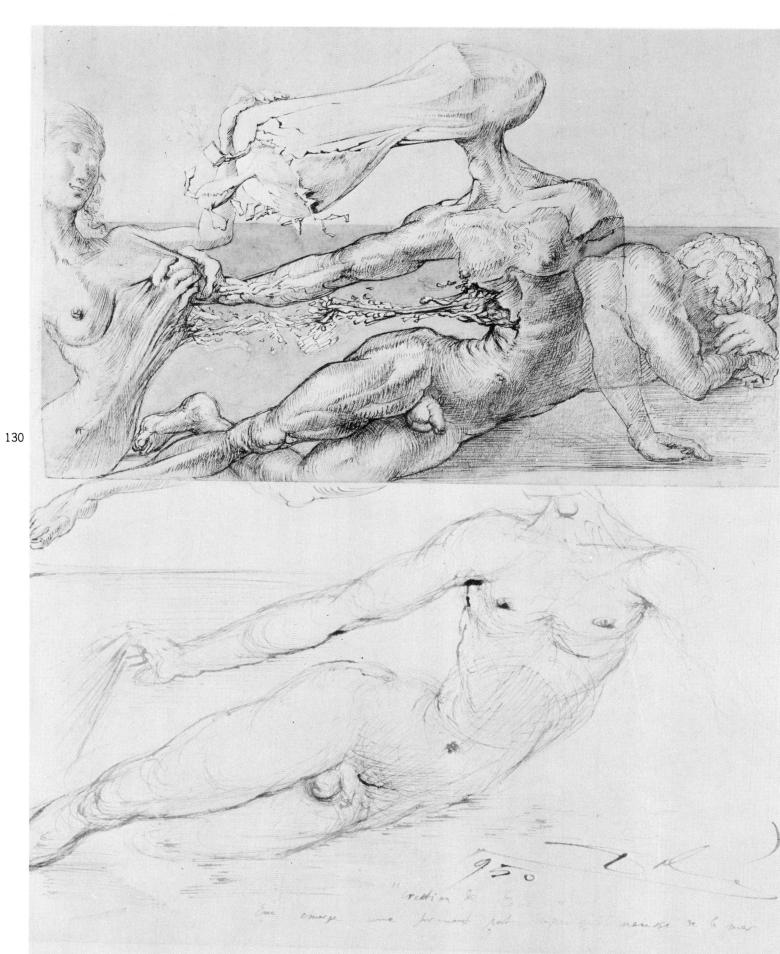

130

hunchbacked with monstrous protuberances which dislocate the placid anatomy of bodies, Dali's prose is subject to ill-timed fits of temper and momentary moods. It is agitated by all the movements and excitement of narcissistic rapture. The verbal material, stimulated by the lyrical warm-up, swells with adjectives, balloons with bulky superlatives. Adverbs clump together. Long strings of substantives stretch out as a result of an irrepressible prolixity. Dross changes into a happy find, into a clot, and ricochets, and it is the whole dictionary that gives way. Page after page, the charges at full tilt, the motionless trampling of this continual, brilliant fantasia, follow each other. The pages narrow into pieces called odes or sonnets, propitiatory dronings, dedications to the obscure, monuments to the sphinx of Paranoia.

In Dali's writings, the authoritative grandiloquence of the vocabulary, the exaggeration of epithets, the starts of wit spurred by the most arrogant qualifier, and a pronounced taste for the corrosive apothegm, the venomous flower of a rhetoric reduced to a belief that beats its assumptions in order to convince itself and overcome every objection, are all at the service of Dali's willingness to promulgate, in full view of the world, the cult of the One and to proclaim its unparalleled excellence. The daily journal that Dali keeps punctually is, for the writer, an everyday exercise in self-inspection, in the confirmation of his "genius." He himself becomes the faithful or inaccurate bookkeeper—but this again is a way of following his profound principle—of his slightest outburst of thought, of his lively intellectual whims. He omits nothing from the trifling doings of his daily life, the most trivial coincidences considered to be illuminating revelations, shamelessly mixing anecdote with stray impulses which occur to him and the most indiscreet confession. He revels in the sport of this perverse puzzle. He sees himself as the very same yet changeable, in each bit of that shattered mirror where he appears visible to himself under the glitter of that *traje de luces.*

"I have in myself," said Andre Gide, "all that is needed to be and to not be a great man." Dali does not admit to such a division of his person at all. He lacks nothing, according to what he loudly maintains, in order for him to be what he has decided to be, what he cannot *not* be. Thrown across his doubts, those frail verbal footbridges, when he comes to them, are his gangplanks to salvation. A fearless tightrope walker fascunated by his own exploits, he passes, makes a standing leap over the ridiculous, salutes and gets applauded. His brave feats of verbal intemperance make one think of the extravagant technique of the lithographer who, with a shower of spatters from a harquebuscade of ink, makes all the windmills of madness revolve on the lithography stone, and all the specters of his dreams dance and embrace each other.

Across from the pages that he covers with the angular downstrokes of his writing, Dali presents himself, for his pleasure and for all those whom he invites to read him, a solitary feast. "Celebrations," he says, "are intended for those who do not show up." His invited guests are his readers. He imagines them admiring and subdued, intrigued by that continual parody which, undoubtedly, is really no such thing. To read Dali is to listen to him; it is to attend the performance of a myth, of which, by successive improvisations, he has himself ordered the action, the displays and the figures, the vibrating and icy rhythm.

His journal is a kind of operatic libretto for the brain alone. The great lead in this show one day gave himself the diversion of changing his job. Omnipresent, as is his habit, he hides this time behind some "Hidden Faces." He is the manager of their intrigues. Through these worldly marionettes, he stages the tragicomedy that he ordinarily presents for himself. One senses him under the features of these old-fashioned bit players, the survivors of a society whose rites and refined absurdities have earned the name of decadent. To one of them he whispers a cue, to another a word that sounds strange in his mouth, to all of them a borrowed soul, his own, which echoes back in each one the impenitent snobbery that he shares with them in pleasure and in vanity.

In his novel Dali's voice changes. His register is lower-pitched. The language he attributes to his cast is of a precious banality, very *fin de siecle.* Under the most conventional cliches a "natural" pomposity comes through, introducing the most trivial gossip about dusty furbelows and pleats. There are nothing but "noble attitudes," "firmness of steel," and other banalities that are to writing what the languid poses of Bouguereau are to painting. This one, "his head in his hands, seems to be plunged in meditation." That one is "thinking deeply" and "sighs with the anguish of a broken heart." These antiquated automatons, restrained by out-of-date conventions, might be seen as contemporaries of a Count Kostia or a Monsieur de Camors, who would have frequented, late in life, Des Esseintes. The heroine, "Saint Theresa, the profane," according to what the novelist says, wouldn't she be a distant sister of Justine or Juliette? The hands and the heart "united by the irons of a passion that burns like ice," she knows "sublime tortures," more refined if not more platonic than those which caused the moaning of perverse victims born of the dreams of a man who, while inflicting them on his creatures, forgot for a while the victims of Vincennes and the Bastille. For his part, his partner, a dandy in a well-tailored hair shirt, has, for some unknown pleasure, made himself a rule whereby asceticism adjusts as it can to the uncertain resolution.

Conversations, chitchat of the salon, gossip about amorous casuistry, reserves and refined modesties form the plot of the narrative. The rhetorician of esthetic transcendance, the rigid legislator of

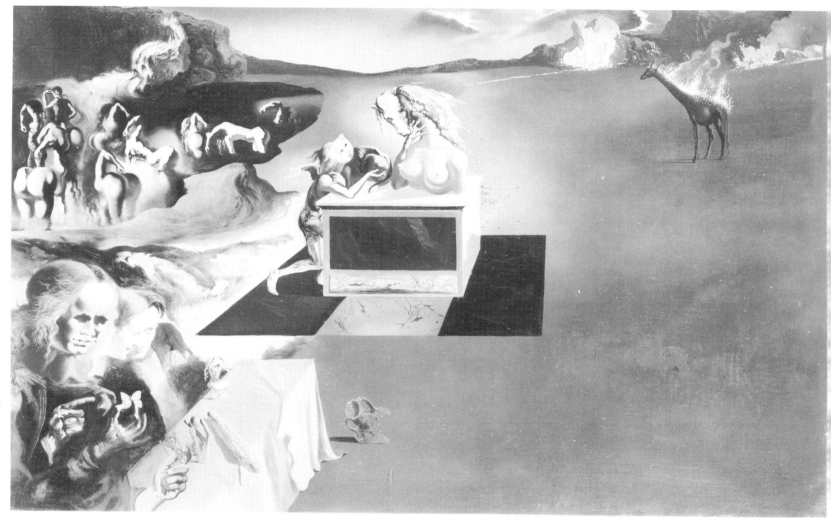

Inventions of the Monsters.
1937. Oil on canvas.
53 x 78.5 cm. (The Art
Institute of Chicago).

Phosphene de Laporte.
1932. Oil on canvas.
109 x 80 cm. (Andre-Francois
Petit Collection, Paris).

deliberate excesses, coyly becomes the rival of a Cherbuliez or an Octave Feuillet. Is it a pastiche or a resurgence of nostalgia, under the author's pen of faded ink, of sentimental styles of the Belle Epoque? His characters could have been the models for those denigrated painters whom he most admires, and in whose style the setting of the novel is also depicted. Nature is barely visible, except through casement windows that open onto a park. The faded leaves lie strewn about the lanes. But the trees conceal tragic shades. Objects play a big part. Symbols more than simple props, they bear on themselves a reflection of the one who has chosen them, who touches them and caresses them with the look of a collector and esthete. Dali makes meticulous still lives of them, colors them, and chisels them with a treasure of an expression. Like bursting dissonances, they tear the web of ready-made phrases. On the "arpeggios of the insolent moon on the little fingernails of a child," a jewel takes on an unexpected prominence. Even a fly "clinging to its post on the tip of a breast of which the pulpous curves gleam like polished marble," is, despite the simile, signed Dali.

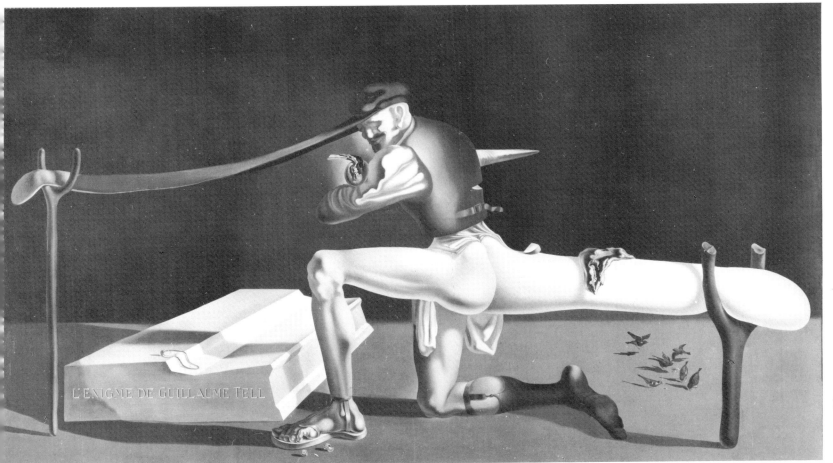

This "long and boring" novel (the author himself praises himself, not without some cheeky self-satisfaction) is the chronicle of a present in which the characters seem to be dressed as onlookers from another century. One might say it is a complicated melodrama through which reverberate the out-of-date echoes of declamatory conflict and intractable and garrulous complications. As the writer observes, a conversation can easily "be established in the solemn mood of synthesis." One thinks one hears them filtered through animated masks of wrinkles, made up with "decadent" and faded features. By themselves, only heroic and forced poses can cause us to think of those shapes that, on the painter's canvases, are congealed in their exaggeration, like those Baroque statues twisted in ecstasy and tortured by their rapture.

When he listens only to his verve and lets himself go with his impetus, Dali then—one can say—is Baroque. He is resolutely Baroque, by an unreasoned fate, almost reluctantly.

The Baroque style is the style of excess and ellipsis, of daring and systematic disorder. Each form,

each expression of thought, is magnetized by the two opposite poles of the area where the Baroque genius opens the field, fleeing from the possibilities, wanders by shortcuts, gaps, and misleading diagonals, returns by a thousand detours and deviations to its point of departure and, from all that seems to be excluded, creates but one. The blending of incompatibles, the flashing hybridizations, the swarming of antinomies, are his means. A complete universe is contained in these divergencies, in these contrasts where extremes touch and are resolved in their double and mutual reflection.

Since the day of Lucain, Spain has been a quasi-autonomous province in the empire of the Baroque. From the most severe enthusiasm to opulence surcharged with a sibylline verbosity, from the proliferation of metaphors to the most poignant laconism, from the most prosaic primitiveness to effusiveness, from the penetrating shadow of its black ray in the light of day to the flashing lightning of the "dark night," from the folly of grandeur to the most arrogant humility, from the lance of El Cid to the pilgrim's baton, from the irregular pearl, the

The Enigma of William Tell #1.
1933. Oil on canvas.
201.5 x 346.5 cm. (Museum of Modern Art, Stockholm).

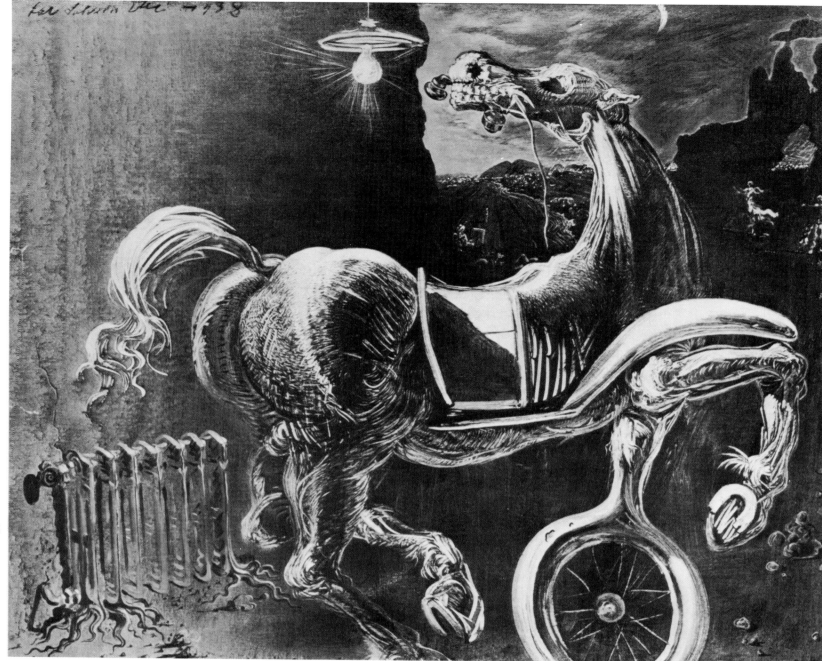

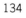

Castilian *berrueco,* to the scallop shell, the Iberian soul is apportioned between the most tiresome reality and mystical withdrawal, upon the steepest summits of the mind.

Upon the austerity of the facades, a suffocating luxuriance blossoms. The flowery fronts shatter. Perspectives fall to pieces and fly away. The stone rants in mid-air. Similarly, the word, the expression, by a sort of reciprocal reverberation, blazes up and in the fairy-like scenography of mental space is charged with sense and with misconception, suddenly condensed into bursts of thought.

A morbid lust for the tragic decked out in derisive rags, the cruelty of the real cast out into pasture to the laughter arising around that bloody *feria,* the cry in the throat which throttles the agony of the *canto jondo,* the fascination for the horrible and the charms of the hideous, the delights of disgust excite to shivers the refinements of art. The grimacing decomposition of flesh under the pitiless brush of a Valdes Leal and the caricatural harshness of a Goya have found new resonances in Dali. Painter of reality and of the most disturbing metamorphoses, of an

appearance that crumbles, cracks, splits, exfoliates, and breaks up, his work is a teratology, an Apocalypse of form. The devouring melee of bodies engrafted with monstrous transplants, gives birth to unprecendented species and torments. The face of "Spain" is nothing but a haggard mask of Medusa, and behind it, in the empty sockets, play the "Miseries of war," abridged to Caprices of Misfortune.

Dali, the writer, had guarantors who are no less illustrious: Gongora, Quevedo. From the one he sometimes rediscovers the secret of sudden verbal crystallizations, obscure and enigmatic thunder. From the other, the contorted earthy realism, the corrosive causticity of "Visions." Like Quevedo, he engraves, but with a pen rubbed in Dalian phosphorous, the confession that spurs him on, the calcinated shadow of a dream of sulphur and fire and, on the spur of the moment, illustrates with a line hidden dreams of burning effigies of another "Ball of the Passionate."

PIERRE VOLBOUDT

Blind Horse Chewing a Telephone.
1938. Oil on canvas.
54 x 66 cm. (The James Thrall Soby Collection, Connecticut).

salvador dali's graphics

by pierre argillet

Dali studied engraving at the faculty of Beaux-Arts at Barcelona. Professor Juan Nunez, who is still famous for his teaching, had recognized Dali's exceptional talent for drawing and gave him evening classes in copper engraving.

In the early part of his life, it seems that Dali did not attach much importance to graphics and that he devoted himself almost exclusively to drawing and painting.

The first two earliest copperplates that I'm aware of are collaborative works. As a matter of fact, shortly after Dali arrived in Paris, he met Picasso and, on a visit to his studio, found him in the process of engraving. As the copperplate was not completed, Picasso, on an impulse, asked Dali to finish it in his own way. Two engravings were created in this way. I am not aware of any printing of them. One of the plates, however, remained in a studio in Montmartre and I imagine it has not, to this day, been the object of any printed edition.

At the beginning of his service in the Surrealist group, Dali had a hand in numerous publications, for which he frequently executed the frontispieces. The best-known is his illustrating of Georges Hugnet's *ONAN*, in which Dali, for the first time, expressed his keen feeling for provocative behavior. In a remark printed at the bottom of the frontispiece, Dali explains, in effect, that he has engraved the copper with his right hand while indulging in the pleasure of Onan with the left.

In 1933 Dali met the publisher Skira in Picasso's studio. Picasso advised Skira to entrust the illustration of *Les Chants de Maldoror* to Dali. The book appeared in 1934 when Dali was thirty years old. It was at this moment that, as much in painting as in his graphic work, Dali was going to express his full personality and—let us say it—his genius. *Les Chants de Maldoror* are illustrated with 42 copper engravings: 30 are inset plates and 12 tailpieces. For the first time, Dali shows a complete freedom of expression between the text itself and his interpretation. It is true that this well-known text is suited for all the reveries, since Leon Bloy was able to write the following in regard to Ducasse's book: "It is not literature, it is lava." Upon its publication, the illustrated book did not have much of a success because of its rather stiff price; only a few copies were sold. Dali and Skira were virtually unknown to the general public at the time.

Anticipating difficulties, Skira limited the printing to one hundred copies; giving each an odd number, he reserved the possibility of publishing another hundred with even numbers later on, for a total of two hundred copies. Because of the era and Dali's treatment of Lautreamont's explosive text, this will be considered Dali's most appreciated masterwork of illustration.

To engrave *Maldoror*, Dali chose an extremely fine steel point, for he did not yet know about the diamond and the ruby points that allow the artist to execute sinuous lines more easily, and that follow the

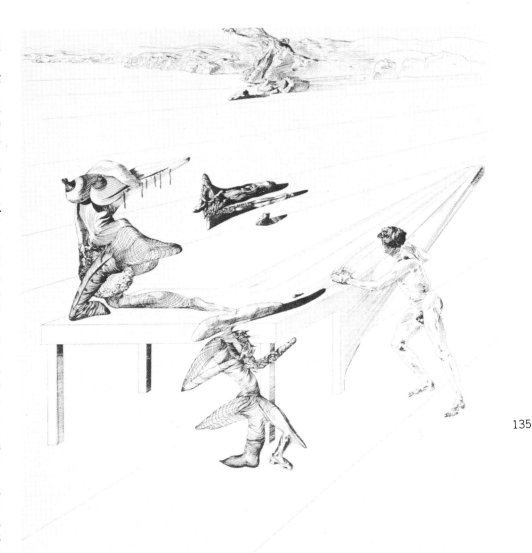

135

The Grasshopper Child.
1932. Pen drawing.

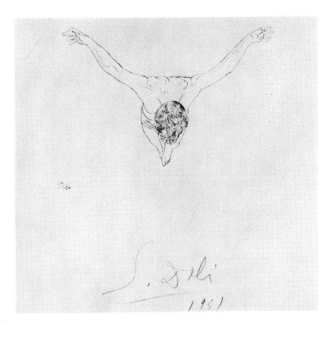

Crucifixion.
1951. 13 x 20 cm.
(Mills College Art Gallery).

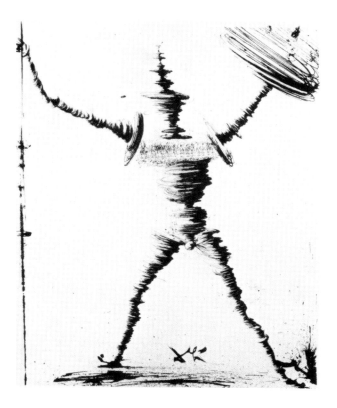

Don Quixote.
1957. Lithograph.
40.6 x 56 cm. (Museum
of Fine Arts, Boston).

Don Quixote.
1946. Lithograph.
(Museum of Fine
Arts, Boston).

impulse of the hand with greater docility.

Whatever the importance ultimately assigned to Dali's work, *Les Chants de Maldoror* will remain, in our era, a major, even unique work. Indeed, Dali's drawing, his stroke line, the printing of that era are very different from what he did later on. At that time Dali was executing drawings in small formats that surely continue to be the most beautiful of all his work. Some paintings are painted on frames of very small dimension with microscopic paint brushes, which made Breton dread the moment when Dali would tackle canvases of the usual size.

After the war, upon returning from the United States, Dali devoted himself, above all, to painting, and he took up lithography only around 1958, with the illustration of *Don Quixote,* ordered by his publisher, Joseph Foret. He approached lithography in a spectacular way—with the impact of shots fired from a harquebus. Using the forms obtained in this way by "objective chance," he constructed around these impacts representations inspired by chance alone. Dali engraved two or three lithographs in this manner, for the *Cavaliers de l'apocalypse,* but he soon abandoned the method, probably after concluding that he had gotten the most use possible out of it.

After that interlude Dali took up copper engraving again. As for the lithographs that were reproduced from watercolors and printed under his name, they cannot, of course, be considered original works, despite the interest they may hold. We must await publication of a catalogue raisonne of Dali's graphic work to determine precisely the artist's personal share in each series and in each period.

Nevertheless, beginning in 1960 Dali's graphic work is very abundant. He illustrates with uneven success the most famous texts of literature and fiction. *The Apocalypse of Saint John,* the *Bible,* and *The Divine Comedy* are his most celebrated works. The poems of Mao Tse-tung, Goethe's *Faust,* the poems of Ronsard and Apollinaire, a series of portraits of great artists, then another series devoted to the history of Israel give only a tiny indication of Dali's extensive production over the past twenty years.

But allow me to regret that this marvelous artist has occasionally yielded to facility and that in a passionate life, but one that is overburdened with works of all sorts, literary as well as scientific, he has been unable to restrict his production and retain in his own possession, without publishing them, the least carefully prepared works of his making.

The most recent technique employed by Dali is the simultaneous use of points of steel, diamond and ruby. The diamond point constitutes the essential of drawing. The ruby point allows for the creation of shadows and details of extreme delicacy. As for the steel point, it accentuates the shaded parts and gives strength to the details of the drawing that Dali wants to emphasize. In this manner, and with these three elements, he gives vigor and force to the subject treated and he avoids what is often the case with the application of the burin alone, the cold and academic side, which chills the senses as it chills the spirit.

PIERRE ARGILLET

136

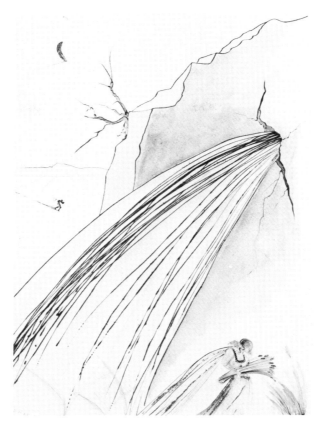

Joseph Hung by His Brothers.
*From the portfolio: Our
Historical Heritage. Gravure.
1975. 40 x 53 cm.*

The Source.
*From the portfolio: Our
Historical Heritage. Gravure.
1975. 40 x 53 cm.*

Elijah.
*From the portfolio: Our
Historical Heritage. Gravure.
1975. 40 x 53 cm.*

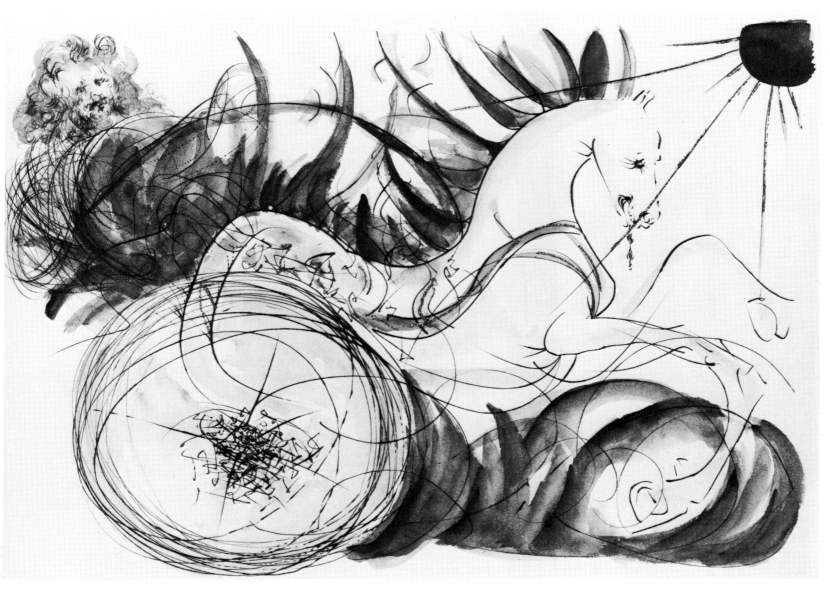

printmaking

by pierre volboudt

Old engraving of the Ampurdanes soldier and politician Josep Margarit, which is displayed at the entrance to the painter's home.

The sheet to be engraved, copperplate or lithography stone, becomes a preferred target for Dali. From near, from far, he caresses it, strokes it, attacks it, violates it. With a precise aim he lets fly his stroke, he riddles the page, wounding it with deep splinters, spattering it with a hail of fragments, with a splintering of atoms. Raging scratches and fine soft arabesques are lost in the interlacing of hatchings and cuts, and penetrate and flee in order to go, in the intact whiteness, and blend with the transparent summits that notch the distances.

Let a great text arrive to tempt him and Dali imparts to the literary image his hypnotic trance. His graphic sense seizes it, subjects it to the developing vision and overruns this theatre of phantasms of which it might be said that a delirious demiurge has regulated the explosive scenography. The myth becomes reality, the artist's reality in which sinuous odalisques enfold rough ascetics, all alike through their thorny flesh to exfoliated rocks and barren lava of those arenas of solitude and madness, congealed ruins eroded by the etching of insidious cataclysms.

Man of theatre, Dali is the producer of these dramas in which he is, by a sort of poetic usurpation, the hero. "Myriad-minded man," he puts on the cast-off garments of Macbeth or Casanova, in turn Faust or Mephistopheles in the penumbra of a cabbalist's chamber, in the phosphorescence of an aura from beyond the tomb, Maldoror as prey to his monsters, Dante undaunted and crowned among the eddies of infernal water and, emerging from the *selva oscura,* standing in the grand finale of light. But Dali is, above all, himself, the great artificer who spreads out his inner displays and, like the Baroque bird proudly spreading out its tail, decorates his universe with banners.

Under the masks that he imposes on them, the disguises that distort them to the point of indecency, Dali plays all the roles. But he is the sole hero of this *faena* where the pen and the point take the place of the sword and the banderillero. The Fable which breaks the bonds that the subject imposes on the artist always triumphs. For it is no longer a question of illustrating, in the banal sense of the word, that is to say, proposing a version parallel to the one the author relates. It is necessary to invent a *gongoresque* visual translation, to transpose the chosen theme, with the assistance of the most convention, the most unusual technical means. It is in the immense borders of the imaginary, in the whites of the text, that the visionary Dali shows his capability, his exaggeration. He does not superimpose or trace. He creates. His phantasmagorias are given complete license. A mythology is invented whose idols disguised by blood and ink reign by strangeness. Through the breach by the blows of the harquebus or the burin and studied blots retouched until impalpable, the engraver opens himself up across the written work and unfolds the teeming ballet where, on vast sheets of paper, as on the walls of a revolving labyrinth, in the privacy of his studio, the man of sharp pointed arms animates the figures, captures by his cruel and subtle nets, the universal demonry.

PIERRE VOLBOUDT

138

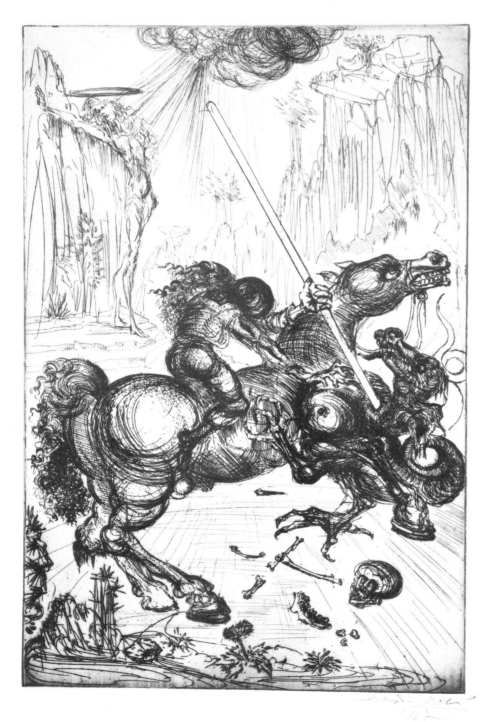

St. George and the Dragon.
1947. Etching.
45 x 28.5 cm. (Cleveland Museum of Art).

dali, a ceremonial and symbolic sculpture

by gérard xuriguera

Today we no longer count the painters who, in the course of their artistic development, have worked with three-dimensional space. The temptation to trap what the canvas hides, the physical and mental desire to erect as artisan a tangible architecture, the will to mould the immaterial or to struggle with the material in order to impress on it a perceptible mark, have in turn excited creators as different as Degas, Picasso, Marcel Duchamp, Matisse, Miro, Ernst, and Lam, to name but a few. For many this quest for the tactile even appears complementary, as Matisse has pointed out: "I took up clay in order to rest from painting," he said. "It was to regulate my emotions, to seek a method that suits me completely. When I had found it in sculpture, it was useful to me in painting." As for Andre Beaudin, he acknowledges, "When I make sculpture, I continue my painting. But it is sculpture that I am making." Even closer to us is a remark made by Messagier: "At an early age I

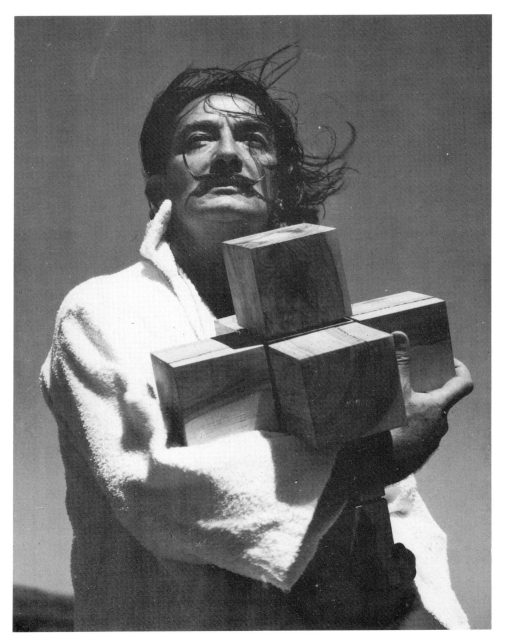

Dali Holding the Hypercubic Body. *1951. Made in olive wood. (Photo by F. Catala Roca. Editions Poligrafa, Barcelona).*

constantly had the need to duplicate my painted forms by three-dimensional forms." This is evidence enough to confirm for us the attraction that sculpture has for painters and their involvement with it.

It is logical that Dali, who was of a curious and paradoxical spirit carried to extremes, constantly possessed by new alchemies, should be interested in sculpture at a very early age. In the manner of his compatriot in Surrealism, Oscar Dominguez, like him temperamental, emotional and hypersensitive, and with whom he shared a similar adolescence, coddled by an indulgent mother—he displayed his frenzied aggressiveness above all in the creation of ceremonial and symbolic objects. To these may be added several sculptures, some molded glass, as well as numerous pieces of jewelry characteristic of his inimitable line. However, if his analysts generally focus their studies on his extraordinary talents as a draftsman, his baffling and corrosive fantasy, his overflowing imagination, his discoveries, such as the "paranoiac-critical" method and by that his regenerating contribution to Andre Breton's movement at a time when Breton was trying to get his second wind, we should not minimize Dali's ability to adapt to all techniques, notably in the field of sculpture. Still, although his sculpture can be considered minor in comparison to his enormous pictorial production, the evidence compels us to stress its unity. In fact, in the varied facets of this proceeding which continually leads to provocative behavior, identical lines of force are rediscovered: A narcissistic and perverse nature turned toward exhibitionism, an unrestrained cynicism, an innate sense of the absurd, a deep knowledge of psychoanalysis, all joined to a personal penchant for metaphysics and scientism. Everything here is governed by the same Freudian impulses which enlighten us more than the distilled commentaries of the pretentious philosophical phraseology of certain of his exegetes, who are quick to worship, about the complex temperament of this Catalan. Furthermore, that disturbing hallucinating often takes deliberate pleasure in bad taste, in a chromo style in which blasphemous, scatological and erotic connotations exhalt obsessional representations, dramatized phantasmatic visions that his sculpture hands back to us as well.

From 1928 on, the Dalian style spread across an artificial reality of disturbing "double images," conceived in a "state of permanent vigil." Refusing the prescriptions of Automatism, he defined his options: "All my ambition consists in materializing with the greatest imperialistic rage for precision, the images of concrete irrationality and of the imaginative world in general." His adherence to Surrealism shaped his definitive style.

Quite naturally and concurrently with his painting, in 1933, one of his earliest sculptures *Bust of a Retrospective Woman* was made in porcelain. This was followed in 1934 by *Hysterical and Aerodynamic Feminine Nude,* a modern-style plaster work show-

139

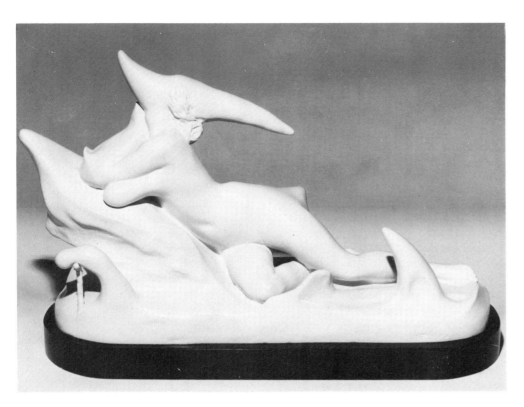

Bust of Dante.
*1964. Bronze, green patina
with gold spoons. 26.5 cm. high.
(Wilhelm-Lehmbruck Museum,
W. Germany).*

140

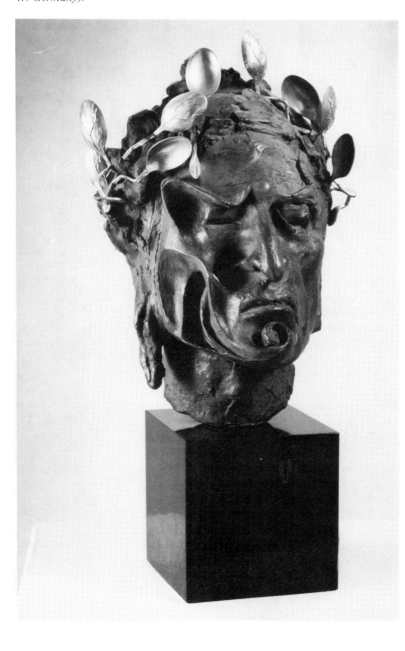

ing a form stretched out langorously on a kind of settee surrounded by a peculiarly animalistic horned head, creating an uncommonly erotic climate. An important historic milestone, this piece was scarcely modified by its author when it was recreated and cast in bronze in 1973.

Now, if we go back in time, we discover in a canvas of 1931, *The Persistence of Memory,* the appearance of a series of soft watches, evidence of his collusion with objects. From then on, night tables, pendulums, crustaceans, chunks of raw meat, cheeses, mannequins and drawers, at first arranged in limp shapes, will haunt the canvases of this visionary from Port Lligat before metamorphosing, some of them, into sculpted forms. Thus in 1936 *The Venus de Milo with Drawers,* a painted bronze of classical appearance, is the echo of a drawing made in 1934, *Premonition of Drawers,* in which open drawers are stacked up like shadowy mouths propagating irrationalism. In 1973 this very drawing takes on the form of a sculpture-object, in patinated bronze, in a casting of eight copies. Its head is a pendulum on which a symbolic *pesol* ("bean" in Catalan) occupies a place of honor; its bust, adorned with four drawers, rests on a slightly curved semicircular surface that allows a glimpse of doubled-up legs. In addition to the symbolic impact of this object, there is an evident attraction to the Baroque style, a reminder of Dali's admiration for Gaudi. "On the long list of symbolic images created by Dali throughout his work," writes Robert Descharnes, "his allegories of time, *The Soft Watches,* and of psychoanalysis, *The Figures with Drawers,* there stand out among the most famous: crutches, flaming giraffes, rhinocerous, etc. . . ."

Again, in 1936, we must call attention to the famous *Aphrodisiac Tuxedo,* a new exaltation of desire, which is considered one of the most astonishing antecedents of Pop Art, and the no less celebrated *Lips of Mae West,* a divan of an irradiant sensuality in the shape of lips, similarly cast in bronze.

Among Dali's successes let us mention, in 1965, *Dante and the Two Nikes,* and, in 1966, *The Slave of Michelin,* which mingles humor and satire with an obviously allegorical image. *The Swan-Elephant,* of 1967, and, in 1968, *The Yin and the Yang,* a burnished bronze, here again a counterpart of an earlier oil painting executed around 1934, *Hypnogogic Monument.* This sculpture-object is composed of three beans; the two most important are harmoniously overlapped in an implicit sensuality. In this connection, Dali wrote, in "The Tragic Myth of the Angelus of Millet," "I really enjoy the effect of stones with rounded and sensual contours that I have simply placed one on top of the other, all the while seeking to make their concavities and their convexities coincide in positions evocative of love."

In 1969 it is the *Atavistic Vestige after the Rain,* a burnished bronze still crowned with a bean, in the concave fleshy line which evokes a rainbow as well as

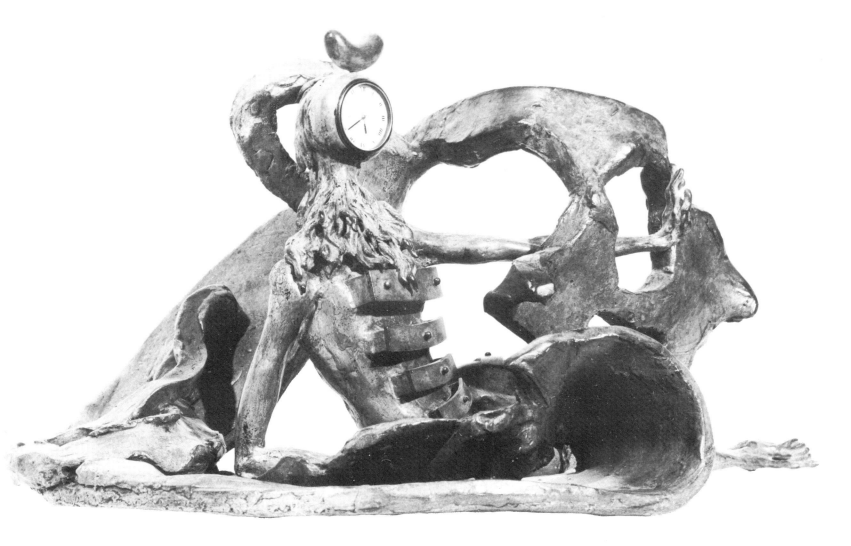

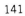

The Premonition of Drawers. 141
*1973. Sculpture, bronze
patina. 21 x 40 x 27 cm.
(Private Collection).*

Atavistic Vestige After the Rain.
*1969. 21 x 28 cm. Edition of eight.
(Andre-Francois Petit Collection,
Paris).*

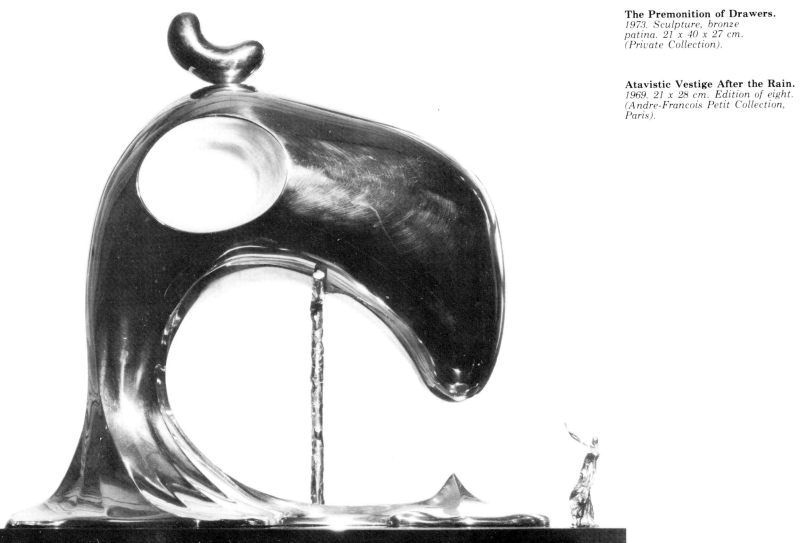

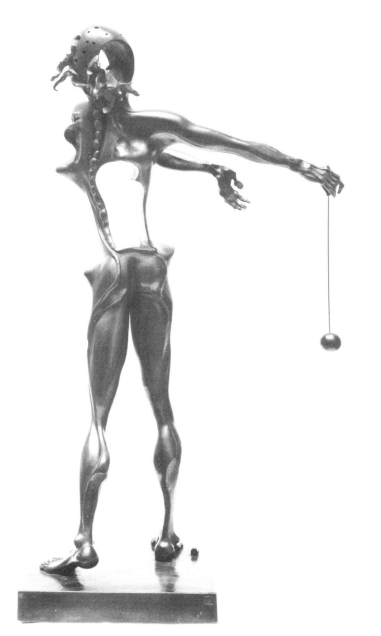

Homage to Newton.
1969. 70 x 40 x 132 cm.
Edition of eight.
Andre-Francois Petit
Gallery, Paris).

Funeral Mask of Napoleon.
1970. 22 x 19 x 28 cm.
(Andre-Francois Petit Gallery,
Paris).

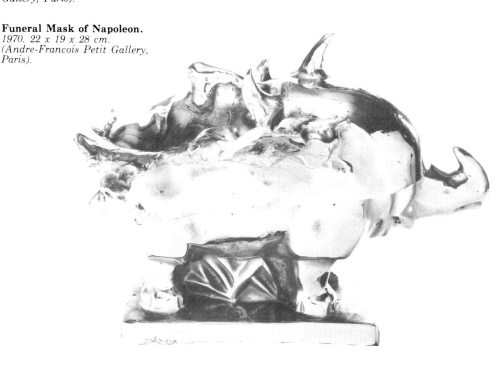

a bird's beak. And in 1969 again *Homage to Newton,* a patinated bronze of eight copies, a sculpture of large dimensions, 132 x 70 x 40 cm, underscoring the artist's interest in anything touching scientific discoveries. The shape of the English physicist and mathematician eludes realism; it is cut up into syncopated rhythms; bones and round humps create tensions of shadow and light with a definite majesty. There is an elegance here, a flexibility, an expressive energy worthy of an authentic sculptor who is entered in the mainstream of the concerns of his Catalan precursor, Pablo Gargallo, who, like Dali, was passionately fond of the work of Gaudi.

In other respects, this ambitious sculpture draws its forces from an oil of 1932, *Phosphene de Laporte,* which had already placed on stage a silhouette of the scientist within a semihallucinatory desert landscape.

Finally, let us single out, from 1970, *Funeral of Napoleon,* a patinated bronze whose removable mask fits onto the body of a massive rhinocerous with a sharp pointed horn . . . forever the game, the challenge, the symbols of Dali's world.

Beside the sculptures in molded glass, Dali, beginning in 1949, created countless pieces of jewelry. He was encouraged in this effort by his wife, Gala. These pieces of jewelry, tiaras or crowns, worked out on Surrealist themes dear to the Catalan, were carried out in gold, silver and precious stones. He exercised a great deal of care in preparing them, before entrusting them to great jewelers like Alemany & Company in New York. Certain of them display an unequaled inventiveness and a remarkable execution. But many are difficult to wear, and that is what their creator seems to wish when he declares, "A piece of jewelry should be unwearable. If, by chance, someone had to wear one of mine, I would want it to be worn under clothing, right on the skin, and that the touch of the jewelry be rough and prickly, in the manner of a hair shirt."

We may say that Salvador Dali's contribution to our esthetic adventure, without being so decisive as that of the heads of art movements in our time, will have been the introduction of a breeze of creative madness that is profitable, above all, to Surrealism, of which Dali was and remains the *enfant terrible.* Whether he was more of a draftsman or more of a painter than a sculptor doesn't matter much. His work forms a whole that continues to provoke and captivate and to stimulate the dreams of the great and the little people alike.

Let us leave the last word for Andre Breton, who says that "Dali has endowed Surrealism with a first-rate tool, in the guise of the 'paranoiac-critical method,' which he straight off showed himself capable of applying equally to painting, poetry, cinema, the construction of typical Surrealist objects, fashion, sculpture and even, if necessary, to every kind of exegesis."

GÉRARD XURIGUERA

dali and the cinema

by antonio urrutia with the collaboration of catherine iglesias

When people talk about Dali and the cinema, reference to two well-known Surrealist films is obligatory: *Un Chien Andalou* (1928) and *L'Age d'Or* (1930). However, these two basic documents do not offer the clarity that at first sight they seem to bring and that would be desirable in order to elucidate the relationships that exist between the painter of Cadaques and the seventh art. Although these two films are traditionally presented as the fruit of a close collaboration between Salvador Dali and Luis Bunuel, the co-authors of the two aforementioned scenarios, we now know that the name of Salvador Dali should be omitted from *L'Age d'Or,* for, ultimately, Bunuel kept only one of the gags conceived by the painter. Dali himself wrote several lines in

Dali in front of the bear at the entrance to his house at Port Lligat.
(Photo by H. Roger Viollet, Paris).

The Secret Life of Salvador Dali that leave no doubt whatsoever: "In my opinion, this film was supposed to translate the violence of love impregnated by the splendor of the creations of Catholic myths. . . . Bunuel alone made *L'Age d'Or.* I was practically shoved aside. . . . Bunuel had just finished *L'Age d'Or.* I was terribly disappointed. The film was nothing more than a caricature of my ideas. Catholicism was assailed in a narrow way, without any poetry."

This interesting document must be put aside with regret that the scenario Dali wrote is not available. But it is possible to guess about several of its characteristics from another scenario, *Babauo,* published in 1932, that everyone or almost everyone ignores and that we shall discuss later.

As for *Un Chien Andalou,* how can we determine what comes from Dali himself and what comes from the inspiration of Bunuel? Faced with this problem, Ado Kyrou, the great specialist of Surrealist cinema, shows herself to be very unkind and very scathing, to the point where discussion is useless: "Everything that to us today seems to be facile, superficially Surrealist, everything that resembles the dream sequence that Dali later produced for Hitchcock's ultracommercial film *Spellbound,* everything that is only symbolism [discussion of Batcheff with his double, schoolbooks transformed into revolvers, etc.], everything that comes from the windows of Hermes is certainly due to Dali . . ." (*Luis Bunuel,* Cinema d'aujourd'hui). 143

Things being what they are, we must turn to more reliable texts, for example, a document by Dali himself. And there is nothing better for the occasion than that little book published by Editions de Cahiers Libres in 1932 in Paris, which, under the main title of *Babauo,* contains not only the complete scenario of the same name but also an interesting introduction to the cinema and its history up to that time, appropriately edited by Dali.

Since it is a matter of two valuable documents fallen into oblivion, nothing could be more appropriate for this essay on Dali and the cinema than for us to reveal the contents. Let us begin, then, with the brief introduction to the history of cinema. Right off, Dali affirms that, contrary to public opinion, the cinema is infinitely poorer and more limited than writing, painting, sculpture, and architecture, with respect to the real functioning of thought. And he adds that "with the cinema there remains only the music, whose spiritual value is, as we all know, almost worthless."

Here we can see that Dali's penchant for provocative remarks does not date from yesterday. For it can be admitted, by keeping to the superficial, that writing, by its more abstract nature, better expresses the functioning of thought than does the cinema. But the thing becomes more surprising when we arrive at the same conclusions concerning arts as concrete as painting, sculpture and architecture—an exciting theme if ever there was

one, above all when it is a question of architecture. For it seems that architecture was the first art to materialize or give shape to the anxieties and visions of each era.

However, I find myself obliged to avoid the problem so as to restrict myself exclusively to the designs and intentions of Dali. The ambiguities of Dalian asseverations stem from the use of the terms "concrete" and "abstract". As a matter of fact, Dali wrote, "The cinema deliberately takes the absurd and stupid road of the abstract. It creates a boring language based on a cumbersome visual rhetoric of an almost exclusively musical character culminating in the rhythmic use of long shots, traveling platforms, dissolves, superimpositions, monstrous cutting up of the shooting script, an allusive and sentimental spirituality of editing and a thousand other crimes that, passing through the deplorable silent films of all the countries of the world, culminate in a cinema that is increasingly cinema."

To understand what is at issue we must determine the sense of the abstract concept and the use Dali makes of it. For him, abstract is tantamount to idealization; abstract is camouflage, clouding over of the subject. And criticism that speaks to the point, against all this cinematic cookery is due to the use of such trickery as virtuosity which impedes the true blossoming of liberated powers. For Dali the "concrete," as opposed to the abstract, is that which remains in a latent state, almost always engulfed in amnesia and reappearing in dreams. The concrete is the irrational. Poetry, the supreme art, requires irrationality. What is strange is that Dali seems to deny the cinema that potentiality of the irrational.

Dali speaks of the Golden Age of cinema which followed an initial metaphysical stage (from the beginning until Melies). This Golden Age is born with the first Surrealist films of the Italian school: "Magnificent era of historic cinema with Francesca Bertini, Gustavo Serena, Tulio Carminati, Pina Menichelli, etc., a cinema so right, so marvelously close to the theatre, with the huge merit of offering us real and concrete documents of psychological disorders of every kind, of the true development of youthful neuroses, of the realization in life of the most impure yearnings and fantasies. All the rest is decadence."

It is not surprising that the world of passion and delirium that then reigned in the Italian studios and was so well reflected, according to Georges Sadoul, "in extravagant and naive scenarios" (like Pina Menichelli rigged up as a bird of night) in which grandiloquence and gesticulation triumphed, attracted Dali, thus confirming by the same token that in the cinema there still remained possibilities of salvation.

Otherwise, why would Dali publish, some pages later, a scenario destined to become a film? The fact is that Dali rejects as valid art of creation all cinema that will not yield to the standards and principles of Surrealism and under the aegis of which Freudian

144

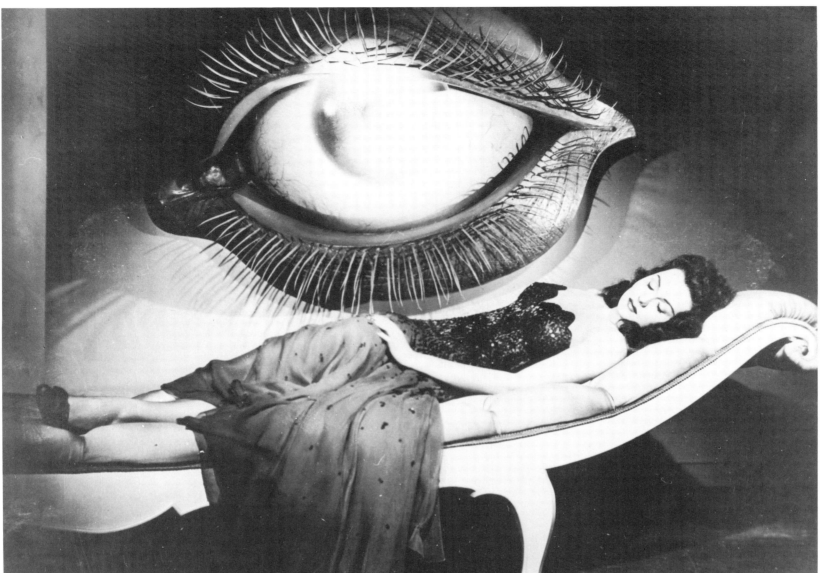

Rhonda Fleming
in "Spellbound."
Scenery by Dali.

theory and Expressionism function side by side. What our painter does not see, on the other hand, is that the days of random juxtapositions (like the photomontages of Man Ray), allegories, metaphors of poetic origin, gratuitous objects (as with Duchamp) were numbered.

Luis Bunuel realized this in time, abandoning orthodox Bretonian Surrealist cinema to take up true Surrealist cinema—permit me the paradox— and to grasp latent life, "to howl anguish and love, to throw black humor in the world's face." (Ado Kyrou)

That would make Bunuel's cinema, in the final analysis, the only Surrealist cinema, just as it is certainly possible that the only Surrealist painting, facing what is recognized as such, is the painting of Abstract Expressionism. For we must not confuse fantastic realism, dream realism or the cinema of the marvelous with Surrealism.

For a better understanding of what I am driving at, it suffices to turn to the analyses that Salvador Dali made of the comic cinema throughout his text in 1932. His position is summarized in the following dichotomy: he considers those such as Sternberg, Stroheim, Chaplin and Pabst to be without consistency, examples of "psychological, artistic, literary, sentimental, humanitarian, musical, intellectual, spiritual, colonial, departmental and Portuguese ex-

crement," but he shows himself most favorable to Max Sennet, Harry Laughton, William Powell and the Marx brothers, with whom the desires of systematic irrationality attain their zenith.

Everything consists in knowing what this systematic irrationality is going to assume, that is, what its contents will be. When Kyrou enumerates the essential aspects of the Surrealist cinema as a taste for the miraculous, the imaginary (science fiction), the fantastic (horror), anti-logic, the dream, social rebellion and black humor, it seems that there we hold one of the keys to Dalian problematics on cinema. And it is by his detachment from the last two categories cited by Kyrou—social rebellion and black humor—that the Catalan will never succeed in overcoming his limitations. Without any doubt, there is in Dali something that prevents him from breaking all the moorings. Perhaps it is his love of certain esthetic attitudes, his penchant for banal farce, his restraint before what is anarchizing and Dadaist that prohibit to him the supreme choice of freedom.

Let us say, in a word, that the Dalian irrational turns its back on true unconscious deliriums. Perhaps all this will be clarified when I have presented a summary of the scenario entitled *Babauo*.

The action takes place in some unknown country

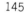

in Europe during a civil war. A groom knocks at the door of a room. Through the slit of the half-open door we see a woman in a transparent neglige. A chicken without a head makes a running exit. The groom gives Babauo a telegram that says, "Alone in Chateau du Portugal for past three days. I can't go on. Help. Your adored Mathilde Ibaiz."

Babauo leaves the hotel and runs into a friend in the street. They debate while a cloudburst, a veritable tidal wave, wets them up to the knees. The water carries all kinds of dead animals. Babauo crosses a square full of blindfolded cyclists. He dashes into the subway. On the platform a band plays amid the uproar and the mob of passengers. Between the rails a legless cripple is seated, fried eggs (without the plate) in his hand. He is begging. A coin falls on one of the eggs and it bursts. The cripple closes his hands to take the money and bursts the other egg.

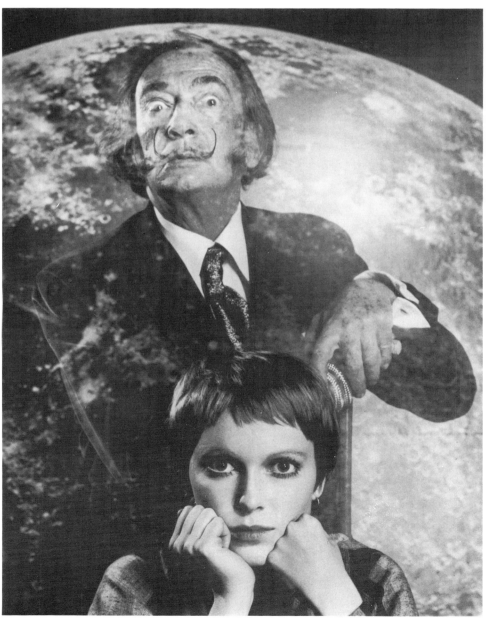

Mia Farrow at the time of the filming of "Rosemary's Baby;" visited by Dali, who presented her with a capsule containing a lunar meteorite. *(Photo by Philippe Halsman).*

146

Babauo takes the train. He sits down. From time to time he looks at his (soft) watch. At the other end of the subway car there is a woman completely nude. Near Babauo a postman is seated. Beneath his feet, raised so as not to touch them, are two fried eggs (again without a plate).

Babauo leaves the subway and hails a taxicab. On the road the driver stops, dresses his hair with feathers and climbs a tree. Babauo, tired of waiting for him, takes the car and arrives at the city of Chateau du Portugal. The cafes and the street are empty. The facades are covered with sheets the wind tosses and carries away. Several notes of the tango "Renacimiento" are heard.

In a cafe the sight of a napkin carefully introduced into a glass terrifies Babauo. At one of the windows on the sidewalk opposite, there is the bust of a woman. Babauo goes into the house and soon afterward comes running out.

Now the street is strewn with roses. Babauo climbs a slope that follows the path of roses and leads him to a theatre. The roses then carry him along to the fourth floor. In this empty theatre there is only a violinist, immobile in an impassioned pose, an armoire on his head, his pants rolled up on one of his legs, which is soaking in a saucer of milk.

Babauo leaves the city. In the vicinity he sees the chateau. An ever-increasing, deafening noise is heard. Babauo, again frightened, passes through a very high wall. On the other side large waves surge and break wildly on a beach of small pebbles.

Babauo finally arrives at the door of a chateau decorated on each side with statuettes, each representing a chicken with its head cut off.

In the courtyard there appears a bed fifteen meters long with a cypress tree lying on it. A coffin goes out carefully through the door of the chateau.

Babauo enters the chateau. Mathilde throws herself into his arms. Then the plot thickens in different scenes with Mathilde's parents, and numerous guests, but also with a mysterious package on Mathilde's bed. When finally it is found to be a corpse, Babauo and Mathilde take advantage of the confusion to leave the chateau.

In their flight they meet a group of Communist soldiers on the way and cross a deserted square, while in the distance deafening machine guns go off. Next they see an enormous bus, full of water, and on the inside there are three Japanese legless cripples, in a boat.

Suddenly Mathilde sinks her teeth into Babauo's neck: the bus crashes; the stuffing from the gutted seats burns in an immense funeral pyre. Babauo goes blind.

In the epilogue, Babauo, now cured, lives in Brittany, where he paints. There is a long shot with children eating apples, then a long scene in a fisherman's house where there live a mother and her two sons, who are in their thirties. The scene ends with grotesque fireworks. Babauo now rides blindfolded on a bicycle, with a loaf of bread on his head. Around

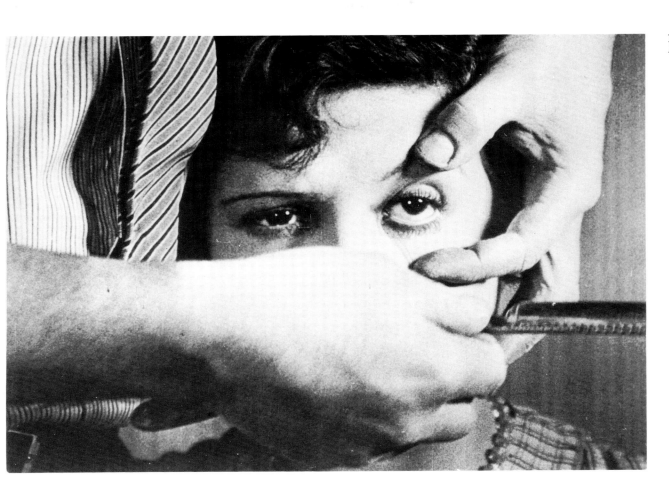

Le Chien Andalou.
Luis Bunuel.

him are a group of musicians and several tango dancers. He rips the blindfold from his eyes and at that very moment is riddled with bullets fired from a car.

Here, then, is the only scenario we possess from Dali's hand, and in it the author's limitations in regard to the use of cinematic language appear very clearly. Dali conceived the scenario without giving a thought to any of the particularities of cinemagraphic expression. The scenario may serve as a basis for a film director who will retain several images, changing many of the others, thereby bringing to it all of the necessary plastic formalism. But by itself this scenario does not give the Surrealist dimension hoped for. Dali often uses a large portion of his pictorial iconography, without succeeding in determining the necessary transposition in the passage from one genre to the other.

Dali lacks Bunuel's understanding of the world. *Babauo* fails by an absence of disturbing elements and profoundly dramatized signs of death. The irresistible force of love, the playful sexuality and eroticism that are essential features of Surrealism are scarcely emphasized at all. Yes, there is caricature, and unhoped-for alliances, but no fantastic deformation, such as Dali knew how to confer upon his canvases. The occupation of space here is always without surprises, obeying standards of classical perspective. In a word, we miss above all the authentic frenzy that the Surrealist group describes as follows in a text in 1930: "the frenzy so often decried, outside of which we, Surrealists, refuse to consider worthy any expression of art."

Another aspect to be emphasized in the reading of *Babauo* is the use of a spontaneous style and too much systemization. Dali has expressed his opinion of that tendency in these terms: "I believe that the moment is near when, by a process of a paranoiac and active nature, it will be possible (simultaneously with automation and other passive states) to systematize confusion."

I shall not discuss the goals achieved in painting, but simply guess up to what point this conception exercised control in the cinemagraphic domain.

Ultimately, Dali resists maleficent deformation in order to immerse himself in what is, more often than not, artificial and absurd.

It is possible, then, that all of this comes out of that more than unwarranted distrust of the cinema as a means of expression of the true functioning of thought? Dali offers the proof in the introduction discussed above. We can draw conclusions from such Dalian behavior, insofar as the painter never succeeds in establishing profound and intimate connections with the cinema. Nevertheless, this does not mean that certain characteristics of Dali's painting did not influence the cinema, for the Dalian mark is evident in the creation of the worlds of the dream, infinite spaces, pre-Raphaelite constructions, and Freudianism.

But we shall always be left in the lurch regarding the true application of the paranoiac-critical method to cinema. If only Dali had tried to handle the camera instead of wanting to be a scenarist.

In short, an unconsummated marriage is that of the painter from Cadaques and the cinema.

ANTONIO URRUTIA
with the collaboration of CATHERINE IGLESIAS

dali-telly or the persistence of memory

<div style="text-align: right">by daniel le comte</div>

What television producer would not be secretly pleased to learn that Salvador Dali had agreed to participate in his program? For the managers, too, it is a kind of consecration (the master's aura will make the television tube sparkle in a special way). And for the viewing public there is the promise of a series of rollings of those "terrible" eyes and poses validating the famous mustache; and finally, for the happy few, a cascade of light-headed intellectual pirouettes. In short, Dali seems an authority who guarantees the success of the whole show.

However, when I approached the painter in 1969, with the help of Robert Descharnes, I had no intention of filming him for long. The subject of the series "Ombre et Lumiere" was the work of Antonio Gaudi and I intended to show, above all, the structures of the Catalan architect. Furthermore, at the end of my visit to the Hotel Meurice, where our conversation with the painter was continually interrupted by the arrival of publishers, tradesmen, and various guests, I was persuaded that it would be difficult ever to obtain a serious interview.

That is why, on the day of short takes, with the agreement of Dali's secretary, Captain Moore, I used the technical crew and its equipment to blockade the corridor leading to the suite in the Hotel Meurice (always the same suite over the years).

I went in accompanied only by the sound man, and for half an hour Dali spoke with us brilliantly (in front of the microphone) about the work of Gaudi. Since the publication of the article on the Minotaur his analysis had remained the same, but under the impact of the questions his presentation and tone took on a new acuity.

Abruptly, Dali interrupted himself: through the partition he had just recognized the voice of "Bobo" Rockefeller, whom the Captain was trying to detain in the corridor. Dali immediately got up and greeted the visitor with all sorts of bowing and scraping and an excessive politeness. Then he accompanied her to the door of Gala's room.

After a minute or two he came over to us: "She's a friend who had the exquisite idea of giving me a small painting by Bosch and asserting that I am the Bosch of the twentieth century. I can't refuse to see her. . . . But, by the way, didn't you want to do a TV broadcast? If your technical crew is here, you can have them come in."

The technicians burst in, bag and baggage with some photo enlargements of the work of Gaudi. Dali moved toward a reproduction of the colonnade of Guell Park. The crowd of visitors behind the camera became thicker and thicker.

To my first question on the originality of Gaudi's research into the forces of architectural thrust, Dali, advancing toward the camera, responded in a stentorian voice: "Paco Rabanne, my friend, whom I see over there in the back, come here . . . and help me answer the question, since fashion has nothing to do with forces of thrust . . ."

To me this kind of evasion seemed catastrophic, for I had very little film. I had the camera stopped and the spotlights turned off. Dali never seemed to notice. After speaking in a low voice to the Captain, he asked the technicians to wait a few seconds. A short while later the technicians, stupified, witnessed the appearance of a series of rolling tables covered with trays of food surrounded by various bottles: champagne, whiskey, vodka.

"Gentlemen, please. . . ."

As one, the crew recovered its wits in order to take advantage of the Godsend. Dali went from group to group, polite and somewhat disdainful. From time to time he went into Gala's room and came out to

The Bestegui Ball in Venice.
(Photo by Daniel Le Comte).

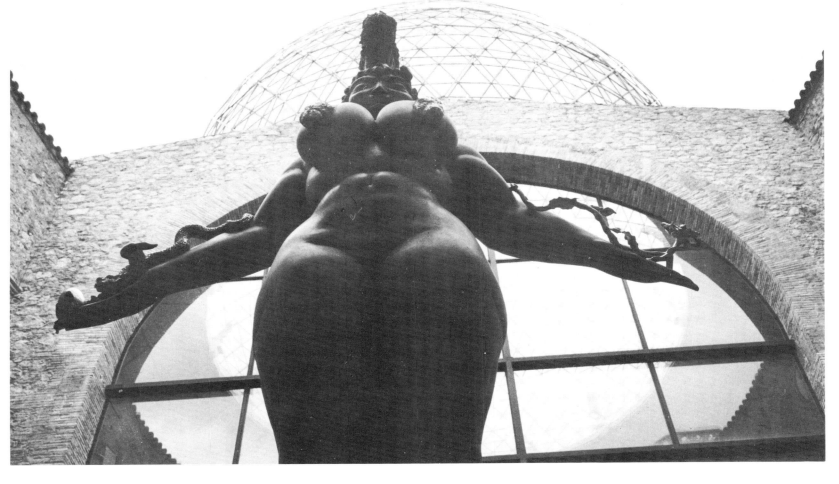

answer some phone calls (he was preparing a spot advertisement for Lanvin chocolate at the time and was demanding a significant sum of money from his caller). While on the phone, he toyed with a lorgnette that was strictly decorative, since the two lenses had been replaced by two crystal reflectors cut to a point.

Suddenly Dali came up to me: "Is that all the questions you have for me?"

"Monsieur, I have several dozen more, but you have to be ready to answer them."

"I'm ready, right now."

The technicians hastily swallowed the canapes they had begun and resumed their places. For twenty minutes Dali remained attentive and effective. He even sketched a dancer's leap to explain what kept Gaudi from making columns that were straight. It was this sequence alone—twenty images or thereabouts—that would appear after the final editing.

However, Dali's absence from the remaining shots was favorable to him: the public, listening to him without being hypnotized by his mimicry, discovered the relevance of his analysis, and one journalist went so far as to write that he had finally proven his intelligence!

His associates let me know soon afterward that the program had appealed to Dali. From then on he was willing to grant me a kind of favored treatment: for all the programs I asked him to participate in, the man whom Breton had nicknamed "Avida dollars" refused to accept any fee.

In the summer of 1970 he consented that I might go to Port Lligat to shoot a sequence that was to be included in a series of three broadcasts, "Surrealist Perspectives" in Ombres et Lumieres.

But a few days before my departure, Dali requested by telegram a transcript of a broadcast promised him by the French radio and television organization long ago. In spite of the difficulties, I was able to take it along to him.

I arrived at Port Lligat at nightfall. A projector had been set up on the patio. The ground was strewn with hippies dressed in white linen. Dali himself wore a kind of white robe, and orange blossoms were sprinkled in his hair. When he brandished his scepter-cane, his form conjured up, with a certain verisimilitude, that of an ancient priest.

Then there appeared on the screen a "living" recreation of the Angelus of Millet. Between the peasant man and woman the belfry from the village of Chailly could be seen, as in the original painting.

Dali approached the screen as if he couldn't believe his eyes. Part of the image was projected onto his tunic. Amazed, he repeated several times, "They filmed on the spot . . . at the very place where Millet painted." His joy was like that of a child's on Christmas eve before an unhoped-for present. And yet, the next morning he began the interview with a general assault on the media and the facility the camera possesses for traveling about everywhere and filming anything. He compared cinematic practice to the only art that he judges truly great: classical tragedy based on the three unities and performed before a plain curtain backdrop.

The interview took place in a room opening onto

Queen Esther, a Statue by Ernst Fuchs with which Dali decorated the hood of a Cadillac and the cupola of his museum.
(Photo by Daniel Le Comte).

the patio.[1] Under the stuffed and mounted head of a rhinocerous that decorated the back wall, Dali then executed an engraving by scratching a copperplate, using a stylus with a diamond point. He worked "blindly," his eyes concealed behind a fan. He told us specifically that this was his way of explaining the "secret" of automatic drawing that the Surrealists had extolled so much.

At the conclusion of this filming his Italian publishers, Mr. and Mrs. Albaretto, appeared. They had come from Turin to pick up some engravings that Dali had been promising them for over a year.

"Our subscribers patience is exhausted; you never attend to us."

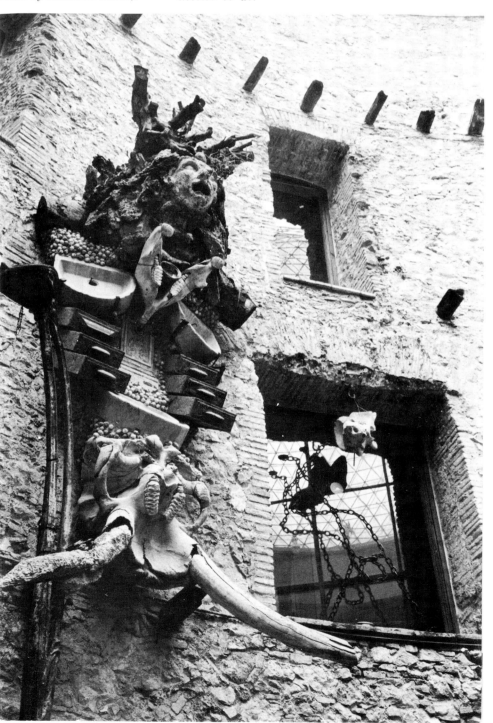

Decorations in the ancient foyer of the theatre. Dali said that the whole theatre is under the rule of death. But the decorative elements seem to emit shouts of life, like the sculpture by Bomarzo.
(Photo by Daniel Le Comte).

150

"What?" Dali asked, feigning surprise. "Right this very second I've been at work thinking of you." And he handed them the engraving covered with spirals that he had just made in front of the camera with his eyes closed.

A thick silence fell over the patio. Even the cicadas seemed to grow silent. Then Mr. Albaretto dared to say, in a hesitant voice: "Maitre, this isn't possible. My clients will never accept this engraving. Furthermore, printing it would do you a lot of harm."

Dali pretended not to hear and called for some pink champagne. The next morning, however, he delivered the notorious copper plate, which he had reworked during the night, to the Italian publisher. This time Mr. Albaretto turned it in the light and seemed to admire it. Dali took it from his hands to sign it.

That same day, when the technicians arrived, he had them come up to the patio and asked me to come into his studio. He wanted to show me how, based on photo enlargements, he worked out the designs that his assistant transferred to the canvas. He spoke to me of his doubts about his composition, his hesitations over the choice of subject, his constant need to consult Gala. At this time, he was so different from the persona that he usually presents that I suggested he send for the technical crew to record it. He stopped immediately and his gaze turned hostile.

"Fine, you are like the others." And as he was getting up, "Let's go make the arrangements."

Despite his distrust of us, he did not spare himself. He began like a shot and, leaving by the patio stairway that he had just decorated with "luminous images of sinks," he pounced on the camera so suddenly that the cameraman backed away and ruined the end of the take.

While we were putting the equipment away, Dali decided to take a boat ride in the sea, and he went off with Gala. As was his daily habit, he went swimming in Port Lligat in front of his house, which was embellished with Dinosaurian eggs.

It was in Paris the following year that I saw Dali again in connection with a program on photography. In order to talk about the photographic eye of Meissonier he insisted on being in the presence of the statue of that famous *pompier* painter. However, it had disappeared from in front of the courtyard of the Louvre, ever since Andre Malraux had had trenches dug along the Perrault colonnade, and Dali was no longer able to accomplish his ritual; pilgrimage to "his" master. Where had that colossal statue gone?

Upon inquiry, it was found hidden in the basement of the Musee d'Art Moderne. Dali arrived on the scene in a Cadillac. Overwhelmed by emotion in the presence of the statue, he wanted to interrupt the interview after a few sentences. But I insisted, and he agreed to resume the discussion.

The next day Dali proposed to a meeting of the National Museums to give one of his important

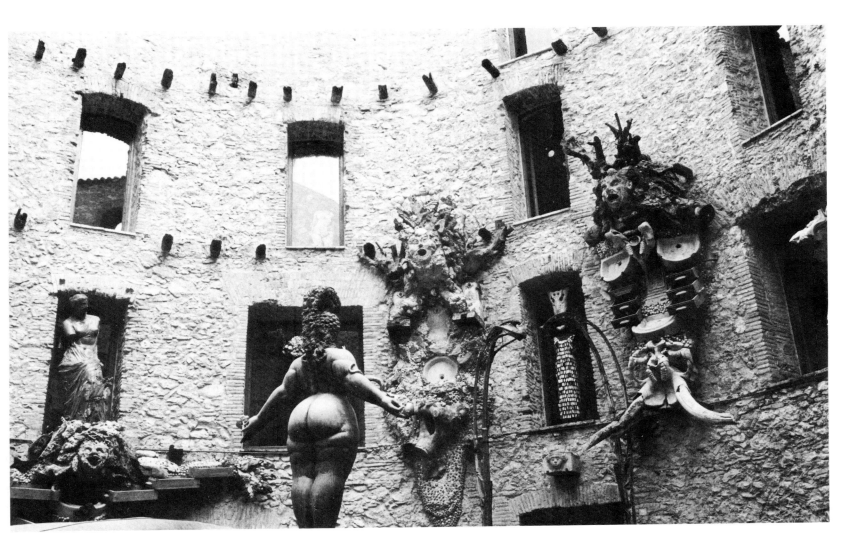

The ancient foyer of the
municipal theatre of Figueras,
burned during the Civil War.
(Photo by Daniel Le Comte).

151

paintings to the French nation if France, in turn,
would give him the Meissonier statue and transport
it to Figueras. Unfortunately, the arrangement was
never made, to the great sorrow of the painter, who
has often spoken about it.

In 1976 I resumed contact with Dali for a series of
interviews destined for France-Culture ("Keys for a
Museum Theatre," ten thirty minute programs.) We
had planned to tape them at the Hotel Meurice. But
instead of the five sessions promised, Dali came only
to one, and he used that one to return the contract
that the program director had thought it wise to offer
him.

For my part, I had been thinking about the possi-
ble use of those few recorded reels for a long while
when, in 1977, Dali let me know that he hoped to
resume the interviews at his home in Port Lligat.
This time I found a Dali exhausted by two successive
operations, and his voice had become very muffled.

Our first meeting took place in the evening, as a
violent storm was breaking. He suggested another
appointment with us, the next day, at the Figueras
Museum, but he did not show up. Finally, the day
after that, he gave us several hours before the crew
was to cross back over the Spanish border.

Was it the absence of the camera, the ease he feels
when he doesn't have to be on stage? For on that last
day he gave us straightforward answers and avoided
repeating his "classic couplets": it was a "live"
broadcast in the true meaning of the term. It was
there that he brought up the approach of death and
dwelt on the task to which all his attention has been
since then related: the continuous transformation of
his museum in Figueras.

But I have been able to confirm by other means

elsewhere, that Dali continues to draw and paint in-
defatigably, practically every morning. Invited to
enter his studio for a second time, I saw the latest
work in process, painted on copper. It is a new por-
trait of Gala, seated in a fifteenth-century gown.
Around her dress she wears a scrupulously detailed
necklace, in which pearls of coral shine. In this com-
position Gala appears as an aged woman. Beside the
painting was one of her photographs, taken twenty
years ago. She had, it seems, brought it to Dali so he
would "rejuvenate" her image.

But does the painter who has expressed so well the
plasticity of time with the "soft watches"[2] care now
to erase every trace of its passing from the face of his
companion.

Gala rejoined us out near the patio as pink cham-
pagne was brought out to us. She had been present
for some of the interviews.

"Have you listened to the tape recording?" she
asked me "You must be pleased. I thought you were
so serious, so stern . . . and Dali was so brilliant . . ."

That meeting took place last year at Port Lligat,
at the edge of the pool Dali had had built using a
design conceived by Ledoux in the eighteenth cen-
tury, for the bordello of his ideal city. It had the
shape of a phallus. The pool is filled with sea water,
and it is there that Dali now swims, for he no longer
has the energy to cross the creek of Port Lligat in
front of the house, as he had done for so many
decades in the past.

DANIEL LE COMTE

1. Dali's home comprises three fisherman's dwellings joined
together by a corridor stairway. The patio is located at the level
of the highest house.
2. The actual title is *The Persistence of Memory.*

dali's museum-theatre in figueras

by luis romero

Museum-Theatre of Figueras.
1976. (Photo by M.W. Daouse).

The twenty-eighth of September marks the most glorious of glorious days to be counted in the already long life of Salvador Dali. He made his entrance in the town of his birth, Figueras, like a Roman emperor returning from victorious campaigns, surrounded by a motley, noisy Dalian procession.

Authorities, personalities from the arts and letters, science, finance, with genius or without, people from Barcelona, Spain, France, the United States, from many countries, had assembled there to celebrate the event. Folklore groups, giants, huge masked heads, musical troupes, snake dances, fireworks, everything was moving in the greatest confusion due to an annoying program delay. Autumn was close at hand. The darts of the North wind were blowing, chilling the bare shoulders of

Museum-Theatre of Figueras.
(Photo by Meli).

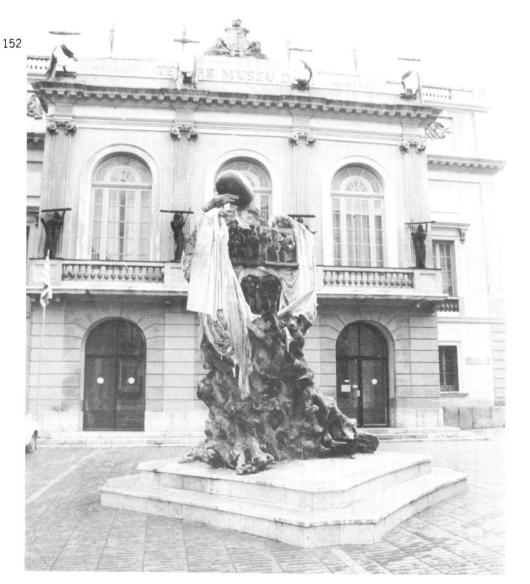

women still dressed for summer, sliding insidiously under the whirling dresses. A ferocious wind unleashing sneezes and making flying saucers out of the hats of elderly gentlemen. Applause by the public, fracas of rockets that one of the groups fired into the air as a sign of welcome.

The parade of Dali-Emperor was a conspicuous procession. Some folklore groups, amidst majorettes or elephants, danced with an ancient elegance. The townspeople of Figueras, sons of friends of the notorious Salvador Dali, shopkeepers, artisans and workers, peasants from the villages of the Ampurdan, the last of the tourists prolonging their vacation on the Costa Brava, the most beautiful women within a radius of a hundred kilometers, and many others, all were contemplating this ill-assorted Surrealist fiesta. Former classmates from high school and college, acquaintances, friends and others less intimate, from such and such a time, they had all come to approve or confirm the glory of Dali. Young people, old people risking pneumonia, and children, lots of joyful and curious children. But one among the children was missing. The one who ceased being a child a long time ago, a child named Salvador Dali Domenech, the son of the notary Salvador Dali Cusi. Some people were waiting near the town hall next to the dignitaries; others, surprised by the unexpectedly cold weather, huddled together, and all the rest all along the way, some of them punching, invitation in hand, to get into the museum, but no one had a full view of the masterpiece whose author was the principal actor and the foremost protagonist of this special, impressive, unusual, humorous, tender, fantastic, Surrealist, programmed and improvised, percussive happening. And the director was to skip out immediately, slipping away in a Rolls Royce, leaving the rest to chance. No photograph, no television, could capture it all. The work was destroyed in constructing itself, like an invisible belt unrolling in spirals of forgetfulness.

Until now we have never had anything more than insignificant fragments of that Dalian work in which almost all of his themes are found: landscapes of the Ampurdan, of which the principal city is the locale of that work: landscapes of Cadaques and Port Lligat from where Dali arrived, childhood evoked and sublimated; double, triple imagery; distant young woman eternally at her window; hyperrealism; the Freudian and the dreamlike; Monturiel, inventor of the submarine; opulant, trembling, shivering women's rumps, cypress trees agitated by the wind; large masturbators who were found there incognito; some old sphinxes; angels, and flies. Mystification, mythification, mixtification, hypercubic bodies, Andalusian dogs. Fireworks drawing in the sky the portraits of Voltaire and Lenin, of Velazquez and Vermeer, lace of fire, soft watches falling in multicolored sparks, critics and paranoiac-critics, blazing giraffes, Venus de Milo, the Marquis de Sade, Ramon Lull and Mao Tse-Tung. And next

to him, in flesh and blood, present in his work, Gala, forty five years later. . . .

The name of this unusual museum is in itself revealing, but the word "theatre" takes on its full meaning only when we know that the building that shelters this museum used to be the old municipal theatre, built in 1850 and almost completely destroyed during the Spanish Civil War. The neo-classical facade, the walls, the dome, reveal the theatrical character of the museum: appearance, scenography, representation, play, simulation of what is and what is not. Never before was a museum created by the author of the work that was destined for it. The original idea goes way back. Dali had vaguely contemplated transforming his home in Port Lligat into a posthumous museum. Since then, and

A view of the hallway with elements of the ancient decoration, the roof and other Dalian items.
(Photo by Meli).

153

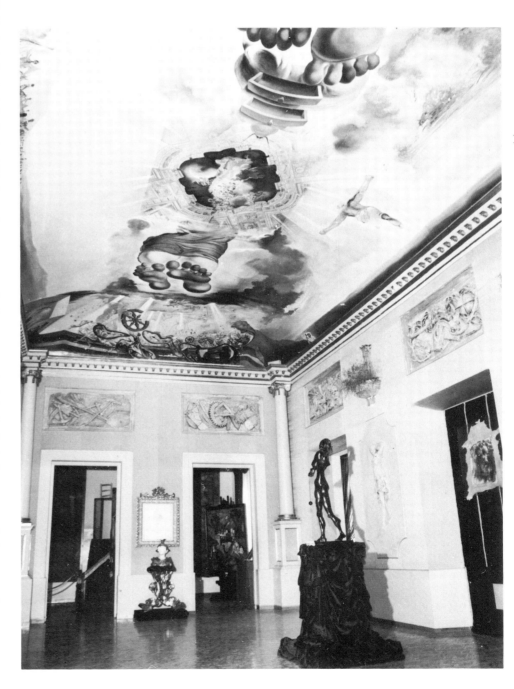

**Museum-Theatre of Figueras. 1976.
Each Tuesday the master gives free
drawing classes to fifty students
of all nations and he corrects
their sketches.** *(Nadege and M.W.
Daouse interview with Dali).*

until its realization today, coincidence and chance
have been at work. Dali's fantasy did the rest.
Several years ago, he had a show in the Caryatids
room of the Royal Palace in Milan. The roof of that
building, having been destroyed, was replaced by
another one, smooth and white. Dalis saw the old
roof in a photograph. He sketched in cypress trees
going beyond the walls in order to cancel out that op-
tical effect. The relation with the theatre of Figueras
where the roof had also been destroyed was ap-
parent. It must also be said that Dali had his first
show when he was a child in this same theatre.

The dynamic conception characterizes this
theatre. It is in constant and unpredictable develop-
ment. For, despite all the plans and planning, pro-
jects change according to necessity, or impulse. This
museum could be defined by comparing it to a work
that Dali might be in the process of creating, an

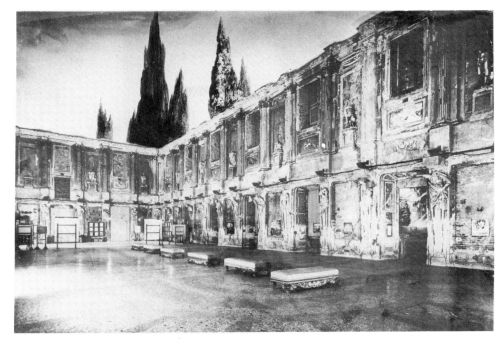

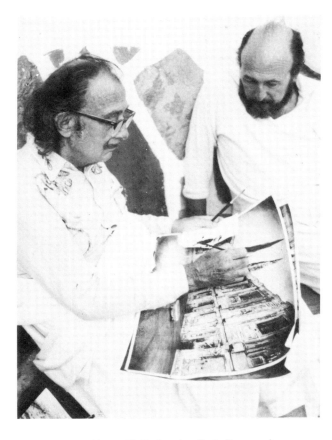

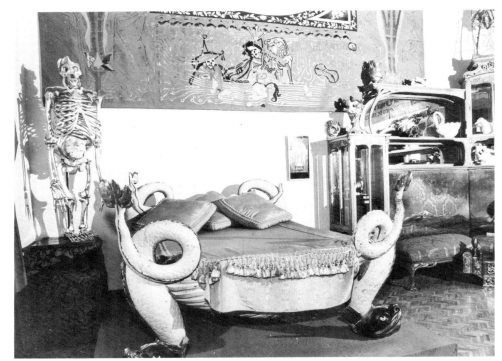

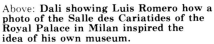

Above: **Dali showing Luis Romero how a photo of the Salle des Cariatides of the Royal Palace in Milan inspired the idea of his own museum.**

Top right: **Dali's transformation of the photo of the Salle des Cariatides in Milan.** *(Photo by Editions Poligrafa, Barcelona).*

Center: **Room of the museum where Dali had his siesta before the museum opening.**

Below: **Dali working on a scaffold during the construction of the museum.**

155

authentic work, gigantic and complete, that contains its own works at the same time, in a process of auto-fecundation. No museum can be compared to it. The construction, the architecture, the lighting and the scenery are not intended to show the artist's work in a logical or esthetic sequence, according to a style or a precise chronology.

The building having been found to be available—the walls, the facade, the supporting structures included—Dali obtained the grants and the necessary permits to rebuild it in this original way. From the easel the painter plunged into the open spaces where undreamed-of perspectives opened up for him. Measure and excess, proportion and disproportion exist side by side in an accumulation of objects and contemporary works, where pure chance or design has guided the choice.

This museum in Figueras is the hidden face of

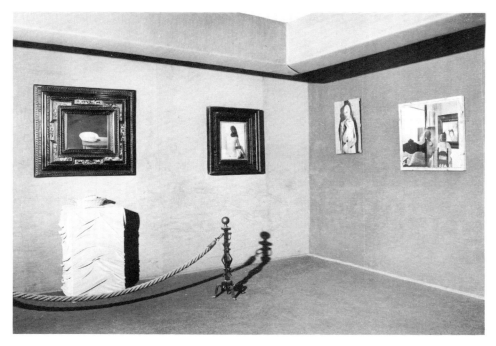

"The Basket of Bread" exhibited at the museum above its model.

Mae West (detail).

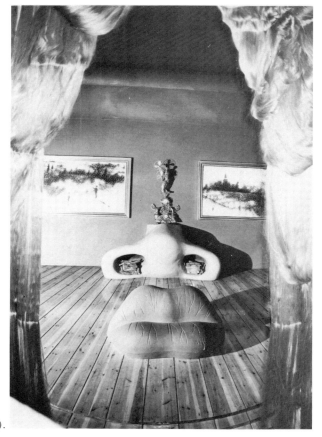

Mae West (detail).

156

Dali, the summation of his human and artistic adventure, the totality and the continuity of his personality, a dynamic anthology, a biographic essay.

The impatient have criticized, and not entirely without justification, the shortage of painted works in this colorful collection, but, the museum is in perpetual development. Important works are already exhibited there. Certain of them are among the best known: *The Specter of Sex Appeal, Galarina,* several self-portraits, *The Basket of Bread, Atomic Calm, Gala Nude from the Back, Purist Still Life,* some recent stereoscopic paintings, and a collection of early paintings. The engravings that are hung on the walls (and there is almost no more free space) enable us to get an idea of the importance of Dali's graphic work. There are drawings, gouaches, sculptures of various styles and dimensions, some of which are incorporated into the architecture. And there are unclassifiable works, for example, the lived-in face of Mae West or a new version of the Rainy Taxi, and a thousand inventions and fantasies. Then there are the ceilings in the foyer, the scenery of the ballet "Labyrinthe," and the stage curtain which, for several years, was in the theatre at Cadaques.

The large reticular transparent dome by the architect Perez Pignero dominates this orgiastic ensemble: stage, courtyard, corridors, salons, staircases, steps, loges, and engine room. Some works by other artists are shown: *Queen Esther* by the sculptor Ernest Fuchs, paintings and sculptures in stone by Ramon Pichot, photographs by various artists, oriental garments, paintings by Gerard Dou, Bouguereau, Fortuny, Modesto Urgell . . . and also an El Greco. A Goya still to come will soon be a part of the collection. There are statues, furniture, figures, transformed or not, the remnants of scenery from the old theatre, fountains, samples of Op Art, golden thrones, ancient bronze bathtubs, an imperial bed, rugs and numerous other objects, all of them making of this museum a sumptuous flea market, without a market, without fleas.

Such an accumulation of elements constitutes a show, a permanent theatre of surprises which, added to Dali's prestige, attracts a large number of visitors to this little town, more than two thousand a day, a figure never attained elsewhere in Spain, except at the Prado. It is an immense puzzle in which are mixed and intermingled gems and fake gems, works of art and decorations, flashy gold display and purple bronze varnish. An immense collage like a cathedral that must be visited in its entirety, the spectator, the visitor can see here the essential part of Dali's work: his paintings. The acquisitions will continue without the whole's being unbalanced in this vital overflow of a scandalous game which has for its locale a theatre in perpetual and prolific performance, a delirious universe, apotheosis and provocation.

LUIS ROMERO

Note: It is impossible to speak about the Museum-Theatre of Figueras without mentioning the Dali Museum in Cleveland, run by the Reynolds Morse Foundation. A magnificent, important private collection can be viewed there. A significant number of the works are paintings of very large format.

figueras or the illustrious theatre of salvador dali
by pierre volboudt

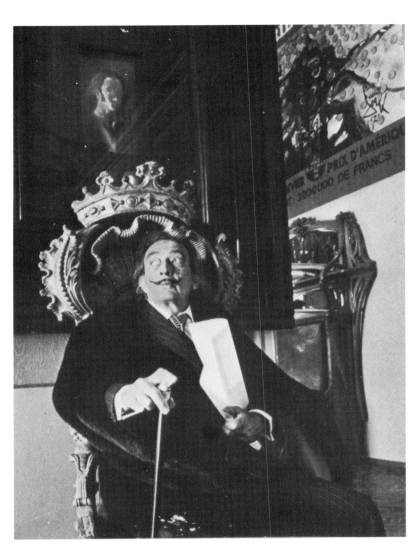

A museum is a work in itself. It is the integrated work of an artist, a manner of museum scattered across the world. But we can think of one place dedicated to a whole creation and, as if marginally, to that incongruity of accompaniment that is its distorting mirror, shattered according to caprices of taste, infatuations, the mood of the moment, into a thousand secret images. Dali dreamt it and he made that dream a reality. He wanted it to be uncommon and, like him, changeable. He has insisted on being the perpetual director of the displays of his art during his lifetime.

Figueras is the temple destined—if posterity is not unfaithful to him—to celebrate the cult of an Ego deployed in all directions of the mind, in defiance of all the conventions of the order of reason. It is also a kind of gorgeous Baroque opera. On stage, the extravagant, the sumptuous, the incoherent, follow one another from room to room. An action takes place among things, multiplying the surprising peripeteia, the metamorphoses, the coups de theatre. On the walls, the canvases introduce us to a dream world, populated by creatures born of the painter's phantasms. Costumes possessed by shades soliloquize in corners, confidants of what pompous, soundless monologue? Objects in delirium, golems and fetishes set up as monstrous knick-knacks, occupy a place of honor here and there, disguised as what they are not. Queer panoplies are the talking arms of the Great Magician, exorcist of the demons of ambiguity. On the ceilings, in the style of a colossal trompe-l'oeil, the Dalian empyrean culminates. Between the rocks suspended in clouds, in the heaven of deification, chimeras and titans hover, incarnations of a mythology of hyperbole.

This is a museum whose every turning is a trap, a place of incongruous marvels where, from maze to maze, wanders the master of the house, the collector enamored of chance curiosities and of the distinguished rejects, which pile up there, the spoils of the bizarre, the plunder of the unusual. But it is a theatre above all that an omnipresent absence fills, the sole actor and the inspiration of the place. At the heart of his mausoleum that absence is seated invisibly, on that high gilded chair, the torso upright, the eye fixed, portrayed with its own visions. With a cane between the fingers folded on the handle, echoing the voice of which everything is the cue, isn't it going to knock three times, three raps that announce the raising of the stage curtain, sounds that will resound through the ages?

PIERRE VOLBOUDT

158

The Academy of France.
1975. Gravure
66 x 43 cm.

a renaissance man

by michel deon of the french academy

At the age of six, he wanted to be Napoleon or a cook. He hasn't been Napoleon, and I don't think he would know how to boil an egg, but he has been, since May ninth, a member of the Academy of Beaux-Arts. All of his life Dali has openly asserted his liking of academies, while at the same time allowing himself to be the least academic of painters and, probably, of all the Surrealists, the most faithful to the literary and artistic movement that welcomed him upon his arrival in Paris. It was only natural that upon becoming in turn an authoritarian academic movement, Surrealism came to distrust Dali, who, by exhibiting a loaf of bread, an old shoe, and a glass of milk, provoked Aragon's displeasure.

"Bread and milk are for the workers," exclaimed Aragon, who was at that time a Stalinist. As for the Pope of Surrealism, Andre Breton, eager to strike the deviationists down with his vetoes, he excommunicated Dali, who was not afraid to admit his taste for money: "A painter who still takes the subway at the age of thirty is a failure." Breton countered with a vengeful anagram, baptizing Dali "Avida dollars."

But all this is a sidelight on history, if we look at the work accomplished by Dali over the past fifty years. He clowned for the public but, in private, he worked as few artists do. This man of the Renaissance seeks in vain to hide behind his exhibitionism; it is his work that we love, and it is by his work that he will be judged, not by wet firecrackers, his sea urchin engravers, his waxed mustache, his mink-lined capes, his Rolls Royce, his ambiguous friendships with transvestites and his obsessive exploitation of his love for his wife Gala. To painting he has brought an awareness, a rigor that the breakdown of form started by Picasso has made us lose sight of. A painter is also an artisan. Few people know that Dali is a skillful technician who has rediscovered lost formulas. His greatest canvases, and his best known, will one day bear comparison with those of Velazquez or Raphael. Their peculiarity has perhaps not yet been understood by everyone, and it often diverts attention from their formal and fervent beauty, whether it is a matter of the Ascension of the Virgin, the Crucifixion or the Last Supper. He lovingly violated tradition, thinking only of renewing it while leaving his mark on it.

Salvador Dali is also a writer: The *Secret Life*[1], *The Journal of a Genius*[1], and *Les Cocus du vieil art moderne*[2] reveal a real temperament, and intellect that are constantly alert. People readily take him for a madman because he says shocking things with a

Dali looks over the top of Gala's mask which is on the head of the sword.
(Photo J. L. Ceccarini-Aurore).

confusing common sense. All those who care for him, who find in him a genius, or a great talent, would like this tireless man, now a member of the French Institute, to put an end to some of his clownishness. I hope that he will shave off that upturned mustache and stop rolling those globular eyes, and no longer have recourse to flukes of chance. He has had all that an artist could wish for. If he agreed to stop being a media event, his painting would appear to us in full illumination, and certainly enhanced. Then we would know that his oeuvre is one of the greatest of this era. But perhaps this is to ask too much of a man who has raised mystification to the level of dogma.

MICHEL DEON

1. La Table Ronde, French edition.
2. Fasquelle, French edition.